Take a moment to look around the room. Think about where you are sitting and who else is here. Because some day you will want to look back and say: "I was there. I was at the launch of this extraordinary festival of arts and creativity. I was there when Luminato began to transform our city."

GREG SORBARA
Minister of Finance, Government of Ontario,
at the July 2006 event to launch Luminato

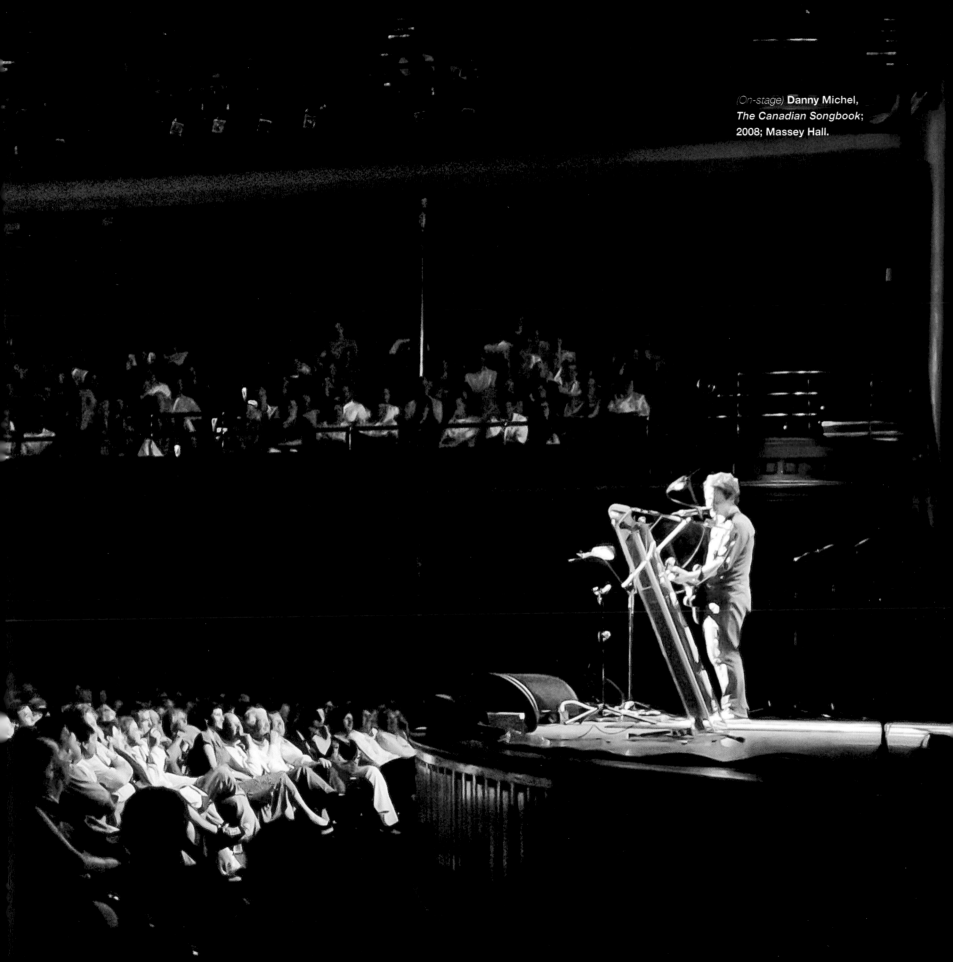

(On-stage) **Danny Michel,**
The Canadian Songbook;
2008; Massey Hall.

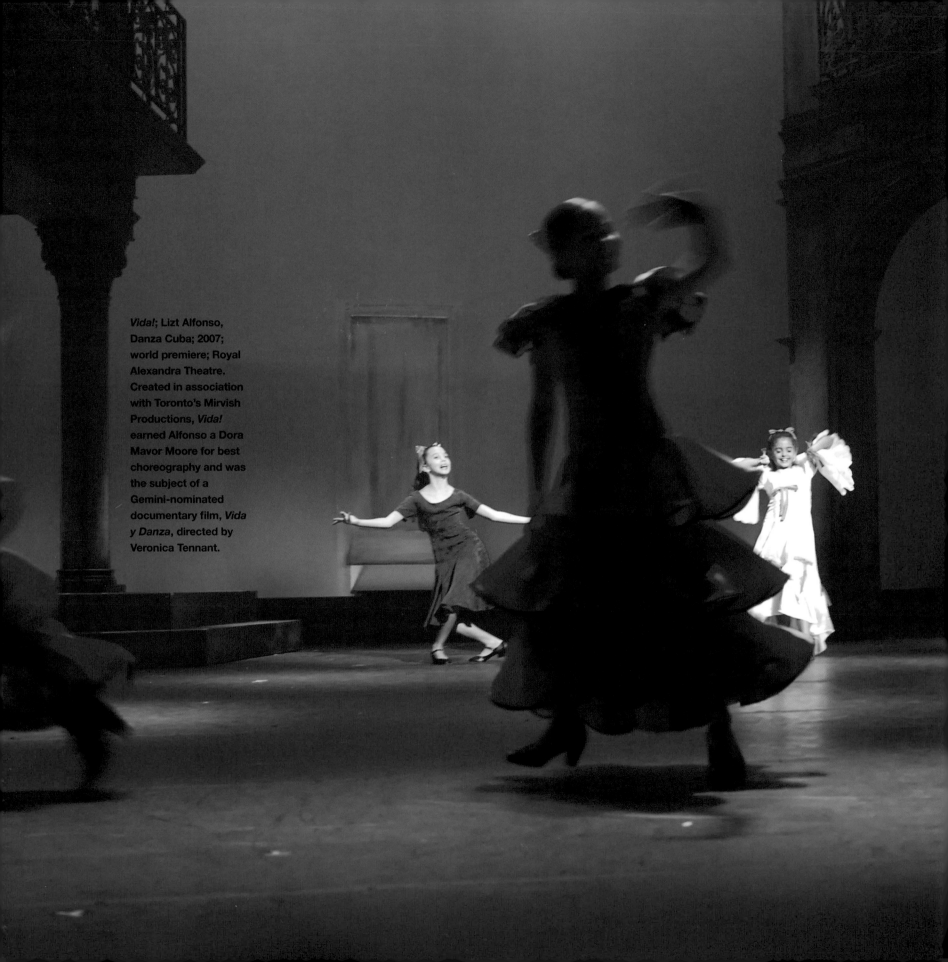

Vida!; Lizt Alfonso, Danza Cuba; 2007; world premiere; Royal Alexandra Theatre. Created in association with Toronto's Mirvish Productions, *Vida!* earned Alfonso a Dora Mavor Moore for best choreography and was the subject of a Gemini-nominated documentary film, *Vida y Danza*, directed by Veronica Tennant.

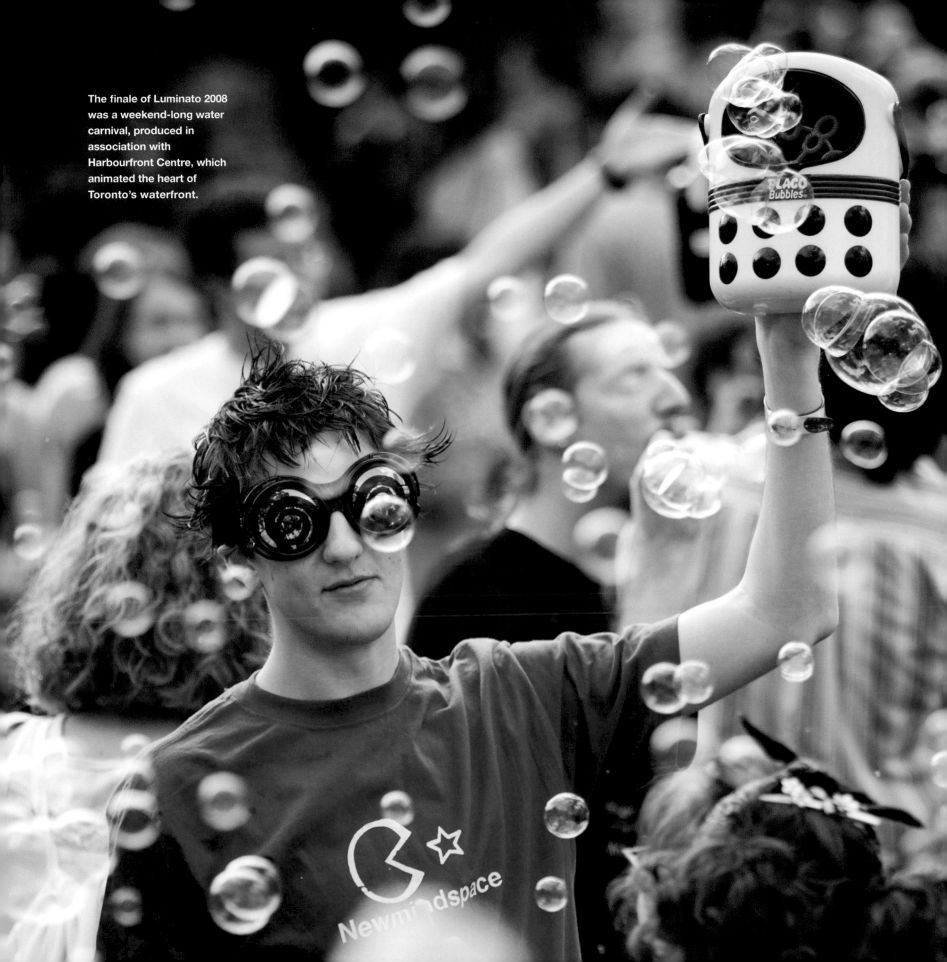

The finale of Luminato 2008 was a weekend-long water carnival, produced in association with Harbourfront Centre, which animated the heart of Toronto's waterfront.

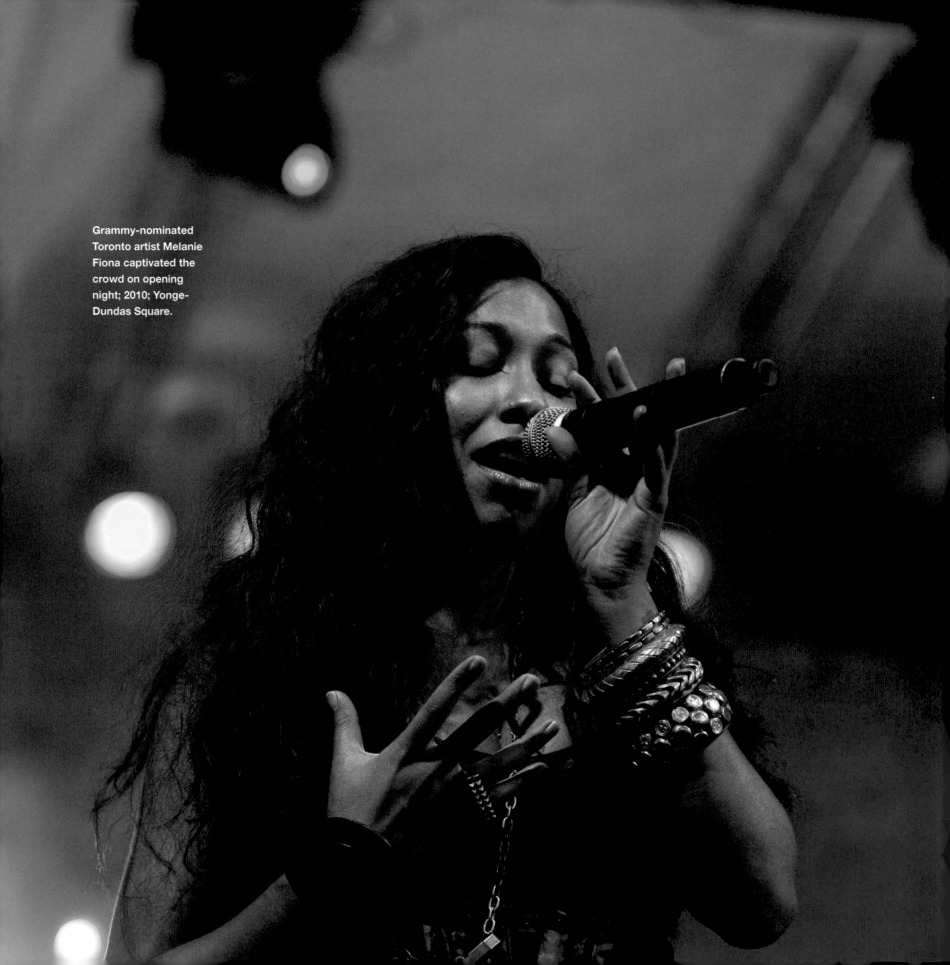

Grammy-nominated Toronto artist Melanie Fiona captivated the crowd on opening night; 2010; Yonge-Dundas Square.

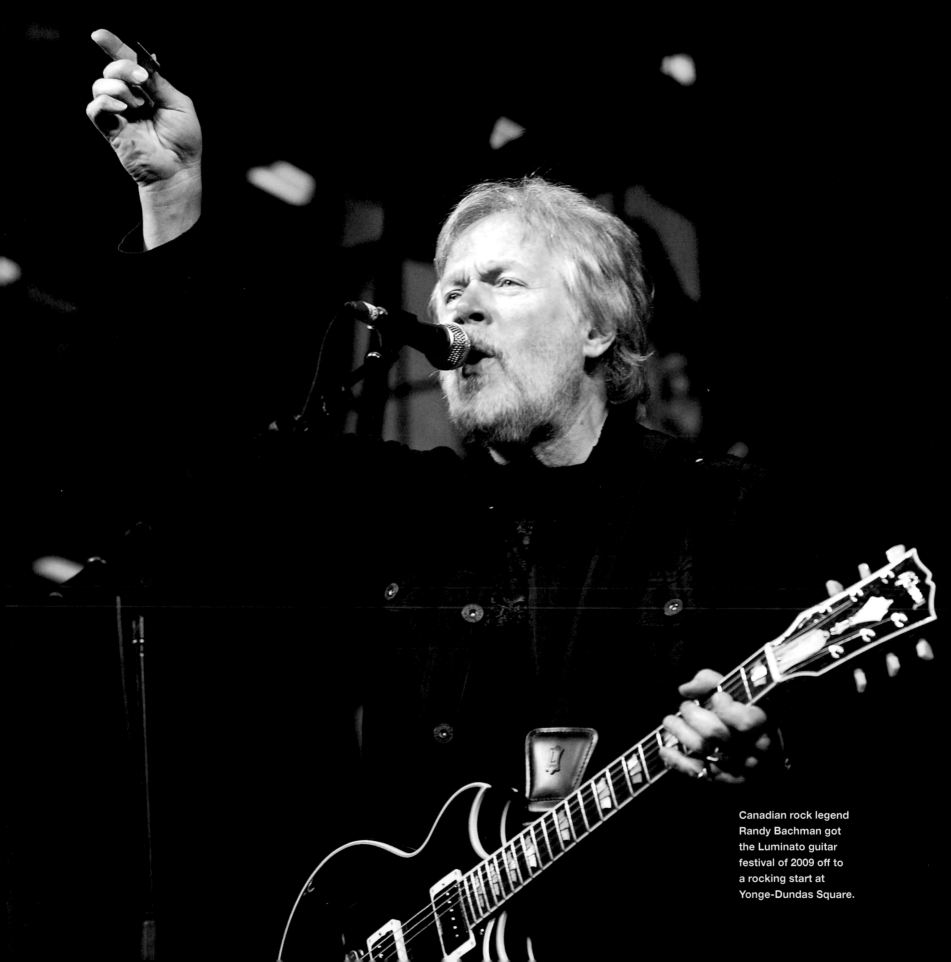

Canadian rock legend Randy Bachman got the Luminato guitar festival of 2009 off to a rocking start at Yonge-Dundas Square.

Light Play; Thomas Payne, Bruce
Kuwabara, Michael Levine; 2008;
Yonge-Dundas Square.

TEXT BY DAVID MACFARLANE PORTRAIT PHOTOGRAPHY BY NIGEL DICKSON

LUMI

NATO

PAINTING THE CANVAS OF A CITY

McCLELLAND & STEWART

Text by David Macfarlane
Portrait photography by Nigel Dickson

Library and Archives Canada Cataloguing in Publication

Macfarlane, David, 1952-
 Luminato : painting the canvas of a city / David Macfarlane ; portrait photography by Nigel Dickson.

ISBN 978-0-7710-5479-2

 1. Luminato (Festival). 2. Art festivals--Ontario--Toronto.
I. Title.

NX430.C32T67 2011 700.79'713541 C2010-908085-8

We acknowledge the financial support of the Government of Canada through the Book Publishing Industry Development Program and that of the Government of Ontario through the Ontario Media Development Corporation's Ontario Book Initiative. We further acknowledge the support of the Canada Council for the Arts and the Ontario Arts Council for our publishing program.

Every effort has been made to secure permission from the copyright holders of excerpts quoted in this book.

Typeset in Helvetica Neue by M&S, Toronto
Printed and bound in China

McClelland & Stewart Ltd.
75 Sherbourne Street
Toronto, Ontario
M5A 2P9
www.mcclelland.com

1 2 3 4 5 15 14 13 12 11

LUMINATO is a registered trade-mark of Toronto Festival of Arts, Culture and Creativity in Canada.

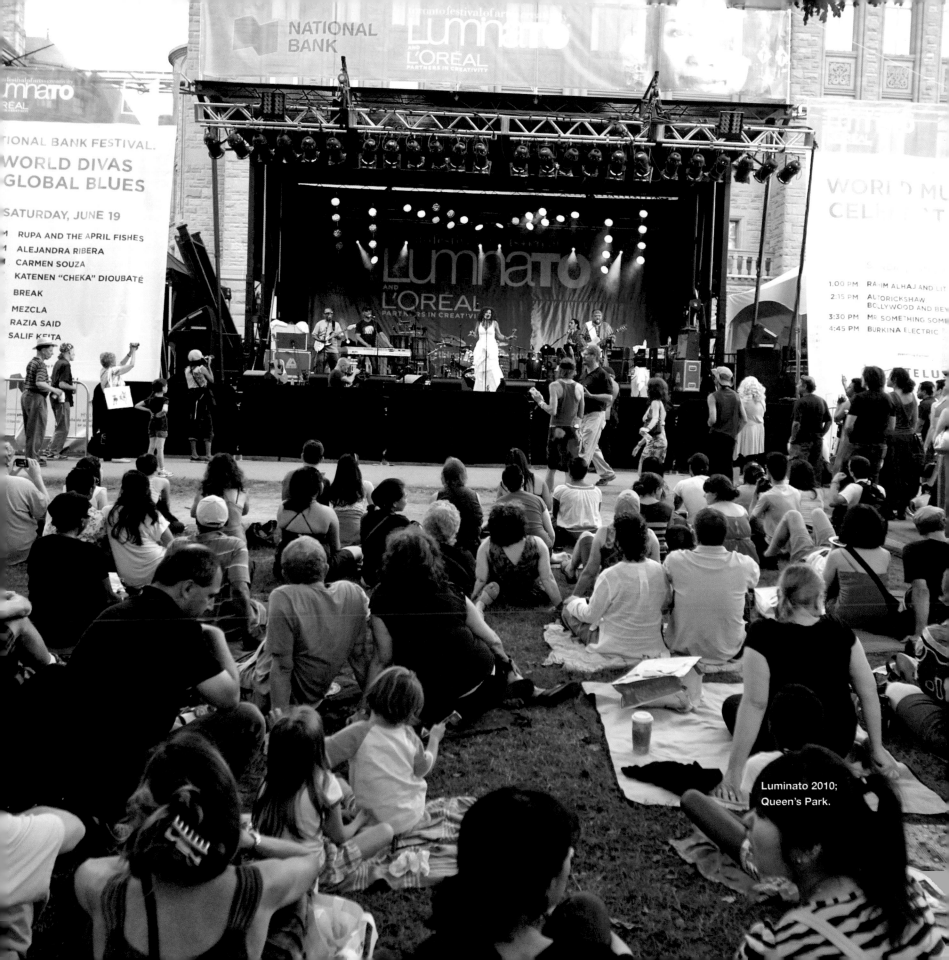

Luminato 2010;
Queen's Park.

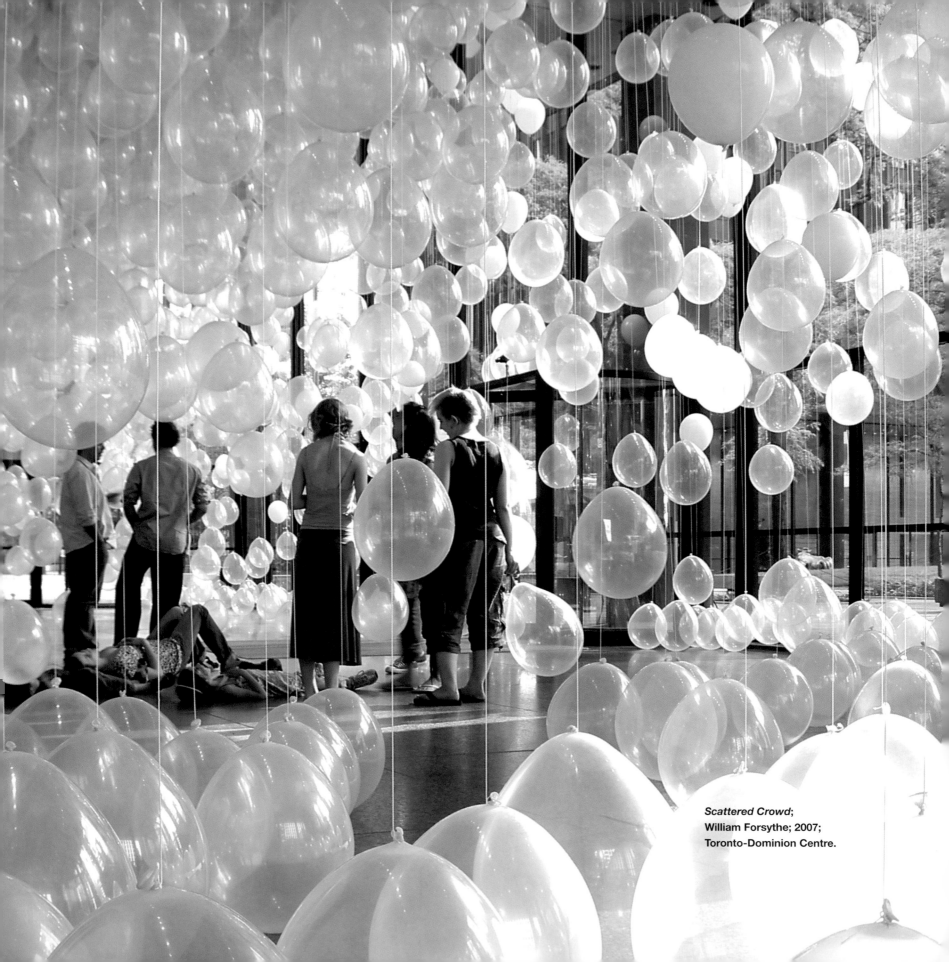

Scattered Crowd;
William Forsythe; 2007;
Toronto-Dominion Centre.

CONTENTS

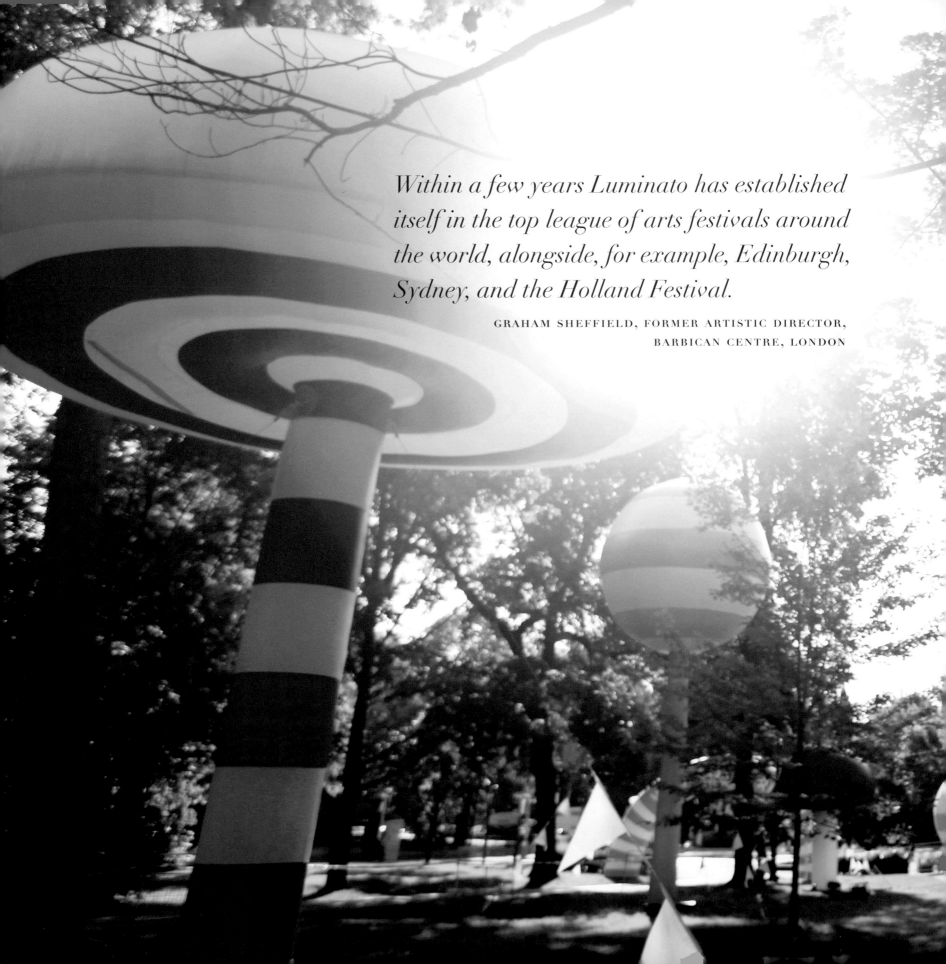

Within a few years Luminato has established itself in the top league of arts festivals around the world, alongside, for example, Edinburgh, Sydney, and the Holland Festival.

GRAHAM SHEFFIELD, FORMER ARTISTIC DIRECTOR,
BARBICAN CENTRE, LONDON

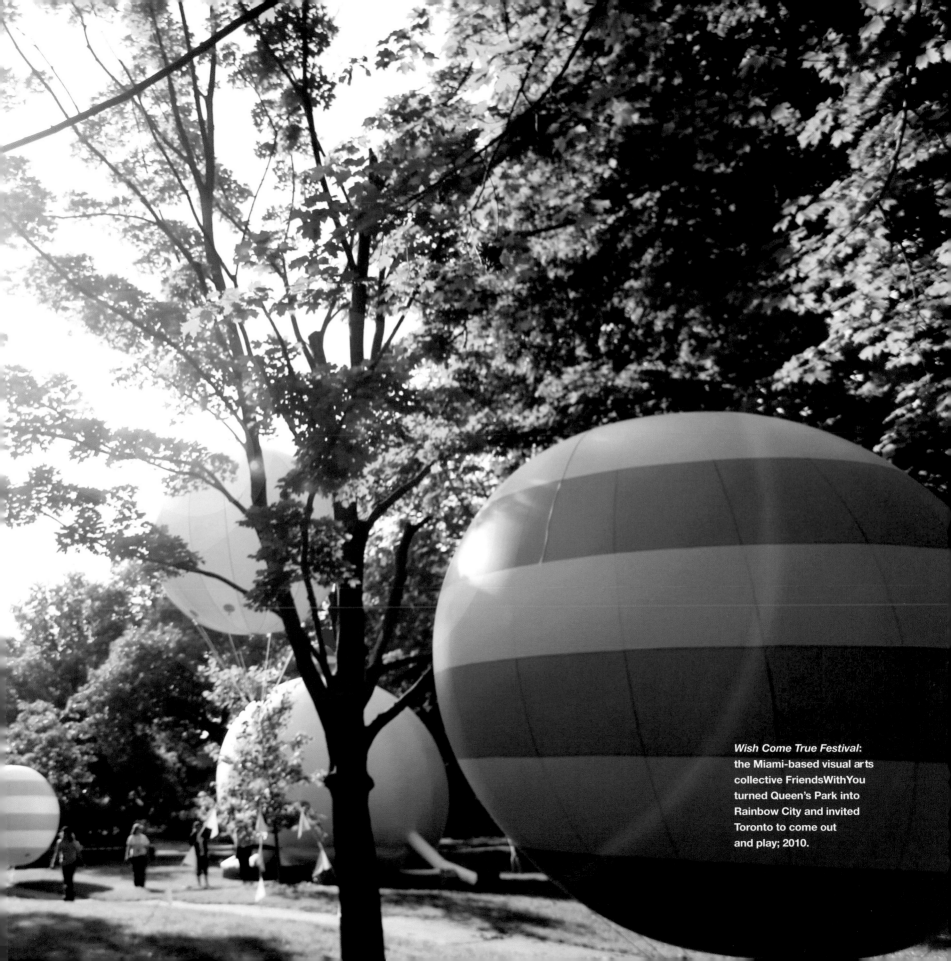

Wish Come True Festival: the Miami-based visual arts collective FriendsWithYou turned Queen's Park into Rainbow City and invited Toronto to come out and play; 2010.

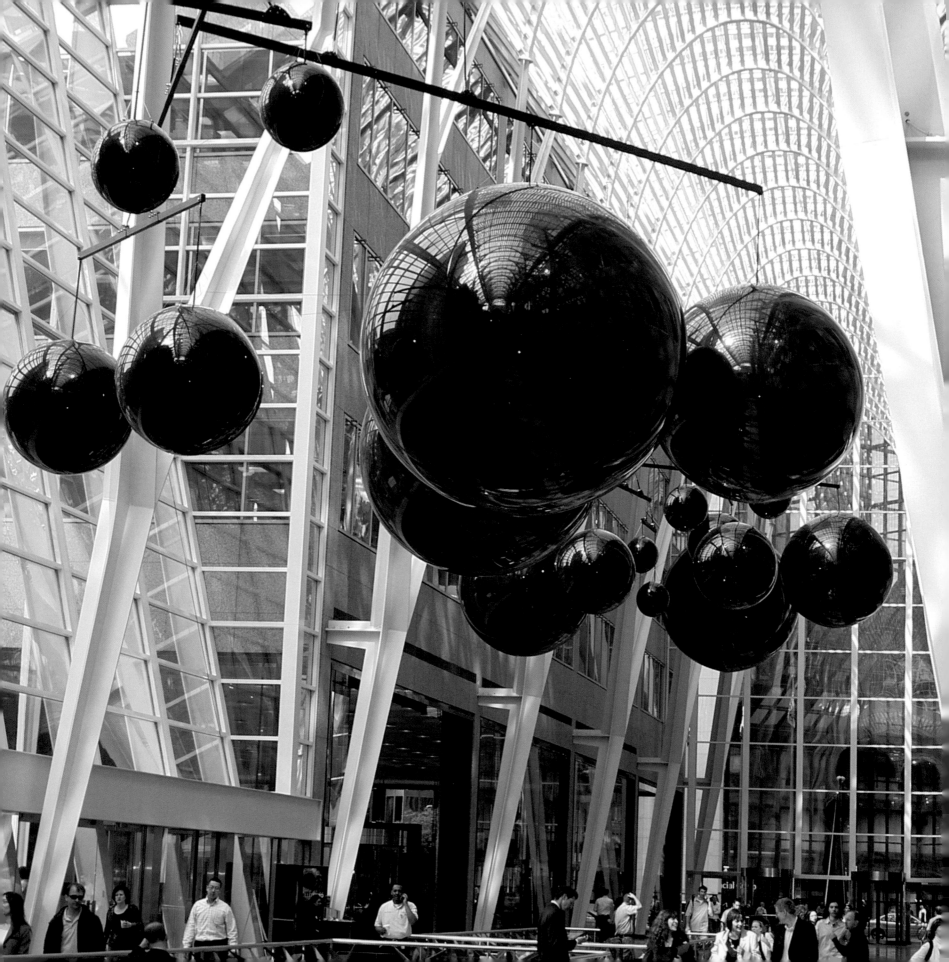

The Need to Create, the Potential to Transform

In December 2008, at the beginning of a regularly scheduled Luminato meeting, David Pecaut said he needed to make an announcement. The working team of some dozen staff members were deep into the planning of the third annual festival of arts and creativity, and the typically upbeat mood of Luminato's co-founder and co-chair gave no hint of what was to come.

The Festival, held each June, was intended, as Pecaut's friend and Luminato counterpart Tony Gagliano put it, "to shine Toronto's light on the world and the world's light on Toronto." Luminato's success had depended largely on the combined efforts of co-chairs Pecaut and Gagliano, CEO Janice Price, vice-chair Lucille Joseph, artistic director Chris Lorway, general manager Clyde Wagner, and the festival's dedicated staff—but David, as much as anyone, embodied Luminato's spirit, vision, and unbounded ambition. Indeed, it was difficult to imagine Luminato without his relentless energy—a fact that made the news that his cancer had returned, all the more devastating to those in attendance on that dark winter afternoon.

"But David," as Janice Price recalled, "was always about ramping it up. Always about taking things to some whole, new, unexpected level. And so, instead of allowing us to dwell on this terrible news, he told us about an essay by Robertson Davies that he had come across in a second-hand bookstore. He reminded us that our work together was making something remarkable happen."

And then David Pecaut read what he had found:

Le Grand Mobile;
**Xavier Veilhan; 2007;
Brookfield Place.**

The Festival Idea: 1952

A few weeks ago we commented in these columns on the enterprise of the people of Stratford, Ontario, who have been investigating the possibility of holding an annual Shakespeare festival in their city. Since that time they have taken the advice of Mr. Tyrone Guthrie, who is internationally known as a theatre director, and whose association with the Edinburgh Festival has contributed greatly to the success of that venture. What Mr. Guthrie said about Stratford has significance for Canada as a whole.

He warned against any festival which was organized solely as a money-maker. Such advice must be unwelcome in the ears of many Canadians who feel, quite honestly and sincerely, that the chief aim of a festival is to attract tourists and charm money out of their pockets. But a festival, as Mr. Guthrie pointed out, may have another and greater purpose; it may be an expression of what is finest in the life and aspiration of a country. That is what the Edinburgh Festival has become. If it were

Robertson Davies writing in the *Peterborough Examiner*, July 26, 1952

If we want prestige other than the kind which comes from having the best dollar in the world (and it may be that we do not) we must gain it by showing the world that we can do something which cannot be duplicated elsewhere.

organized solely to make money, it could be done comparatively cheaply by arranging some Highland games and some parades of Highland regiments; instead, it recruits the finest musical and dramatic ability in the world, and that costs vast sums of money. The Edinburgh Festival makes money, certainly, because it brings money to the Edinburgh hotelkeepers and shopkeepers, but the festival itself is not organized with the making of money as its chief aim. What the Edinburgh Festival does do is to direct the attention of the whole civilized world towards Scotland, and to raise Scottish prestige everywhere.

In the world of art Canada has no prestige whatever; in the eyes of the world we are a nation of wealthy, law-abiding, hard-working, lucky savages. If we want prestige other than the kind which comes from having the best dollar in the world (and it may be that we do not) we must gain it by showing the world that we can do something which cannot be duplicated elsewhere. If Stratford wishes to have a Shakespeare festival it must not be an imitation of the festival at Stratford in England; it must be something different and something first rate in its own way. The organization of such a festival, says Mr. Guthrie, will cost a great deal of money, and we are certain he is right. But it would present Canada to the world in an entirely new and flattering light, he continues, and we believe that, also.

The advice that Stratford has received is valid for the rest of Canada, as well. This is now a rich and important country, and the seedy amateurism which has afflicted the arts here for so long is not good enough for our new place in the world. A majority of Canadians, having no interest in the arts, and no suspicion that the arts are important, do not recognize this situation as yet, but that is not a matter of consequence; a majority of Canadians have never yet recognized the importance of any great forward movement in our country's history until a minority of alert and perceptive people had completed it. If any development in the festival line is to take place in Canada it can only succeed on the highest level; it must not be organized to make money, but to be the best thing of its kind in the world; if it makes the money, well and good, but its first task is to be good, and to bring honour to Canada.

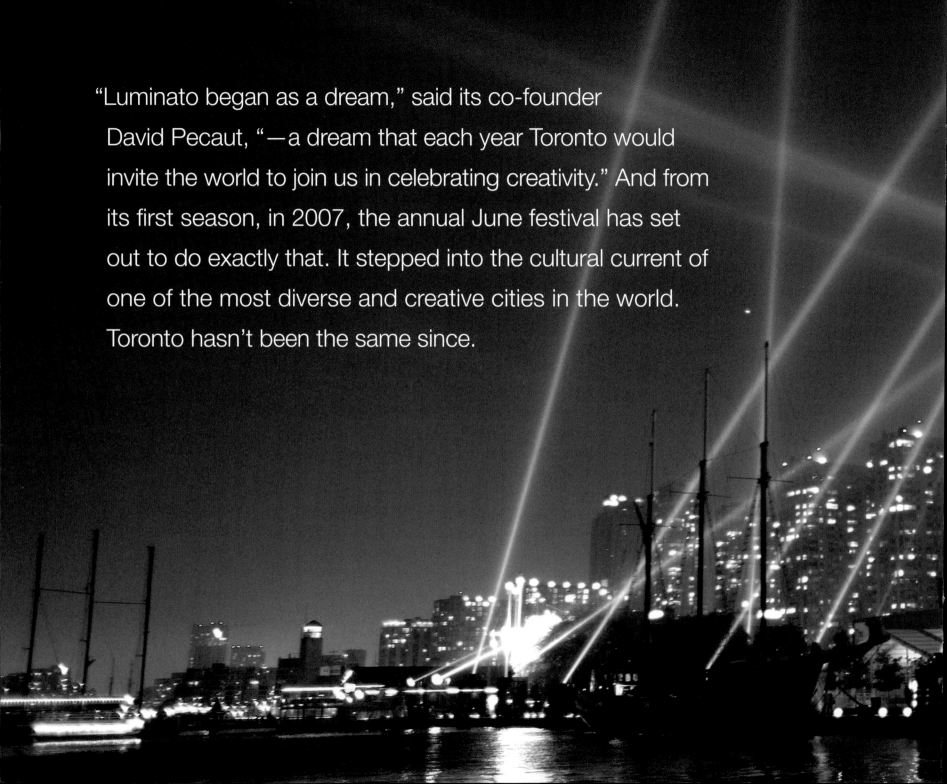

"Luminato began as a dream," said its co-founder David Pecaut, "—a dream that each year Toronto would invite the world to join us in celebrating creativity." And from its first season, in 2007, the annual June festival has set out to do exactly that. It stepped into the cultural current of one of the most diverse and creative cities in the world. Toronto hasn't been the same since.

Pulse Front: Relational Architecture 12;
Rafael Lozano-Hemmer; 2007; world premiere;
co-produced with Harbourfront Centre.

THE DEA

My dream is for Toronto to become the most diverse, most creative city in the world. I want this city to be a place where creativity is celebrated at every corner, where artists from around the world choose to collaborate and perform with our homegrown talent. I see Toronto becoming a place with such authentic creative spirit that it draws many of the world's great artists here to make it their home.

TONY GAGLIANO

The lunch that David Pecaut and Tony Gagliano had at a well-known Toronto restaurant in December of 2003 was remarkable for many reasons—not the least being that the two men who found themselves sitting across from one other, over platefuls of calamari and a few glasses of red wine on that Saturday afternoon, had never previously met.

There are 5.5 million people in the Greater Toronto Area, and as one of the world's most diverse and demographically complex cities, Toronto could hardly be described as small. But the many communities that exist within its economic and cultural reach are often tightly-knit—none more tightly than the unofficial caucus of citizens who act as both influential business and active civic leaders. Tony Gagliano and David Pecaut were both members of that group. It was singular—almost miraculous—that their paths had never crossed.

Both were devoted to Toronto, and to what they each believed to be the untapped potential of Canada's largest city. Both were more than cognizant of the challenges the city faced—the ongoing fallout from the outbreak of severe acute respiratory syndrome (SARS) in 2003 had preoccupied them. Both men held the arts in the same high regard—if from the different vantage points of their very different personalities (Gagliano: deeply respectful; Pecaut: irrepressibly curious). Both understood that a vibrant cultural community creates jobs, generates revenue, enhances the quality of life, and attracts tourists. As businessmen, neither Pecaut nor Gagliano underestimated the broad social importance of the sustained prosperity of a city.

Pecaut was the founding chair of the Toronto City Summit Alliance—an organization created specifically to help Toronto continue an upward trajectory, beyond the plateau at which, in many regards, the city seemed to have stalled in the 1990s. The decade had not been a good one for Toronto—the aftershocks of a recession continued and the city staggered under the weight of newly downloaded costs.

Tony Gagliano and David Pecaut first met at Roberto Martella's restaurant, Grano, in December 2003. They shook hands on a plan to transform the city.

There was a lot of skepticism from some people. But we didn't say, "This is our vision, take it or leave it." We said, "Let's develop it together." Once we got past that, it really came together.

DAVID PECAUT

Then, in 2003, came SARS. "Suddenly," recalls Kevin Garland, the Executive Director of the National Ballet of Canada and a key member of the steering committee at the Toronto City Summit Alliance, "it was as if we all woke up, and we all decided that we had to do something."

The Toronto City Summit Alliance report, "Enough Talk: An Action Plan for the Toronto Region," was tabled in April 2003, and, among a broad array of issues, it had devoted a section to the role of arts and culture in city-building. It was becoming increasingly apparent to Pecaut—and to the growing number of Torontonians who were paying attention to him—that the role was going to be significant.

The old-fashioned notion that the arts were a non-essential add-on to urban life—a frill—was being eclipsed by new ways of thinking. Levels of government that had traditionally seen cities as self-centred bottomless pits of funding demands, began to think of them as engines of the economy. Ontario's provincial government, championed by its Minister of Finance, Greg Sorbara, was already inclined toward this view. It was clear to Ontario's Liberal government that in a country in which 80% of the population live in urban centres, city-building, region-building, province-building, and nation-building amounted to much the same thing.

These ideas would be most popularly articulated in Richard Florida's bestseller *The Rise of the Creative Class*, but Pecaut and Gagliano already understood that a vibrant urban culture was intrinsic to sustainable well-being. A dynamic, interesting city—one with theatres and concert halls and galleries and coffee houses and nightclubs—drew visitors, but a bustling creative community was also what attracted companies, investment, innovators, and new residents. In turn, this vibrancy would appeal all the more to tourists interested in a vital and sophisticated urban experience. Both Gagliano and Pecaut were convinced of what they regarded as an obvious truth: that visitors would be excited about visiting a place that its inhabitants were excited about living in.

Born and raised in Toronto, Gagliano, one of ten children, grew up with a deep love and respect for his hometown. His devotion to Toronto was, in part, inspired by the gratitude his immigrant parents expressed for the opportunities provided to them by the city in which they had settled. Gagliano and his wife, Lina, have raised their children, Michael, Guy-Anthony, and Krista, in this same spirit of volunteerism and community service.

"If it was an initiative David Pecaut was behind," said one of the Festival's original supporters, "then I was immediately interested."

To tell you the truth, previous to the experience of bringing **Prima Donna** *and my song cycle to Luminato, I'd never much cared for Toronto. I'm from Montreal, so that kind of attitude was kind of bred into me. And to be fair, it was sometimes warranted. There often seemed to be a stale quality to the city. But coming to Toronto this time— meeting and working with so many really incredible people—I've done a complete 180-degree turn. My experience with Luminato made me realize that a really remarkable shift has occurred. After a lot of soul-searching, Toronto has become a vibrant and important cultural hub.*

RUFUS WAINWRIGHT

Gagliano believes that "what matters most are the things that cannot be weighed or measured on a material scale: the beauty of art and music, a close friend, your loved ones, the privilege to serve others." Pecaut, an American by birth but a passionate Torontonian, spoke of "creativity best nourished where cultures come together in a spirit of common humanity and citizenship." With his wife, Helen Burstyn, Pecaut was also raising a family steeped in the importance of civic engagement.

But both men were also aware that Toronto needed the attention of its most innovative and creative minds. It needed to do a better job selling itself—both to its own citizens and to its visitors. Having identified itself for so long with staid, established tourist attractions such as the CN Tower, the Eaton Centre, and Casa Loma, Toronto was not marketing itself very successfully as an arts and culture destination. "It was really time to refresh the image," Pecaut said.

Toronto's image outside its own regional borders was at odds with what was happening inside. The changes taking place in the expanding, increasingly diverse population seemed unable to do much to alter the notion that Toronto was pleasant enough, safe enough, clean enough but not really all that exciting. It had always been known as a stop for touring bands, orchestras, and shipped-in, shipped-out productions of operas and plays. The old Toronto was the one described by Raymond Souster in his poem "Yonge Street Saturday Night"—a city where people walked "as if we were really going somewhere . . . as if there were something to see." This image—reflective of a reality that prevailed until the last four decades of the twentieth century—was one the city found difficult to escape despite ever-increasing evidence to the contrary.

Many Torontonians were becoming more confident about creating, and more insistent on supporting, their city's own culture in the 1950s and '60s. The city's rapid post-war growth was a factor. So was the creation of the Canada Council for the Arts in 1957—a federal cultural agency that, among other responsibilities, provided financial support to artists and arts institutions across the country.

"Toronto is an excellent place to mind one's own business in," Northrop Frye once remarked. Indeed, minding one's own business was often all there was to do in the Toronto that prevailed until the second half of the twentieth century. A "sanctimonious icebox" was Wyndham Lewis' blunt description. Outposts of nightlife, such as the Colonial Tavern on Yonge Street, were few and far between.

and there are some like us,

just walking, making our feet move ahead of us,

a little bored, a little lost, a little angry,

walking as though we were really going somewhere,

walking as if there were something to see at Adelaide or maybe on King,

something that will give a fair return for this use of shoeleather,

something that will make us smile with a strange new happiness, a lost but recovered joy.

RAYMOND SOUSTER
Yonge Street Saturday Night, 1947

Toronto's cultural life also benefited from the city's growing affluence and its gradual ascendance over Montreal as Canada's banking, investment, and business capital. Montreal's glamour was something that Toronto could never quite attain, but a shift was taking place in the rivalry of the two cities. Even Montreal's great celebration—Expo '67—brought benefits to Toronto. As part of a wider wave of cultural nationalism that Expo '67 encouraged, the city's singers, dancers, actors, musicians, directors, writers, and artists were building on a cultural momentum that had already been set in motion.

Long before Expo, Robertson Davies' plays were being produced at Toronto's Crest Theatre. Margaret Atwood was reading her poetry at a coffee house called the Bohemian Embassy in Gerrard Street Village. Neil Young, Sylvia Tyson, Murray McLauchlan, and Joni Mitchell were performing in crowded, smoky coffee shops in Yorkville. The Canadian Opera Company, the Toronto Symphony Orchestra, and the National Ballet of Canada were building devoted followings. Toronto's jazz scene included performers of the stature of Oscar Peterson, Moe Koffman, Lenny Breau, and Guido Basso. Artists such as William Ronald, Harold Town, Michael Snow, and Graham Coughtry were part of a lively art scene, and a handful of influential private galleries, along with the Art Gallery of Ontario, were its best known outposts. A band called the Hawks—later to become famous as Bob Dylan's back-up and then as The Band—was grinding out R&B on the Yonge Street strip. The Canadian Opera Company's production of a Canadian opera—Harry Somers' *Louis Riel*—opened at the O'Keefe Centre (now the Sony Centre) as part of Canada's centennial celebrations. In 1970, what would quickly

Karen Kain in *Swan Lake* (1977). Kain became a principal dancer with the National Ballet of Canada in 1971. Gifted, beautiful, and fiercely dedicated to her art, Kain quickly grew to be what, in those days, was the rarest of things: a true Canadian star.

become "the celebrated jazz quintet," The Canadian Brass, was formed. Northrop Frye and Marshall McLuhan—both professors at the University of Toronto—were filling lecture halls. The community activist and urban philosopher Jane Jacobs moved to Toronto in 1968, in part because—as Tony Gagliano and David Pecaut would believe so fervently four decades later—she thought it a city with potential.

The city had its stars. They seemed not to grow as fabulously wealthy as American stars, and they usually appeared to be hard-working and down-to-earth—but they had the glow of celebrity to them: Karen Kain of the National Ballet, actors such as Gordon Pinsent and Kate Reid, singers such as Maureen Forrester and Gordon Lightfoot, Stratford artists such as William Hutt and Tanya Moisevitch, musicians such as Glenn Gould and Robert Aitken, Peter Appleyard and Ed Bickert. For many, the CBC's television and radio studios in Toronto were where performers and writers made their names known to a wider public.

We used to always have to make the case about how many restaurants and hotels and cab drivers the arts supported. And then Richard Florida came along and it was all about the creative class and the Bohemian Index and about how the arts are so critical to making a city great. But for me, personally, it was always about just doing it, and about supporting people who are expressing themselves—whether through dancing, or singing, or acting. And why is that so important? It's important because people are moved by it.

KAREN KAIN
Artistic Director, The National Ballet of Canada;
member, Luminato Festival Advisory Committee

In the 1970s, there was another burst of creative energy in the city. In 1972, George F. Walker's first play, *The Prince of Naples*, was performed at the newly founded Factory Theatre. (Thirty-five years later, Walker's gritty, darkly funny dramatic work was featured as part of Luminato's inaugural festival. His play *Tough!*, performed by the Factory Theatre's Young Company, was hailed as a "triumph" by the *Globe and Mail*.)

In 1970, Bill Glassco founded the Tarragon Theatre, and among its many early triumphs were *Creeps* by David Freeman—a production that included the young John Candy in its cast—and Michel Tremblay's *Hosanna*, starring Richard Monette and Richard Donat. The future film director Atom Egoyan was a member of the Tarragon's first playwrights' workshop. Housed in a converted bakery and stable, Theatre Passe Muraille produced the early work of Rick Salutin, Sky Gilbert, and Judith Thompson. Carole Pope and her band, Rough Trade, played to packed houses at Grossman's Tavern on Spadina and various clubs on Yonge Street. (Pope would return to Toronto stages for both Luminato 2009 and 2010.)

In 1976, the first Toronto International Film Festival—then known as The Festival of Festivals—began its September tradition of lineups of movie-goers on Toronto sidewalks. In 1982, The Parachute Club, a band that was born of Toronto's burgeoning Queen Street scene, released its first album, produced by Daniel Lanois. Lanois would go on to produce U2, Bob Dylan, and Neil Young, and would also be part of Luminato '09's *The World of Slide Guitar*—along with The Derek Trucks Band, Kevin Breit, Don Rooke, and Debashish Bhattacharya. In 2008, The Parachute Club was one of the featured bands in Luminato's celebration of Queen Street—an all-day concert that took place in the neighbourhood of two of Toronto's architectural gems: Frank Gehry's brilliantly reconfigured Art Gallery of Ontario and Will Alsop's witty, playful OCAD building.

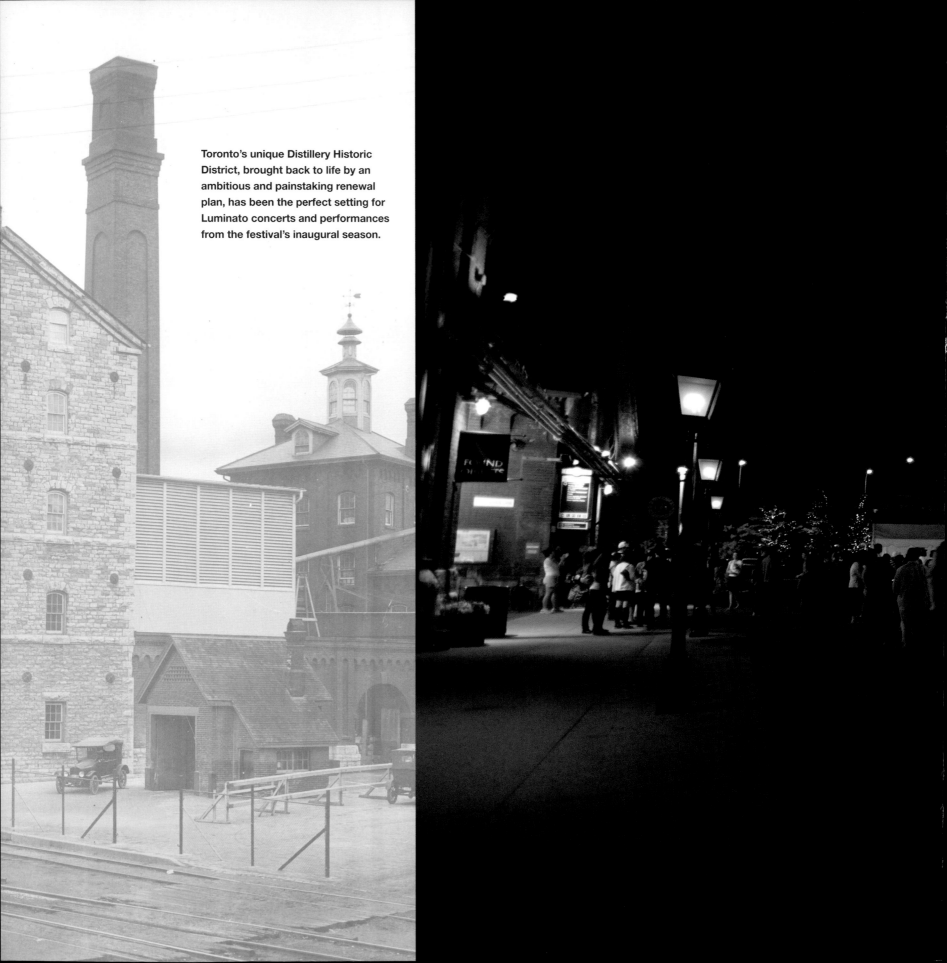

Toronto's unique Distillery Historic District, brought back to life by an ambitious and painstaking renewal plan, has been the perfect setting for Luminato concerts and performances from the festival's inaugural season.

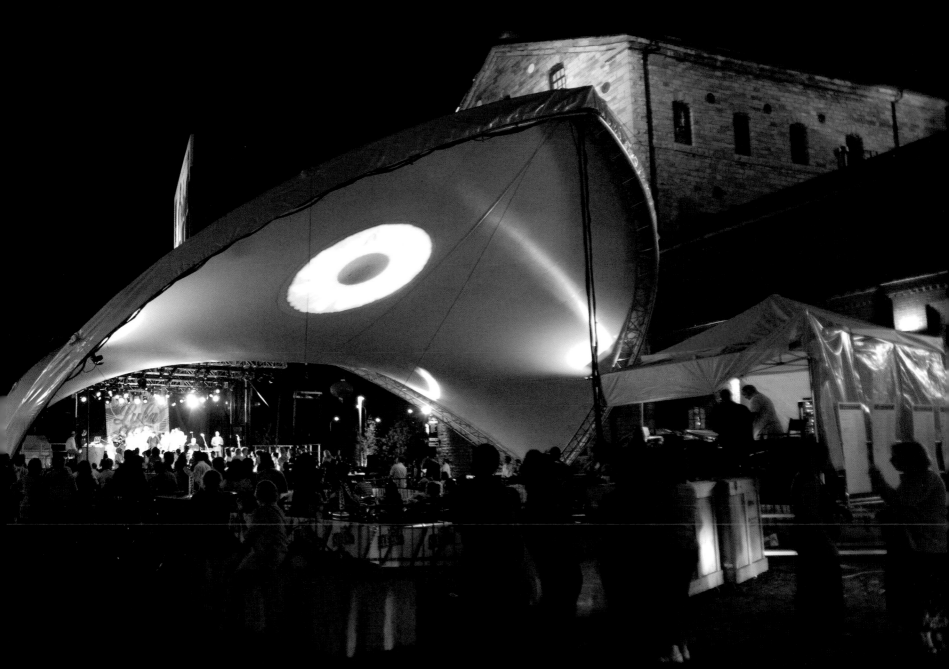

I have some experience in running festivals and I think this is the best thing to hit Toronto since the Toronto International Film Festival.

BILL MARSHALL,
founder and chairman of TIFF,
in the *National Post*, June 1, 2007

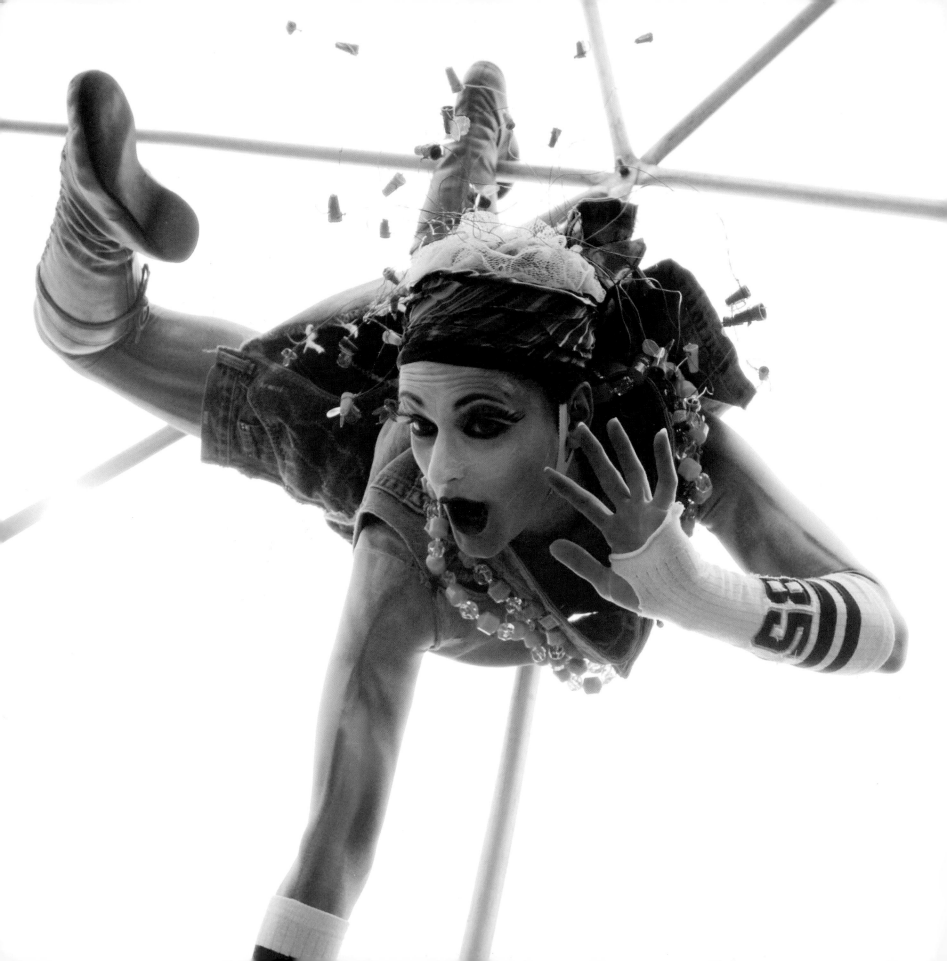

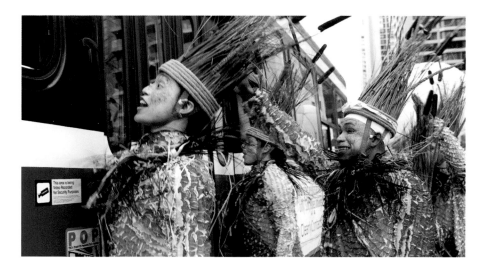

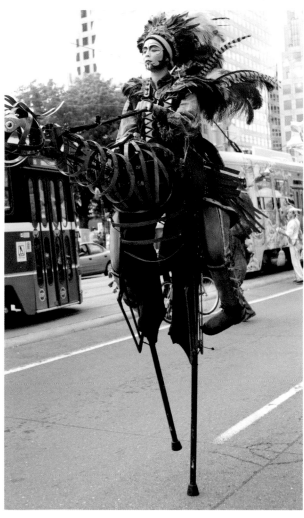

The first time Cirque du Solell performed outside Quebec was at Toronto's Harbourfront Centre. Twenty-five years later, the by-then internationally acclaimed company returned to Harbourfront in 2009 for Luminato's closing weekend celebrations.

"There must have been something in the air or the water in Toronto in the late 1970s," says Wayne Strongman, the Managing Artistic Director of Tapestry New Opera. "Whatever it was, it gave birth to the Canadian Brass, Tapestry, Opera Atelier, and Tafelmusik—and those are the ones that survived." Harbourfront Centre's programming, under the imaginative direction of its chief executive officer, William Boyle, had demonstrated the city's appetite for innovative expressions of contemporary culture. In 1984, the never-repeated Toronto International Festival, produced by Muriel Sherrin, created a template for a Toronto multi-arts festival. Harbourfront Centre brought Cirque du Soleil to Toronto—the adventurous young company's first show outside Quebec. (Cirque du Soleil would return to Harbourfront to celebrate its twenty-fifth anniversary as part of Luminato 2009.) The duMaurier World Stage International Festival, under the leadership of Don Shipley, became a highlight of the city's already richly textured theatre scene. Twelve years later a dedicated group of young actors, under the visionary artistic direction of Albert Schultz, founded Soulpepper Theatre, establishing the Young Centre for the Performing Arts in the Distillery District as a central pillar of Toronto's cultural life.

Toronto's transition in the late twentieth century from a staid, provincial capital to a bustling creative centre was as complete a makeover as its demographic transformation from a predominantly WASP population to one of the most diverse in the world. Toronto's was a rich, vital, urban culture—but a culture that, outside Toronto's boundaries, remained far too well-kept a secret for David Pecaut's and Tony Gagliano's liking. The city's community of artists, writers, and designers had expanded quickly, but the Toronto Pecaut and Gagliano could see before their eyes was not the Toronto the world seemed to know.

Cirque du Soleil artists arrive on stage;
2009; Harbourfront Centre.

Luminato is a wonderful addition to what is already an exciting landscape. It encourages the kind of eclecticism that can give birth to something serious and beautiful, such as R. Murray Schafer's The Children's Crusade, *and, at the same time, something fun like* Not the Messiah. *But Toronto is growing, and it needs a huge amount of culture if it is going to take itself to the next level. It has to be bold and daring—in the way David Pecaut was bold and daring. His positive energy lives on in Luminato, and I believe his presence in Toronto is still very much alive.*

PETER OUNDJIAN
Music Director, Toronto Symphony Orchestra;
member, Luminato Festival Advisory Committee

Designers such as Bruce Mau were establishing Toronto as a centre of innovation. Local architects such as Kuwabara Payne McKenna Blumberg and Diamond + Schmitt Architects were rethinking the city's physical personality. Cultural institutions such as the Canadian Opera Company, the National Ballet, the Toronto Symphony, the International Film Festival, and Harbourfront's International Festival of Authors were measuring their achievements against the very highest of standards. Toronto's lively sidewalks showed little of the racial homogeneity that had prevailed before the Second World War. The city's indie music and club scene were hopping. Commerical theatre producers such as Ed and David Mirvish and Garth Drabinsky were intent on making Toronto "Broadway North." And yet . . . the old image—provincial with occasional flashes of local brilliance—seemed to stick. "Our market research," said David Pecaut, "clearly showed that we were still seen, especially in the eyes of Americans, as Mounties and big, white men in fur coats."

Both Gagliano and Pecaut understood that there was an important relationship between a city's artistic community and its appeal as a tourist destination. Neither man ever apologized for believing that strengthening this relationship was critically important to a city that was within a two-hour flight of 60% of all Americans and within 160 kilometres of 25% of all Canadians. But they also shared a more nuanced and passionate perspective; they didn't think the value of the arts could be measured by simply adding up employed waiters and occupied hotel rooms. Gagliano and Pecaut both believed in the inchoate, difficult, intuitive, multi-dimensional process that is often referred to as city-building. They believed that a city was something to be created, improved, renewed—and not simply an address to be maintained. Both men understood that Toronto—a city very much in the process of being built—has unique characteristics that give the arts a special role in its civic life.

Conversation #4:
a temporary sculpture
of 15,000 books,
created in 2010 by
Tom Bendtsen at
the Toronto
Reference Library.

Toronto now has a fantastic cultural infrastructure, and for this reason some people doubted the need for an arts festival. But I was among those who believed that Luminato could animate the city in a way that no single institution would. And already it feels like a natural inhabitant— something that isn't imposed, something that speaks to the city. And that's an achievement.

GRAHAM SHEFFIELD
Former Artistic Director, Barbican Centre, London;
Luminato advisor, 2007–2009

One of the most multi-ethnic, multi-cultural, multi-racial, and multi-religious cities in the world, Toronto has a population that is 50% foreign-born. One is as likely to hear Cantonese, Portuguese, Urdu, Spanish, Italian, Punjabi, Polish, Ukrainian, Vietnamese, Russian, Arabic, Mandarin, Korean, and Somali on its streets as either of Canada's two official languages, French and English. More ethnically complex than Miami, Los Angeles, or New York City, Toronto has embraced its own diversity with enthusiasm. But not without anxiety. The *Globe and Mail* columnist John Barber referred to the emergent Toronto as a "seminal experiment in twenty-first century democracy." Jane Jacobs once remarked that one of the things that she didn't like about the prospect of her own eventual death was that she wouldn't get to see how things turned out.

Gagliano and Pecaut believed that the experiment would work. They were betting on it. They also believed that the arts would have to play an important role in the experiment's successful outcome.

They knew that the arts were something—perhaps the only thing—that could celebrate Toronto's diversity and, at the same time, bring the city's often disparate communities together. In the scrawled notes that David Pecaut made in the many meetings he convened in the months leading up to the Festival, it is striking how often the words "creativity" and "diversity" and "collaboration" appear. Both Gagliano and Pecaut thought that encouraging, nurturing, and sustaining creativity was the best way to express their love for the big, complicated, ever-changing place where they lived. As well, both men recognized a good product when they saw one. They were businessmen, after all. They saw no reason to be modest about a city where modesty had prevailed for too long. They often wondered how best to show off Toronto and its achievements to the world.

It was Gagliano who took the first steps toward creating an arts festival. He saw it as a way of simultaneously celebrating what he referred to as "Toronto's cultural renaissance" and bringing the city to life. "Transformation" was the word he used, and he had identified several dozen cultural, political, and business leaders with whom he would meet to discuss the idea. Gagliano had already commissioned the Toronto management consultant Rocco Rossi to prepare a feasibility report, and among Rossi's findings were two pieces of information that Gagliano found he was unable to stop thinking about. First, Rossi had concluded that Toronto's geographic location made it a uniquely well-positioned host for an international cultural festival. Second, and most surprising, he had found that no other city in North America could lay claim to a multi-arts festival comparable in scope and ambition to the big international festivals such as Edinburgh's or Hong Kong's or Sydney's.

In many ways, a Toronto arts festival was an obvious suggestion. Toronto had a thriving, if chronically underfunded, cultural community. Its theatres, galleries, performance spaces, and concert halls were popular, and deeply engrained in the city's life. Toronto audiences had enthusiastically embraced homegrown talent—George Walker, Michael Healey, and Judith Thompson would emerge as the city's most influential playwrights; Michael Ondaatje's luminous description of the construction of the Bloor Street Viaduct in his novel *In the Skin of a Lion* would become the most celebrated instance of fiction being incorporated into the very fabric of the city's life;

radio stations that had once played mostly British and American pop stars now made no apology for featuring the work of performers such as Holly Cole, the Cowboy Junkies, Steven Page, Roxanne Potvin, Colin Linden, and Harry Manx (all of whom would appear in Luminato 2009, under the musical directorship of guitar virtuoso Kevin Breit, as part of *The Canadian Songbook*, a tribute to Neil Young's iconic 1971 solo concert at Massey Hall). Dancers such as Rex Harrington, the TSO's conductor, Jukka-Pekka Saraste, and the COC's brilliant general director, Richard Bradshaw, were becoming household names—if not in all Toronto households, certainly in many. At the same time, Toronto audiences had embraced the International Festival of Authors, the Festival of Festivals, and Harbourfront's beloved annual Milk Festival for children. It was also clear by then that no sector of Toronto's economy was more actively concerned in the general welfare of the city than its constituency of cultural leaders. The Art Gallery of Ontario, the Canadian Opera Company, the Royal Ontario Museum, the National Ballet of Canada, the Royal Conservatory of Music, Harbourfront Centre, TIFF, the International Festival of Authors, the Jazz Festival, and theatre producers such as David Mirvish—all lent their voices to the ongoing debates about Toronto and its future.

"The story of a nation is told in its songs as well as its history books." A celebration of Canada's greatest singers and songwriters, *The Canadian Songbook*, held at Massey Hall, has been an annual Luminato highlight.

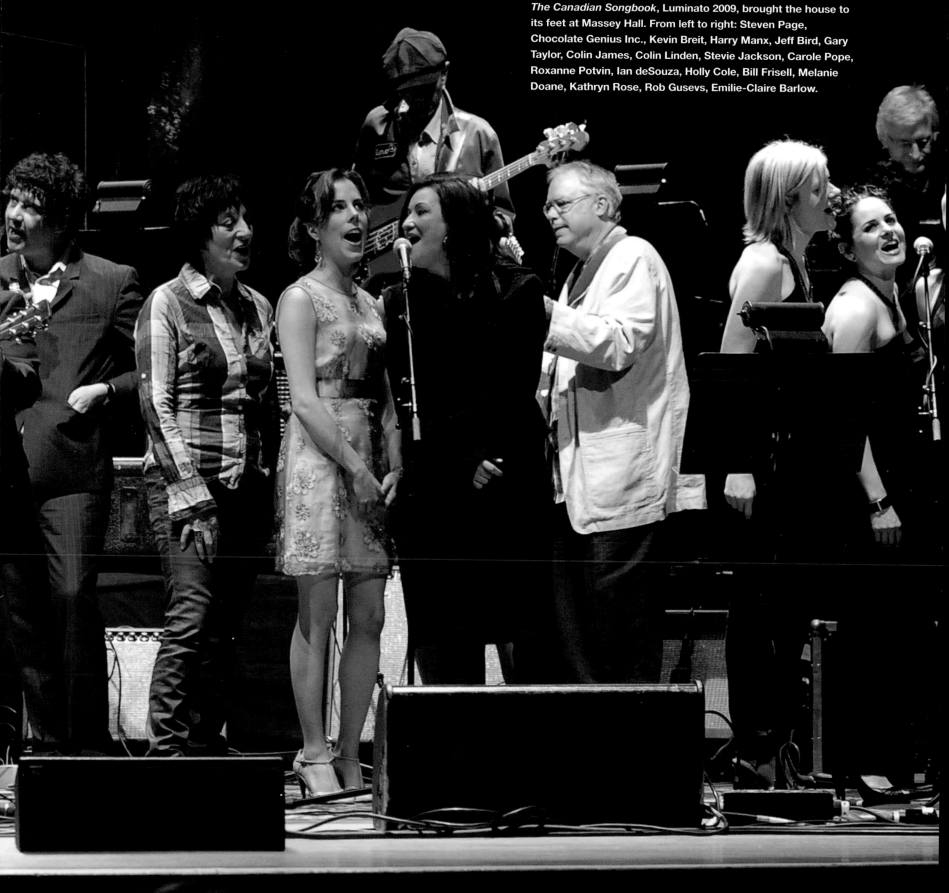

The Canadian Songbook, Luminato 2009, brought the house to its feet at Massey Hall. From left to right: Steven Page, Chocolate Genius Inc., Kevin Breit, Harry Manx, Jeff Bird, Gary Taylor, Colin James, Colin Linden, Stevie Jackson, Carole Pope, Roxanne Potvin, Ian deSouza, Holly Cole, Bill Frisell, Melanie Doane, Kathryn Rose, Rob Gusevs, Emilie-Claire Barlow.

In many ways, the Toronto of the 1990s felt like an arts festival waiting to happen. Janice Price, the CEO of Luminato, recalls that when, in the spring of 2006, she was first approached about taking her current position, she was actually surprised that Toronto didn't already have a multi-arts festival. Price was born and raised in Agincourt, just to the northeast of the city, and while she had not kept daily tabs on Toronto's cultural development during her years at Lincoln Center for the Performing Arts in New York and the Kimmel Center for the Performing Arts in Philadelphia, she was well aware of her hometown's geographic and demographic advantages. She was equally familiar with its cultural potential. "A multi-arts festival seemed a kind of natural," she says.

In 2003, Gagliano knew that Toronto was still in the shadow cast by SARS. He called it "the lowest point of the city's history during my lifetime," but his volunteer work and close involvement with several prominent cultural institutions—most particularly, his position on the board of the Art Gallery of Ontario—allowed him to see the light on the horizon. What he knew to be coming was, in his description, "unprecedented." SuperBuild—a government initiative that matched federal and provincial funding with private sector support—was stoking a transformation of

Toronto's Koerner Hall *(left)*, designed by Marianne McKenna of KPMB, and Frank Gehry's redesign of the Art Gallery of Ontario were part of an investment in the city's cultural infrastructure that Luminato's founders saw as an unprecedented opportunity.

Toronto's cultural infrastructure. The Thomson family alone had given $100 million toward the Art Gallery of Ontario's reconstruction, plus two thousand works of art valued at hundreds of millions of dollars. Anthony Graham, an early supporter of Luminato and a member of the Luminato board, describes this as "a groundswell of philanthropy on the art side, the likes of which nobody had ever seen before." According to Graham, more money had been raised for the arts infrastructure of Toronto in a two-year period than had ever been raised for the arts in the city's history. "We're talking a billion dollars."

Gagliano could see that all of these institutions would be emerging from the dust and noise of their renovation and new construction within the same general time frame. A remark made to him by his friend Nicky Eaton—"Wouldn't it be nice if once all these buildings are completed we could invite the great artists of the world to come and celebrate?"—had hit him, he said, "like a thunderbolt."

(above) **The Four Seasons Centre for the Performing Arts, designed by Toronto's Diamond + Schmitt Architects, opened in 2006 and quickly became central to Toronto's cultural life.**

THE OPPORTUNITY IN CRISIS

The idea of Luminato came at a moment in the city's history that was either one of the most pessimistic or one of the most optimistic, depending on how you looked at it. This improbable combination of the bleakest news and the boldest aspirations could be compared to the aftermaths of the two great fires that swept through Toronto's downtown core in the nineteenth and early twentieth centuries. After both, the city was devastated. And after both, Toronto recognized an opportunity to create itself anew.

The outbreak of severe acute respiratory syndrome (SARS) in 2003, and the subsequent listing of Toronto by the World Health Organization as an affected area, not only resulted in tragic deaths and hundreds of people ill and quarantined, but it had an immediate and dramatic impact on the city's tourism, service, and entertainment industries. "This is going to take years to recover from," said Rod Seiling, the president of the Greater Toronto Hotel Association. "This destination has been hard hit. No one has seen anything like this before in Toronto."

The immediate impact of SARS was the laying off of 95,000 workers in Toronto's tourism industry. Hotel

"Once you've seen the lights off, you know how important it is to keep them shining brightly."

occupancy plummeted, bus tours and fields trips were cancelled, concerts and plays were postponed. Restaurants and clubs were empty and an eerie quiet settled over Toronto's entertainment district. David Pecaut knew that Toronto's tourism industry had been "hammered." But he was characteristically positive about the forces that he helped to convene around the crisis.

SARS was something that Toronto would have much preferred to have avoided. But Gagliano and Pecaut could see that the crisis provided an important lesson. "I can't call it an upside," said Gagliano. "It was an extremely difficult time. For some, it was a tragic time. But it certainly left us in no doubt about how important global exchange and tourism are to the city. It became very clear how crucial it is that Toronto be animated and lively and bustling. Once you've seen the lights off, you know how important it is to keep them shining brightly."

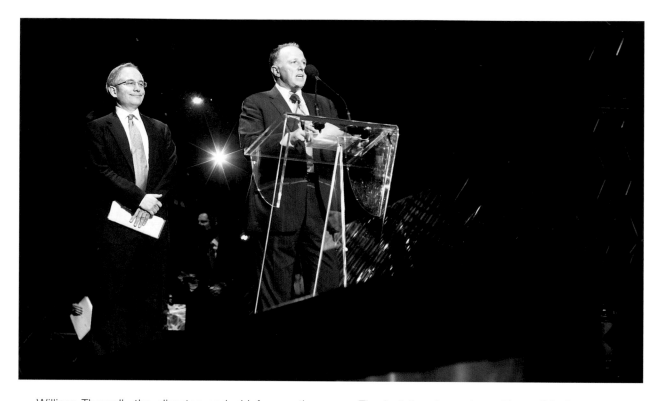

William Thorsell, the director and chief executive officer of the Royal Ontario Museum, was one of several dozen cultural, political, and business leaders Gagliano had decided to sound out on his idea for establishing an annual arts festival in Toronto. Thorsell was enthusiastic. In fact, he had already made a proposal to David Pecaut and the Toronto businessman and theatre producer David Mirvish—both of whom were actively involved in Toronto's post-SARS recovery. Like Gagliano, Thorsell saw the completion of Toronto's cultural building projects as the perfect moment to address the reasons the buildings existed in the first place. Thorsell, who had been editor of the *Globe and Mail* before heading the ROM, was disinclined to accept the territorialism that had been such an historical feature of the city's cultural institutions' struggle to survive. He was much more naturally drawn to the idea of a civic profusion of arts. "Thorsell's position," recalls Harbourfront Centre's CEO William Boyle, "was always: 'Let a thousand flowers bloom.'"

The buildings' openings, Thorsell believed, should be celebrated by celebrating the arts. He saw the completion of so much construction and renovation as a kind of civic exclamation mark that should be put to good use. It was a moment in Toronto's history that could, if leveraged to its full potential, launch the city into an entirely new cultural era—one that would make a city that did not understand the central role of the arts seem as antique as one that considered a touring production of *Oklahoma!* sufficient culture and that only ate roast beef for Sunday dinner.

Thorsell's idea differed from Gagliano's in execution, if not intent. He had proposed to Pecaut and Mirvish a year-long celebration of Toronto's cultural rebirth. "A great, big one-off" is his description. As a result, he already had some ideas about how to showcase Toronto when Gagliano laid out his plan. He didn't hold back. "Typically for William," remembers Gagliano, "he made the idea more grand and more exciting than I had yet imagined it."

The launch of Luminato's inaugural season and the opening of the Royal Ontario Museum's Michael Lee-Chin Crystal were part of the same exuberant party in June 2007.

The venue was a natural choice. Martella's expansive hospitality and civic-mindedness—to say nothing of Grano's fine Italian food— has made the restaurant the site of an ongoing colloquium on matters of political and cultural importance . . .

If Thorsell's first suggestion was to think big, his second was that Gagliano, the Executive Chairman and CEO of his family's business, St. Joseph Communications, get together with David Pecaut, a Senior Partner and Managing Director of the Boston Consulting Group of Canada. David Pecaut was, in Thorsell's description, known as someone who "got things done." He also had a reputation for big thinking.

Thorsell's suggestion was an obvious one—or so it seemed. Anyone in Toronto who was interested in city-building would have had both Tony Gagliano and David Pecaut in their address book. But Gagliano admits that at the time he didn't know who David Pecaut was. He had no idea who Thorsell was talking about. "When he said the name my face just kind of went blank," Gagliano recalls.

It didn't stay blank for very long. The two men made arrangements to meet for lunch at Roberto Martella's restaurant, Grano, in December 2003. The venue was a natural choice. Martella's expansive hospitality and civic-mindedness—to say nothing of Grano's fine Italian food— has made the restaurant, over the years, the site of an ongoing colloquium on matters of political and cultural importance. It's hard to imagine a more appropriate spot for two men intent on transforming the city to have met.

When Lucille Joseph, the Vice Chair and Founding Executive Director of Luminato, recalls the Festival's beginnings, an expression of incredulity crosses her face. She remembers Luminato's start-up with real fondness, although she sometimes finds it astonishing that she and her colleagues managed to accomplish what they did—racing full-tilt from a "big idea" and a business plan to the inaugural festival and a fully functioning new arts organization in just eighteen months. "We benefited enormously," says Joseph, "from the contributions of time and resources from the city's artistic leadership and from extraordinary people and their organizations. Julia Deans and the staff of Toronto City Summit Alliance; Ian Mirlin and MacLaren McCann; Daniel Weinzweig and Searchlight Executive Recruitment; Simon Romano and Stikeman Elliott LLP; and Scott Belton, Garrick Tiplady, and Adam Gordon of Boston Consulting Group all proved to be valuable allies." As David Pecaut described this in-kind civic collaboration, "It was like an old-fashioned barn raising."

(facing page:)
**Toronto Star,
May 24, 2007.**

It all started over lunch

Tony Gagliano, David Pecaut hatched ambitious plan 'for celebration of creativity'

RRAY WHYTE
ERTAINMENT REPORTER

ny Gagliano, it can be fairly id, enjoys a good lunch. hat's my portion," he laughs, l and body-shaking, as a plat- r of grilled breads with various penades — enough for him d lunch date David Pecaut, d then some — arrives at his ble.

They're on the patio at Grano, oberto Martella's Yonge and)avisville restaurant-cum-cul- ural incubator that has been erving big ideas alongside its lassic Italian fare to the city's elite for decades.

Gagliano's first meal here — dinner, not lunch— was 20 years ago, just after he got back from his honeymoon in Italy. He's been a regular ever since, which, one can guess, is a lot of lunches later.

But there's one — in recent memory, anyway — that stands out. It was spring 2003 and his date, then as now, was Pecaut, his partner in the founding of Luminato, the sprawling arts and culture festival that will take over the city June 1-10.

Here, on Martella's Italian-es- que patio, complete with weath- ered Italian playbills and unruly greenery tumbling out of terra- cotta pots, the festival was born.

But first, some background. With the city still reeling from the after-effects of SARS, Ga- gliano, the head of the St. Jo- sephs Communications empire, which publishes *Toronto Life* and *Fashion* magazines among many others, was growing frus- trated with a city that had been knocked down and was having a hard time getting back up.

" 'Don't travel anywhere, and

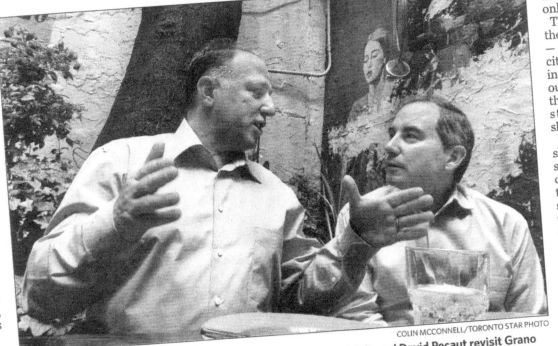

COLIN MCCONNELL/TORONTO STAR PHOTO

Experienced movers, shakers and power lunchers Tony Gagliano, left, and David Pecaut revisit Grano restaurant, where the Luminato idea took root in 2003 as Toronto wallowed in a post-SARS funk.

your way either' — that was ba- sically what CNN had declared to the world," he recalled. "Any- one from Toronto was persona non grata."

Over lunch — what else — with fellow civic booster Nicky Ea- ton, the pair had lamented the irony: at a time when the city's biggest cultural institutions were embarking on wholesale makeovers, the world was being told to stay away.

"We were talking about what a travesty it was," he said. "There was a feeling the stars were aligning with respect to the arts in this city. But the world had no idea."

Gagliano got up from the table with that quandary stuck in his

mind. Over time, it grew, as things often do for him, from problem to opportunity. "I just thought this was a moment where we could launch a cele- bration of creativity here, that it was something we could make work."

Gagliano started talking about it to everyone who would listen. One of them was Royal Ontario Museum director William Thorsell. "When I told him what I had in mind, he said 'You have to talk to David Pecaut.' "

From the restaurant, Gagliano contacted Martella, who knew Pecaut, a senior partner at Bos- ton Consulting. True to form, a lunch was set up.

Pecaut, it turned out, had been

grappling with the same frustra- tions. His pet project, the To- ronto City Summit Alliance, was designed to put leaders from the city's disparate communities in tune with one another in hopes of addressing some of the city's most pressing needs. SARS hadn't helped. Pecaut was sure of one thing: the city needed a shot in the arm. Then came the call from Martella.

"We'd never met before, but I told him my story, and David said 'This is exactly where my mind is at,' " Gagliano said. "And from there, we took it to another level."

They are, at first glance, an un- likely team. Pecaut is quiet and thoughtful, a deep-thinking sort

who absorbs ideas and synthe- sizes new ones almost simulta- neously, while Gagliano is a boisterous, heart-on-his-sleeve action man whose conviction is only matched by exuberance.

The first thing the pair did with their brainchild was give it away — to the heads of some of the city's most prominent cultural institutions. It was a plan born out of solid pragmatism and, in the often divisive world of in- stitutional culture, some shrewd politics.

"I have to say, there was a lot of skepticism from some people," said Pecaut. "But we didn't come to them and say 'This is the vision, take it or leave it.' We said 'Let's develop it together.' Once we got past that, it really came together."

Luminato, by sheer scale, was more than ambitious: bigger and more diverse than anything attempted here, or almost any- where else, before. Its founders made some naive enthusiasm go a long way. "I appreciated the slight element of complete in- sanity about it," says Albert Schultz, artistic director of Soul- pepper Theatre Company. "There were some doubters, be- lieve me. But you can only make a dream come true once it's been dreamed, and they were excellent at that."

One committee member who needed little convincing was Matthew Teitelbaum, director of the Art Gallery of Ontario.

"I'm ready to work with any- body who's an optimist. It's a rare commodity," he said.

Teitelbaum was also im- pressed by their optimism and open-mindedness. "We told them, 'Don't create something that's parallel to what we al- ready do. Use what exists in the community, because we're at the ready.' And they listened.

They we right from From T Film Fe dling to tistic di Bill Boy tre to R Canadia artistic perhap major c worke once. F Gaglia to the end — for all courte Telus uals. lions. comr tract

The men then in 2 200 year mill val a wh sca

K art pal so fo Ce in m g s

I'd have the greatest arguments and discussions with David Pecaut. I had serious disagreements about what Luminato was doing, and I'd phone him up, and he would listen for a while, then he'd say, "Where are you right now?" And I'd say, "I'm in my office." And he would say, "I'll be there in five minutes." I'd try to tell him that I only had half an hour, but he'd say, "Too bad." He'd hop in a cab right away. And we would be in my office for three hours. Because he really wanted to understand the cultural world and how it worked. I'd never seen anything like this in Toronto before.

WILLIAM BOYLE
Chief Executive Officer, Harbourfront Centre

Joseph first heard about Gagliano and Pecaut's idea at a meeting they convened for the city's business and cultural leaders in June 2005. She expressed interest to David Pecaut and immediately found herself drawn into his vision. "That was typical of David," she says. "He never missed an opportunity to sign somebody up." Organized and efficient, Joseph took delight in her sudden immersion in the tumultuous world encountered by anyone who sets out to do anything as rash as launch a large-scale festival from a standing start.

"Like David and Tony," she says, "I have a long and deep interest in the arts." But she has memories of people asking, "Who were we, and what did we know about starting an arts festival?" If there were times when she wasn't sure she knew the answer, she didn't let that get in the way. "We just went ahead," she says, "and did it."

Joseph had been a colleague of David Pecaut's at Boston Consulting for ten years before joining the Bank of Montreal as Vice President of Strategy and in 2005 was serving as Vice Chair of the Board of the National Ballet of Canada. She shared with Pecaut the consultant's talent for immersing herself in an entirely new environment, and often seeing it more clearly and with fewer obstructions to her view than those who had been in the field for a long time. Finding herself suddenly in a whole new world was not a new experience to her. Lucille Joseph had been dropping into new worlds for most of her professional life. She cheerfully admits that neither she, nor David Pecaut, nor Tony Gagliano had any real experience in organizing an arts festival. She also knew that arts festivals are not always welcomed by everyone in the indigenous artistic communities of the cities that host them—festivals sometimes cannibalize funds; festivals sometimes steal audiences; festivals sometimes monopolize venues.

A primary objective of Luminato was to expand the city's cultural pie, and not divide it into more, smaller pieces. After all, Luminato was about city-building, and competing for the resources on which Toronto's arts community already depended would not be much of a means to that end. But Joseph knew that such a commitment would have to be proven over time. In the shorter term, she could see that the road ahead, while exciting to contemplate, would not always be a smooth one.

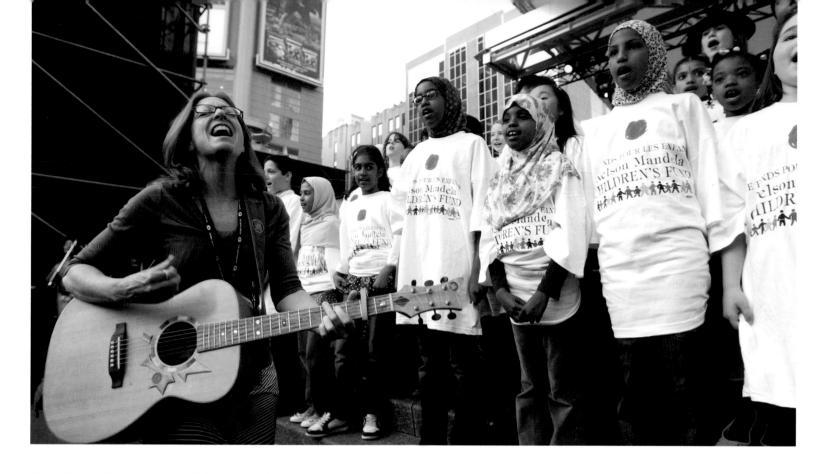

Students from Nelson Mandela Park Public School perform at Yonge-Dundas Square as part of Luminato's education and outreach program; 2009.

Still, her optimism was not going to be extinguished. It was supported, she believed, by a single unassailable fact. "The thing that I most loved about being involved in launching Luminato was that David, Tony, and I had no other agenda. None. We actually really and truly did want to start a festival that would benefit the city and Canada's artists and arts organizations. And I think that's what saw us through the tensions and stresses of starting up. People ultimately came to understand that the reasons we gave for Luminato were, in fact, the only reasons we had. It was all about transforming the city. It was all about outcomes for the city. We were intent on starting Luminato because we believed it was a grand idea for Toronto."

There was no shortage of voices telling Luminato's founders that a 2007 launch would be unwise, if not impossible. "You're crazy," was film director Atom Egoyan's initial reaction. "I told them it couldn't happen so quickly. But then, I didn't know that's what David Pecaut did: make the impossible happen."

Lucille Joseph, with consultation from theatre producer Don Shipley, had programming for the inaugural festival well underway by the late spring of 2006. Gagliano, Pecaut, and Joseph had also consulted with arts administrator Wende Cartwright, whose earlier research for an annual, multi-arts festival was instructive and encouraging as their own plans for Luminato began to take shape. (Cartwright, along with Neil Crory, would produce *Luna* for Luminato's inaugural festival—an opera gala that featured the luminous voices of Isabel Bayrakdarian, Adrianne Pieczonka, Sondra Radvanovksy, Richard Margison, Russell Braun, and the next generation of opera superstars.)

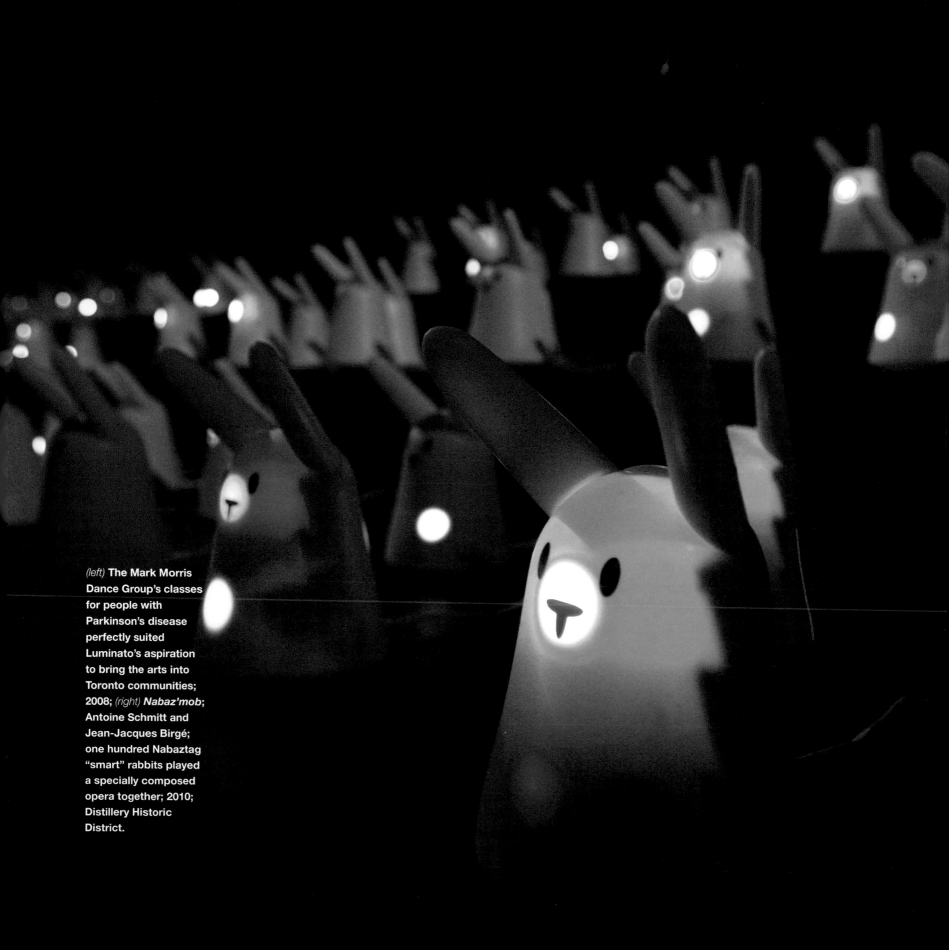

(left) **The Mark Morris Dance Group's classes for people with Parkinson's disease perfectly suited Luminato's aspiration to bring the arts into Toronto communities; 2008;** *(right)* ***Nabaz'mob*; Antoine Schmitt and Jean-Jacques Birgé; one hundred Nabaztag "smart" rabbits played a specially composed opera together; 2010; Distillery Historic District.**

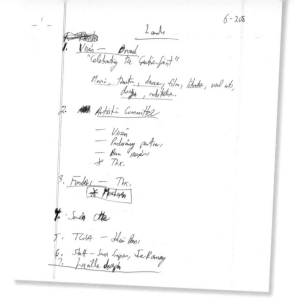

Julia Deans, the executive director of Toronto City Summit Alliance, was already juggling several initiatives for David Pecaut when she leapt into the fray of starting an arts festival. Deans, a lawyer, had previously demonstrated her ability to take Pecaut's big ideas and give them structure and process. Deans incorporated Luminato as a not-for-profit organization and took on the role of secretary of the corporation. Her long-established relationship with the Ontario government meant that the critical early infusion of cash that pushed Luminato from the realm of idea to that of reality would flow through the TCSA to support the development of the new festival. From arranging for the Boston Consulting Group to keep the books to asking CIBC to donate office space, Deans rallied resources to support the fledgling operation.

As well, Joseph engaged Sarah Simpson, a Toronto advertising executive, to be the liaison between the Festival and the ad agencies that had competed for Luminato's pro bono account. This approach—asking the city's leading ad agencies to compete for the opportunity to work for Luminato, for free—was indicative of the Festival's sense of its own civic value. Or perhaps, indicative of Pecaut's chutzpah. "Tony at first was very skeptical," Joseph recalls, "that we were asking ad agencies to compete with one another for the privilege of taking on our branding, logo, sponsorship strategy, web design, and advertising plan—for free!" But, as it turned out, the strategy was effective—it was precisely the kind of account that would allow Toronto's most innovative agencies to be part of a very creative endeavour and work with an organization that fully understood the importance of making its identity as clear as possible from the very beginning. The obligation to create a distinctive personality for the Festival was all the more pressing in a city that already had an internationally acclaimed authors' festival, film festival, and jazz festival, and where a wide variety of annual events were competing for the public's attention. Ian Mirlin, the creative director at MacLaren McCann, the company that won Luminato's competition, emerged as a pivotal member of the Festival's development team.

David Pecaut's yellow notepaper—and his hastily scrawled, idiosyncratic handwriting—were fixtures of the many meetings he attended. At left, his jottings from a meeting on May 5, 2006, at which the word "Luminato" was first discussed.

32

"The paint on the canvas of the city" —a phrase coined by advertising creative director, Ian Mirlin—was a description that became key to Luminato's own self-definition. It succinctly caught the Festival's aspirations to transform Toronto by celebrating the creative spirit.

Joseph recalls that at an early meeting Mirlin "drew a large cross on a page to create four quadrants, and labelled the vertical axis 'edgy / avant garde' and 'traditional / familiar,' and the horizontal axis 'Toronto' and 'international.' He asked us what quadrant the Festival was in and we said, 'All of them.'"

Mirlin's team came up with the name "Luminato." It was one of a long list of possible names they had generated. In order to bring some objectivity to the decision, the naming of the Festival was the subject of street interviews conducted by MacLaren McCann. David Pecaut recalled, "We thought it was very important to have a name that was unique to the Festival. We knew we had a winner with 'Luminato' because people who were in their twenties and thirties were saying that it sounded exciting and electric and modern. They thought it was all about light, and that it seemed web-oriented. And then, older people interviewed as they were leaving theatres and galleries were saying that it sounded very classical and Italian. So we knew we had a name that bridged different age groups and communities, and it had the bonus of the 'TO' in 'LuminaTO' being the city's nickname for Toronto, Ontario."

It was also Mirlin who came up with the image of the city as canvas; the Festival, paint. Immediately, the phrase was recognized as much more than a clever line. It was a neat articulation of the Festival's philosophy, and it became a useful guide—both in planning the Festival and in explaining its objectives to potential supporters.

"The paint on the canvas of the city" was a description that became key to Luminato's own self-definition. It is a phrase scrawled repeatedly on the writing pads David Pecaut took with him to the many meetings that were part of the process of Luminato's development. "The Festival is a celebration of the creative spirit where Toronto becomes the canvas and our imagination the paint" is one of the variations he scribbled. On another page, he wrote—and put a star beside—"Pre-eminence of the Artist should be focus of Festival. Nurturing of our artists."

In Luminato 2008, Mirlin's metaphor was actually the subject of an "Illumination" (one of the series of public talks and panel discussions that have been part of each festival). Architect and urban designer Anne McIlroy moderated a discussion on the subject of "public space as artistic palette." She was joined by Toronto's then–poet laureate, Pier Giorgio Di Cicco; artist Ian Carr-Harris; architect and installation artist Derek Revington; and arts curator Devon Ostrom. This panel addressed a question that was fundamental to Luminato and to the future of the city: "If arts and culture are the heart and soul of urban life, why confine them within the traditional boundaries of concert hall, gallery, and museum?"

The engagement of the Luminaries has been, for me, one of the most remarkable aspects of founding Luminato. Here were people who were willing to support what was still just an idea. They helped make something that seemed impossible, possible. Every time another family joined, we got a new jolt of energy. The willingness of our Luminaries to believe in the idea of Luminato is emblematic of Toronto at its best.

TONY GAGLIANO

Joseph supported Pecaut's conviction that momentum was not something to let slip away. Momentum was part of the energy that Pecaut seemed capable of plugging into and that many people considered an intrinsic part of his personality. Pecaut was a formidable fundraiser. If anything, Gagliano was more formidable. His sterling reputation, his devotion to Toronto, and his warm, inclusive Italian nature made people feel that he was inviting them into a family more than he was asking them for money. Gagliano took the lead role in attracting the original private donations of $100,000 from the individuals and corporations who became known as the Festival's Founding Luminaries.

"Any initiative by David Pecaut and Tony Gagliano was of interest to me. I wanted to be part of it,"said Charles Baillie, the former CEO of TD Bank Financial and the first of the founding patrons of Luminato. Baillie's initiative—and his establishment of $100,000 as the benchmark of a founding patron's entrée—was quickly followed by Robert and Cheryl McEwen and by Jim and Margaret Fleck. In an unprecedented display of civic philanthropy, seventeen families made this donation to Luminato before the curtain went up on the first festival. The momentum continued with twenty-nine more families joining as of today. Ten corporations, led by Manulife Financial and TELUS early in the Festival's planning, also joined this group of donors and became the festival's Founding Corporate Luminaries.

Frequently described as a visionary, David Pecaut was, in fact, a visionary of a particular kind. He had the ability to look ahead but also to read the forces, events, and personalities of the present so perceptively that his projections often felt to people as if he was articulating ideas they were just about to have. This was part of his energy, and this was part of why, with so many voices advising him to slow down, he refused to hold back the momentum he had so persuasively identified. "He was intent on forging ahead," recalls Atom Egoyan.

34

SHINE A LIGHT: THE LUMINARIES

As crucial as the financial support of the Festival's patrons proved to be, there was important significance to the commitment of first founding Luminaries such as Charles and Marilyn Baillie; Rob and Cheryl McEwen; Margaret and Jim Fleck; Michael and Sonja Koerner; Robin and David Young; Avie Bennett; Gretchen and Donald Ross; Helen Burstyn and David Pecaut. In many cases, their support came when the festival was still an idea—typically, the stage of development when funding for a new initiative is most needed and most difficult to come by. This courage was still required when it came to the support of Mohammad and Najla Al Zaibak; Richard Rooney and Laura Dinner; Chetan and Clara Mathur; Sandra and Jim Pitblado; Jonas and Lynda Prince; Gary and Donna Slaight; Anthony and Helen Graham; Joan T. Dea and Lionel F. Conacher; Larry and Judy Tanenbaum; Lucille and Urban Joseph; Kevin and Roger Garland. Their critical support demanded the kind of boldness of vision that was the festival's foundation.

The festival's strength grew with the addition of Judy and Wil Matthews; Kate Alexander Daniels and David Daniels; Howard Sokolowski and Senator Linda Frum; Marisa and Edward Sorbara; The Duboc Family Foundation; Pierre L. Morrissette; John Donald and Linda Chu; and Ian and Kiki Delaney.

But most importantly, the commitment of members of the private sector demonstrated how integral the festival's ambitions of city-building were to the Toronto community. By 2010 the list of Luminaries had grown to include: Tony and Anne Arrell; The Ira Gluskin and Maxine Granovsky Gluskin Charitable Foundation; Nancy Pencer; Joan and Jerry Lozinski; Joseph Mimran and Kimberley Newport-Mimran; Geoff and Megan Smith; Lonti Ebers and Bruce Flatt; Jay and Barbara Hennick and Family; David and Audrey Mirvish; The David and Stacey Cynamon Family Foundation; Salah Bachir; Cam and Alexandra di Prata; Sloan Mauran and Adrian Tauro; Gail Drummond and Bob Dorrance; Patrick and Barbara Keenan; the Hon. Hilary M. Weston and W. Galen Weston; Phil and Eli Taylor; John and Liz Tory; Gordon and Janet Nixon. With every new Luminary, the future of the Festival and its roots in Toronto were more assured.

The desire to transform Toronto and to celebrate the creative spirit were illustrated—vividly and unequivocally—by the generosity and civic-mindedness of Toronto's private citizens and corporations. Ten companies joined in the same spirit as Founding Corporate Luminaries: Manulife Financial; St. Joseph Communications; TELUS; Ivey Foundation; BMO Financial Group; MacLaren McCann; Tourism Toronto; RBC; Dancap Productions Limited; and Falls Management Company.

As highly valued as the support of the various levels of government is to Luminato—and the festival could not survive without it—public funding remains a contribution that goes hand in hand with the commitment of Toronto's own citizens. Their belief in the annual festival is among the brightest of Luminato's many lights. To date, over $5 million has been raised by individual and corporate Luminaries, with only one expectation for return on their investment: that Luminato would one day help make Toronto a more creative, more tolerant, and more successful city.

From left to right: Linda Chu and John Donald; Kate Daniels, Nancy Pencer, Mohammad Al Zaibak, Salah Bachir; Robin and David Young; Rob McEwen, Joe Mimran, Bruce Kuwabara; Jonas and Lynda Prince; Kimberley Newport-Mimran, Cheryl McEwen.

RUFUS WAINWRIGHT BRINGS OPERA TO LUMINATO

Toronto festival scoops the Met, **E2**

Madonna's orphan quest must wait, **E3**

Cupid's back seeking TV viewers' love, **E4**

VOLUNTEE

Launching festival a 'high-wire act'

▶ **Price** From E1

money was being raised to pay for them. Upshot: cooking a stew while facing a tidal wave of anxiety. "I don't think I ever actually cried," Price recalls, "but I felt this fear in my gut."

She admits there were days when she had to wonder: "Is it even physically to possible to reach our goal with the resources we have available?"

But at 51, Price is the kind of person who gets a thrill from the challenge of impossible odds. The question is: how did she get to be that way?

She came from what she describes as an ordinary lower-middle-class family living in Agincourt. All four of her grandparents were immigrants from Scotland. Her father worked at Massey-Ferguson and then joined the police force.

As a kid, Janice MacDonald, who had an older brother and older sister, learned Scottish dancing and played the bagpipes. And early on, she wanted to leap into anoth

"My teachers in troduced me to th sic," she says.

Arts administra simply did not e At U of T's Trin won a history c planning to do g

Instead she wo at Baton Broac she started as a retary and wou of local progra

After seven y director of ma Roy Thomson keting directo Festival. Durin was married writer named

In the mid-1 the O'Keefe self as the Hum tre. By then sh out of mark cations from

Janice Price took a risk and returned home to run the inaugural Luminato, which launches next week.

TANNIS TOOHEY/TORONTO STAR FILE PHOTO

tomorrow

and Toron-eorge F. s will be nato. We'll events ll wrapped spread of ap of where

"Now we have all these exciting new cultural buildings, which feels like a breakthrough. That is what makes Luminato possible. It feels right for this moment."

People keep talking about certain ticketed events, like *Not the Messiah* and *The Book of Longing*, but to Price, what matters most is the free events.

"We want everyone to feel there's a way to take part."

Years from now, she says, euphoric, nothing, in b

David,

Thank you for Luminato. You should feel very proud of what you and your team have accomplished!

Cheers Joe.

Joe Natale

TELUS®

REDBALL
TORONTO
JUNE 5-14, 2009
KURT PERSCHKE

toronto festival of arts+creativity

1:00 PM RAHIM ALHAJ AND LI

2:15 PM AUTORICKSHAW: BOLLYWOOD AND BEYOND

3:30 PM MR. SOMETHING SOMETHING

LUMINATO PRESENTS
NEDERLANDS DANS THEATER 1
MACMILLAN THEATRE
80 QUEENS PARK CRES
SAT JUN 13 2009 8:00PM

Massey Hall
THE CANADIAN SONGBOOK
40 YEARS OF
BRUCE COCKBURN
WED 16 JUN 2010 at 07:30pm

Pecaut's initial activities had been curtailed for some months in 2004 with his first bout of cancer. But things picked up as his strength returned. "By the spring of 2005 we were back into the thick of planning . . ." Pecaut recalled. "We had planning sessions through March and April and May, getting small groups together and also working with the City Summit Alliance, and all this culminated in a statement of intent. By this point we were calling it the 'Toronto International Arts Festival.' We saw it as a festival that celebrated creativity in a broader sense than just the arts. By then we had probably talked to a couple hundred people in the city about the concept from points of view of the arts community, potential funders, the province, the federal government, and with city leaders such as Rita Davies, the Executive Director of Culture at the City of Toronto. In general we were getting a lot of support so we had to finally take a stab at what the Festival would look like. . . . From the beginning we saw this as a multi-arts festival and that's what would really set it apart: that it would be music of all kinds; it would be dance; it would be visual arts; literature; film; theatre; and eventually we felt we could do things like food and fashion. From the beginning, the idea was to really be able to think of arts in the broadest possible sense."

Luminato received $1 million of seed funding from the Government of Ontario in December 2005. Greg Sorbara, the Liberal government's Minister of Finance at the time, quickly realized the value of Pecaut and Gagliano's plan. "The engagement with the province was instantaneous," Pecaut would recall.

Meetings with Toronto's cultural leaders took on a new momentum. A founding artistic advisory committee came together and was made up of: William Boyle, CEO of Harbourfront Centre; Atom Egoyan, director and film-maker; Piers Handling, CEO of the Toronto International Film Festival; Karen Kain and Kevin Garland of the National Ballet of Canada; Bruce Kuwabara, a partner of Kuwabara Payne McKenna Blumberg architects; Bruce Mau, CEO of Bruce Mau Design; Peter Oundjian, music director, Toronto Symphony; Albert Schultz, the general director of the Young Centre for the Performing Arts; Matthew Teitelbaum, director of the Art Gallery of Ontario; and William Thorsell, CEO of the Royal Ontario Museum. The input of this extraordinary collection of individuals was regarded by Gagliano, Pecaut, and Joseph as invaluable. Their collective wisdom was critical. It was a gathering that was also passionate in the framing of the ongoing discussions. Pecaut would recall that Piers Handling and Bill Boyle were not alone in their concerns about overlapping areas of programming and what effect the arrival of a newcomer would have on funding for existing institutions.

But Pecaut's insistence on launching the festival in June 2007 meant that time was running short—even at this early stage. Suddenly, Joseph found herself dealing with budgets and schedules and the planning of an inaugural festival. The launch of Luminato in conjunction with the opening of the Daniel Libeskind–designed Michael Lee-Chin Crystal at the Royal Ontario Museum, world premieres of *Not the Messiah* and *Book of Longing*, a collaboration of Atom Egoyan and Kutlug Ataman, the programming for the Distillery Historic District and for Harbourfront's *Carnavallissima* were all well underway by the time Janice Price took up her position at Luminato. Price added to the mix with The Shen Wei Dance Arts, Guy Maddin's "Brand Upon the Brain!", the mixed media production, *Norman*, and an evening with Gore Vidal.

"For me," says Lucille Joseph, "attending the inaugural Luminato festival was like watching a movie I had seen before. It had been going on in my mind in elaborate detail over and over for the last eighteen months. We had envisioned thousands of people turning up for events, exciting openings with Leonard Cohen and Eric Idle, the astonishment of commuters getting off the train and looking up to see a herd of inflated horses charging across Union Station over their heads. And it all happened, just as we imagined."

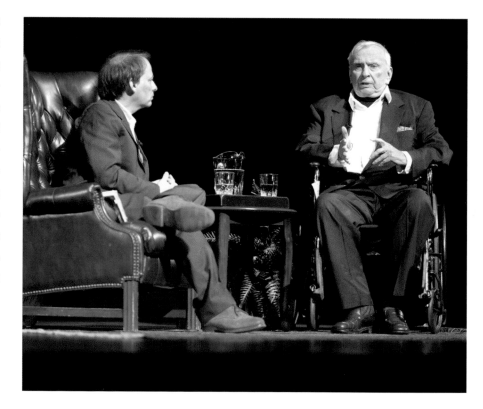

The *New Yorker*'s Adam Gopnik sat down for a chat with American man of letters Gore Vidal as part of the *Illuminations* series; 2007; Elgin Theatre.

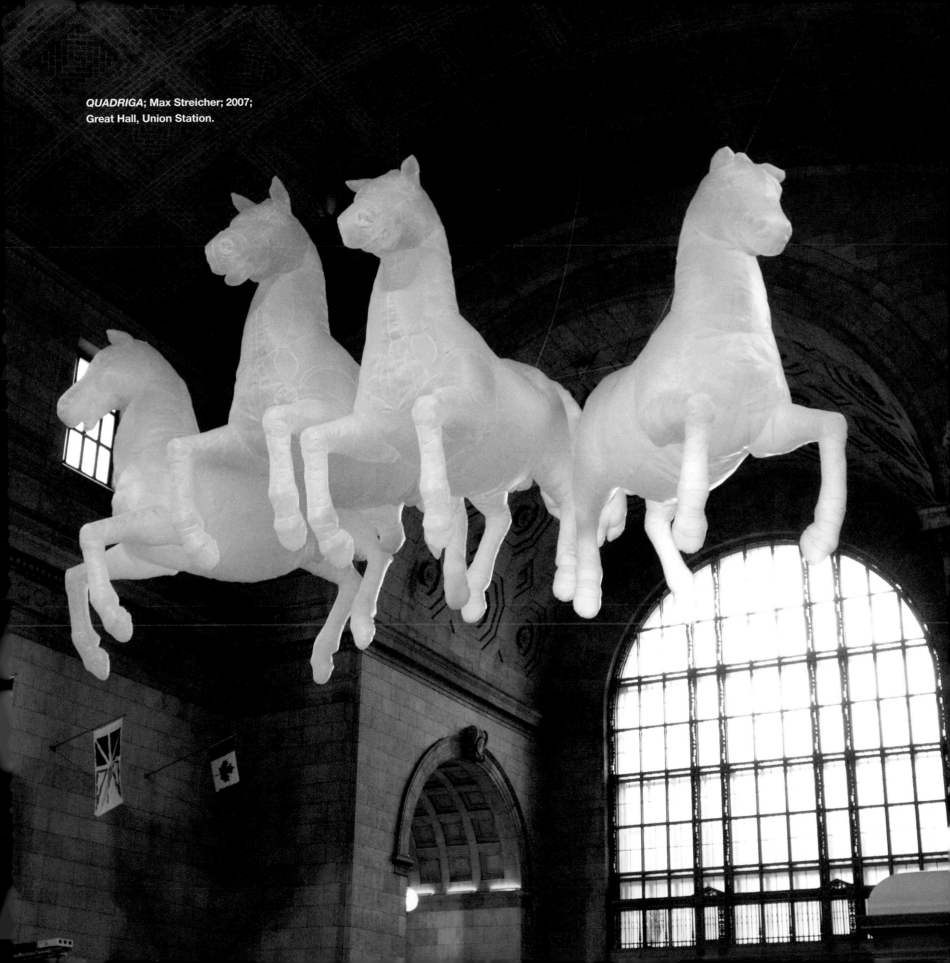

QUADRIGA; Max Streicher; 2007;
Great Hall, Union Station.

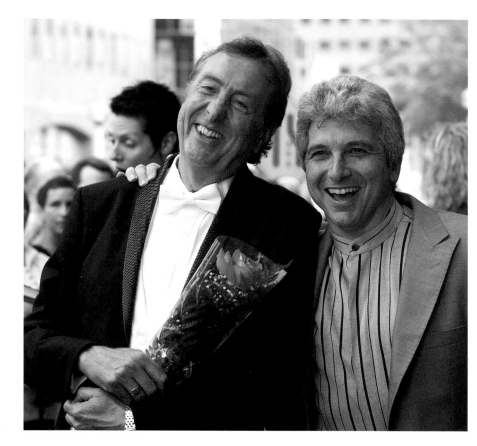

Less than seven years after he met David Pecaut for the first time—over their lunch at Grano—Tony Gagliano stepped up to the podium at Massey Hall. As chair of Luminato, he was opening the fourth season of Toronto's annual Festival of Arts and Creativity. By then, more than a few things had changed.

Luminato's inaugural festival, held June 1–10, in 2007, had landed fully formed, and with a considerable splash. It featured, at Roy Thomson Hall, *Not the Messiah*—a comic oratorio inspired by Monty Python's *Life of Brian*—co-commissioned by Luminato and the Toronto Symphony Orchestra. The TSO's Music Director, Peter Oundjian, and Monty Python's Eric Idle are cousins, and Luminato had been quick to take advantage of Oundjian's and Idle's long-standing ambition to work on a project together. Peter Oundjian remembers telling David Pecaut that Idle had called him with the idea of turning the Monty Python film *The Life of Brian* into an oratorio. "David loved the idea instantly—and Luminato was behind us from that moment on."

Monty Python star Eric Idle *(left)***, and his cousin, Toronto Symphony Orchestra Music Director Peter Oundjian, collaborated in the world premiere of** *Not the Messiah***; 2007; Roy Thomson Hall.**

THE ART OF MEETING

The illusion that an arts festival is automatically welcomed by a city's artistic community was laid to rest quickly in Luminato's development. As early as 2004, the founders were learning that a city's cultural institutions are often deeply suspicious of festivals. Arts festivals can take up venue space, audiences, revenue potential, press attention, and funding, which are seen by many institutions as strictly limited. The arrival of a big, noisy competitor is not what artistic directors wish for when they blow out their birthday candles.

If only as a gesture of goodwill, it made sense for Luminato's founders to consult with Toronto's cultural leaders. But these consultations—eventually formalized as meetings of the Festival Advisory Committee—were much more than a diplomatic gesture. Gagliano, Pecaut, and Joseph were not pretending to ask for advice—their inexperience in the world they were entering meant that advice from people who knew about running festivals, or concert halls, or galleries, or theatres, or performing arts companies was something they very much wanted. Their objective was to create a festival that would highlight Toronto's creative spirit. They had no intention of competing with the institutions they hoped to celebrate.

The meetings of the Festival Advisory Committee were not always placid affairs. All participants welcomed the idea of a multi-arts festival in theory, but all were necessarily protective of their own mandates, disciplines, and audiences. And naturally there was a wide range of views about what should constitute the new festival. "Passionate," says Lucille Joseph, "would be a good way to describe many of the discussions."

But the outcomes were significant. For one thing, the advisory committee meetings were the first time the heads of Toronto's leading cultural institutions had ever come together for a specific creative purpose. For another, many of Luminato's defining characteristics were articulated in their discussions. "We decided to ask the committee to help us to identify attributes of Toronto that would become the attributes of the Festival," Lucille Joseph says. "In one lengthy and lively meeting, we settled on three words: diversity, collaboration, and accessibility. These three words have become touchstones defining the character of the Festival including guiding programming and marketing decisions at Luminato."

Diversity, collaboration, and accessibility. These three words have become touchstones defining the character of the Festival.

The committee continues to meet several times a year with Tony Gagliano, Lucille Joseph, Janice Price and Chris Lorway. Two of its members are appointed to the Board of Directors of Luminato for a rotating two-year term.

The 2011 Festival Advisory Committee is: William J.S. Boyle, CEO Harbourfront Centre; Janet Carding, CEO, Royal Ontario Museum; Charles Cutts, President and CEO, The Corporation of Massey Hall and Roy Thomson Hall; Atom Egoyan, Director and Filmmaker, Ego Film Arts; Kevin Garland, Executive Director, National Ballet of Canada; Piers Handling, Director and CEO, Toronto International Film Festival Group; Karen Kain, Artistic Director, The National Ballet of Canada; Bruce Kuwabara, Partner, Kuwabara Payne McKenna Blumberg Architects; Bruce Mau, Bruce Mau Live; Alexander Neef, General Director, Canadian Opera Company; Peter Oundjian, Music Director, Toronto Symphony Orchestra; Albert Schultz, General Director, Young Centre for the Performing Arts; Andrew Shaw, President and CEO, Toronto Symphony Orchestra; Matthew Teitelbaum, Director and CEO, Art Gallery of Ontario.

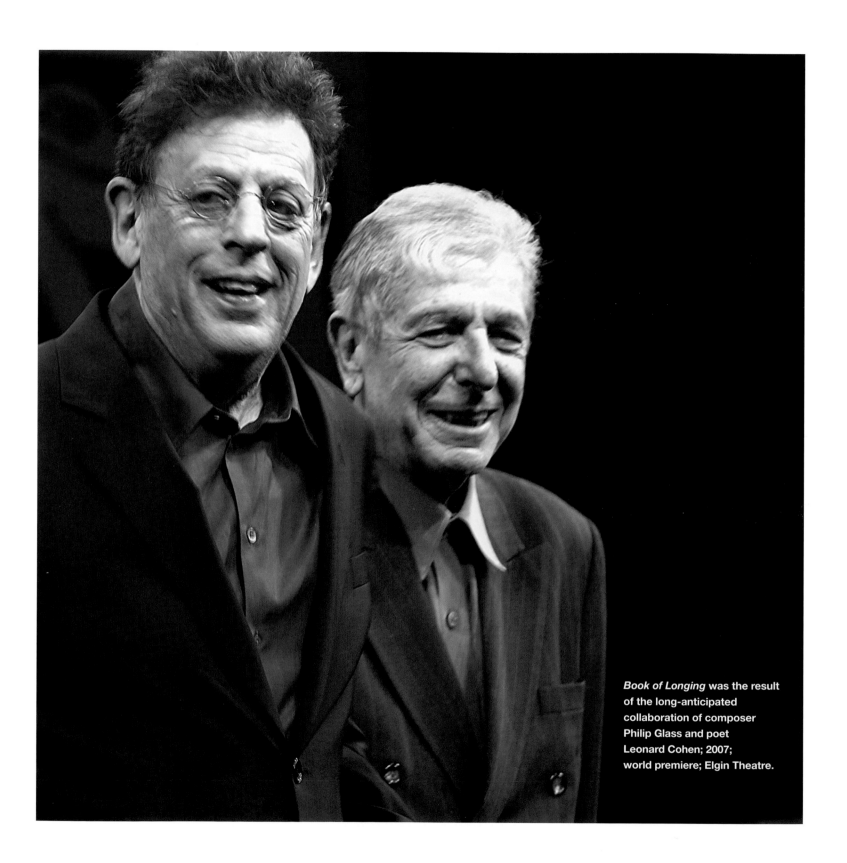

Book of Longing was the result of the long-anticipated collaboration of composer Philip Glass and poet Leonard Cohen; 2007; world premiere; Elgin Theatre.

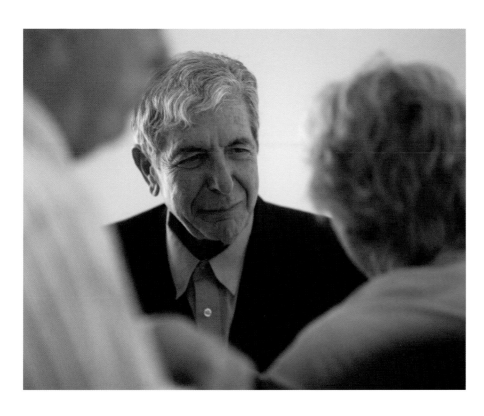

In that first season, the celebrated American composer Philip Glass collaborated with Leonard Cohen. In *Book of Longing*, presented in its world premiere at the Elgin Theatre, Glass set Cohen's recorded poetry—"at once playful, erotic, meditative, and singularly provocative"—to a new score performed by an ensemble of singers and musicians drawn from indie rock, classical, and new music. *Book of Longing*, like *Not the Messiah*, were examples of productions that simply would not have come to Toronto had it not been for Luminato.

During the inaugural Luminato season, Toronto was buzzing with names: singers such as Russell Braun and Richard Margison; musicians such as K'Naan and Hawksley Workman; directors such as Atom Egoyan and Guy Maddin; writers such as Dylan Thomas and George F. Walker—all became part of a public conversation that had not taken place so intensely in Toronto before. Rafael Lozano-Hemmer's *Pulse Front*—featured in Luminato

2007—quickly became an iconic image of Toronto. The world's largest interactive light sculpture would remain, for Harbourfront Centre's CEO, William Boyle, a prime example of David Pecaut's boldness. "We were all very excited by the idea of it," recalls Boyle, "but we were anxious about its cost. But David was so taken with its drama that he said 'Let's do it.' Not words you hear often in Toronto." Then, as part of their tag-team, it was Gagliano who found the perfect partner for *Pulse Front* in TELUS.

Luminato's first season had been a collaboration between the Festival's founders and the incoming team put together by CEO Janice Price. The courage and conviction that had been demonstrated by the Festival's Founding Luminaries—many of whom had provided critical financial support in the Festival's earliest development—were characteristics Price looked for in her choice of staff. "We were looking for people who could imagine what the Festival could become," she says. "We wanted people who were willing to make a leap of faith—who were willing to jump from the diving board before it was absolutely certain there was water in the pool." Artistic director, Chris Lorway, general manager, Clyde Wagner, associate director of education and outreach Jessica Dargo Caplan, director of development, Trish McGrath, director of ticketing and volunteers, Scott Gainsburg, and director of finance and administration, Marcia McNabb, were brought on board. "Frankly," says Lucille Joseph, "the unsung hero is Marcia. She brought order to the chaos." Luminato had engaged a book-keeping company called Profitline to set up the Festival's financial systems, and as it happened it was Marcia McNabb whom Profitline sent. She started working at the Festival in August 2006 and soon became indispensable. "It was obvious she had the qualifications to do more than day to day accounting, and Janice and I quickly decided to hire her as our Director of Finance and Administration," says Joseph.

43

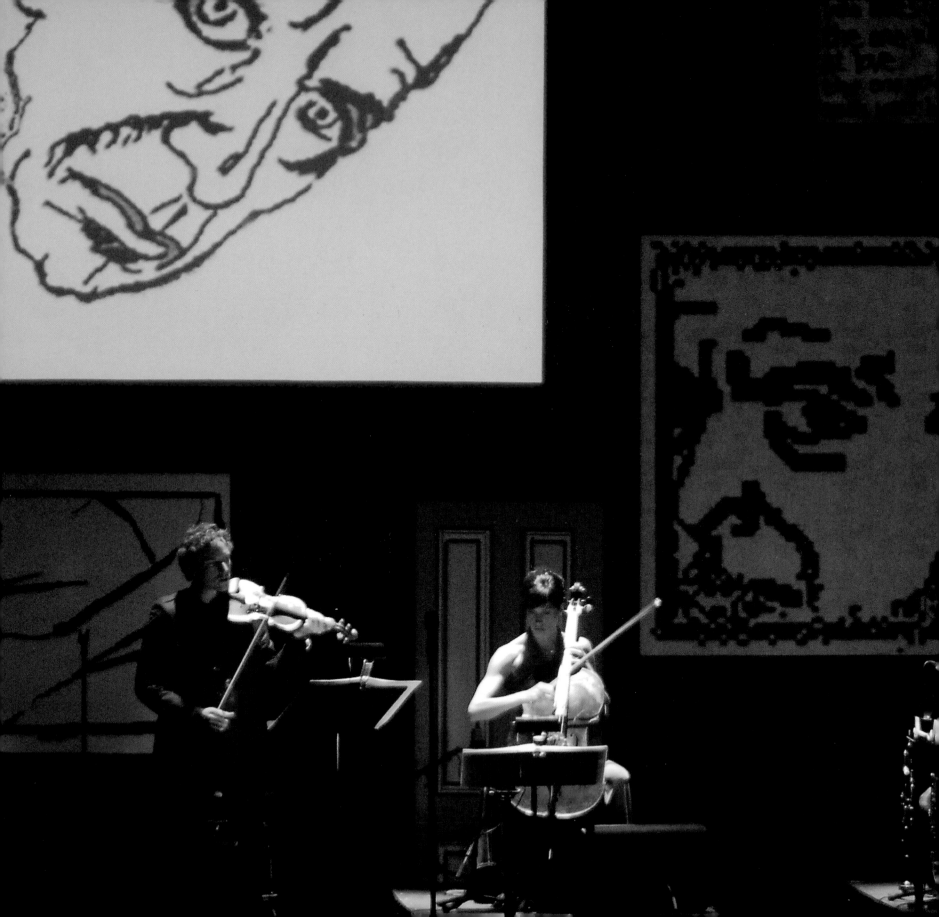

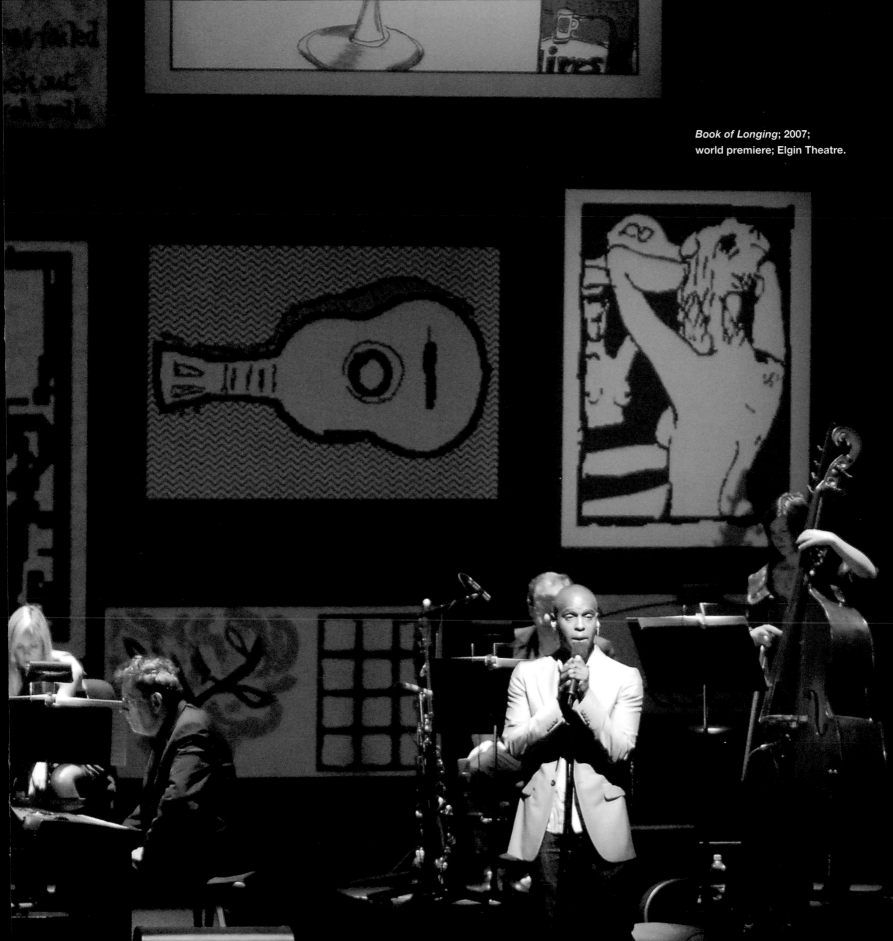

Book of Longing; 2007;
world premiere; Elgin Theatre.

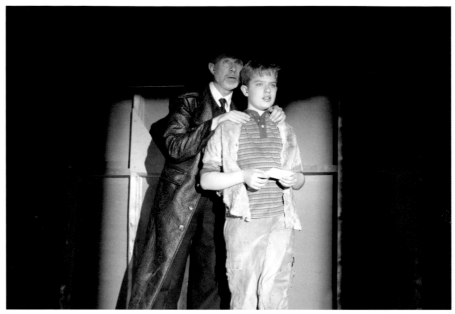

The next three seasons built on the success of the first: the National Theatre of Scotland's *Black Watch*, Laurie Anderson's *Homeland*, and the Mark Morris Dance Group came to town in 2008. (Janice Price remembers being shocked in her first year as Luminato CEO to learn that the Mark Morris company had not been to Toronto in twenty years.) In 2009, Cirque du Soleil, Robert Lepage, and the Nederlands Dans Theater became part of Toronto's airwave and water-cooler chatter. And throughout all subsequent seasons, Canadian artists have been displayed as prominently as international stars: Kenneth Welsh, Guy Maddin, Daniel David Moses, Ross Manson, Bruce Cockburn, Molly Johnson, Kevin Breit, and R. Murray Schafer's *The Children's Crusade*, directed by Tim Albery—all were given pride of place in a variety of Toronto venues. Price is particularly proud of the fact that Luminato's outreach program—designed to "engage and inspire students, teachers, and the community through participation in interactive and inclusive encounters with the arts" was a Luminato cornerstone from the beginning.

The Children's Crusade; **Soundstreams; R. Murray Schafer and Tim Albery; 2009; world premiere; performed in an abandoned ware-house, this dynamic, full-length opera had an extraordinary impact on its audiences.**

(opposite) ***Black Watch***; **The National Theatre of Scotland; 2008; Canadian premiere; Varsity Arena. This stunning piece of theatre—an international work that resonated strongly with the local audience—was the must-see event of Luminato 2008.**

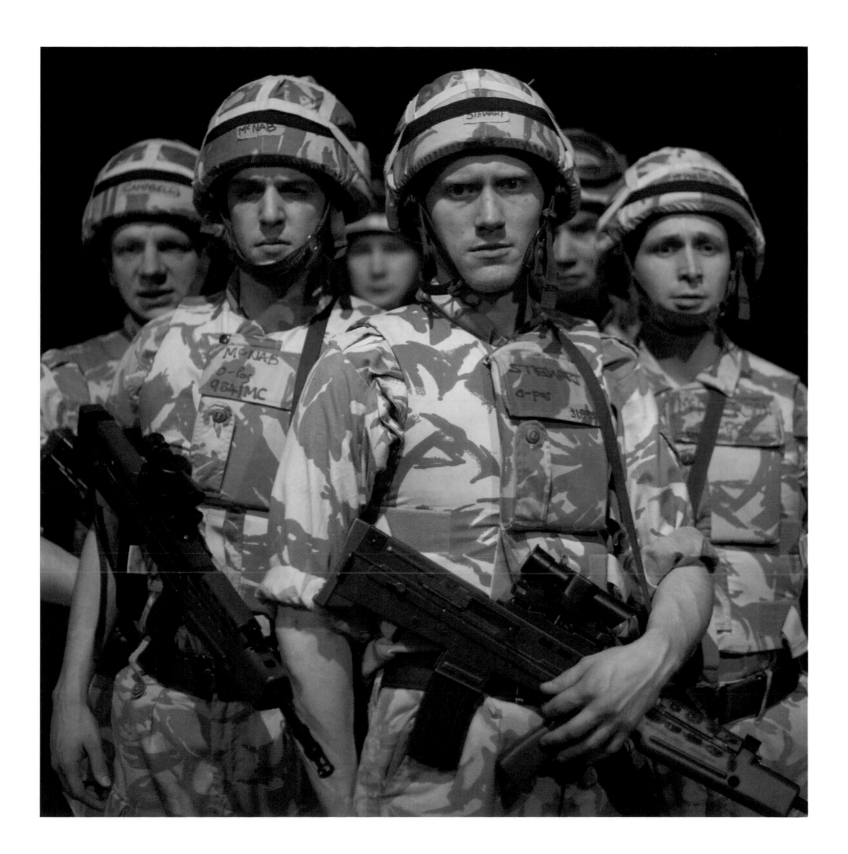

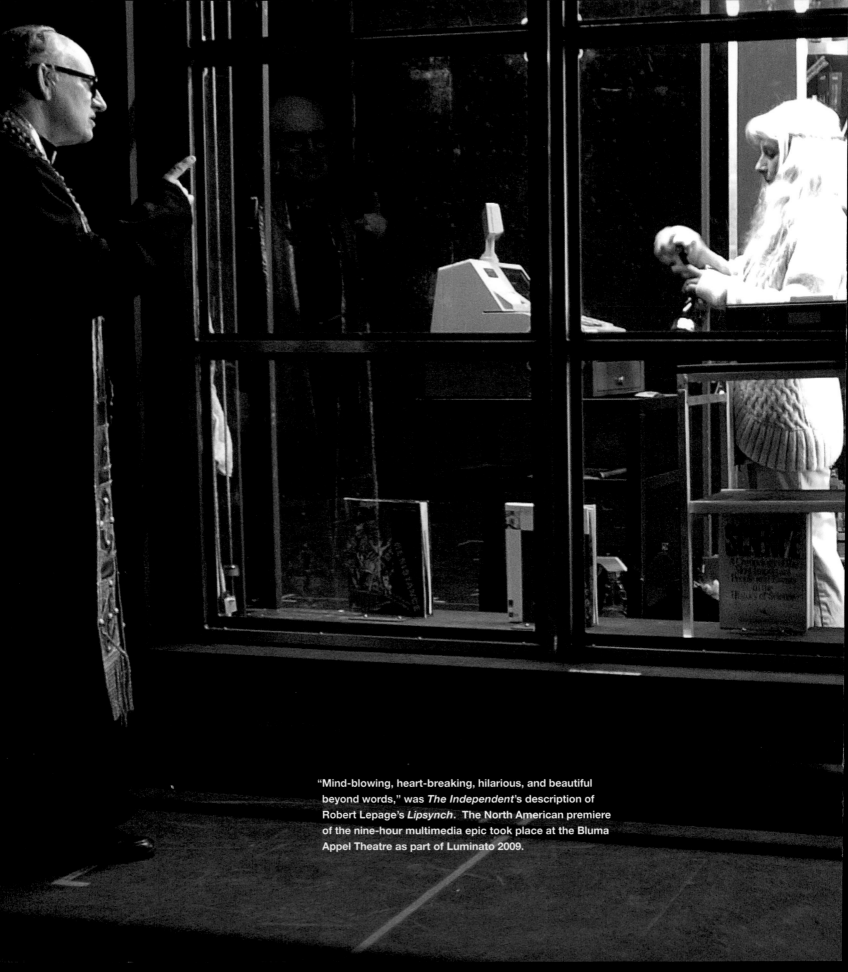

"Mind-blowing, heart-breaking, hilarious, and beautiful
beyond words," was *The Independent*'s description of
Robert Lepage's *Lipsynch*. The North American premiere
of the nine-hour multimedia epic took place at the Bluma
Appel Theatre as part of Luminato 2009.

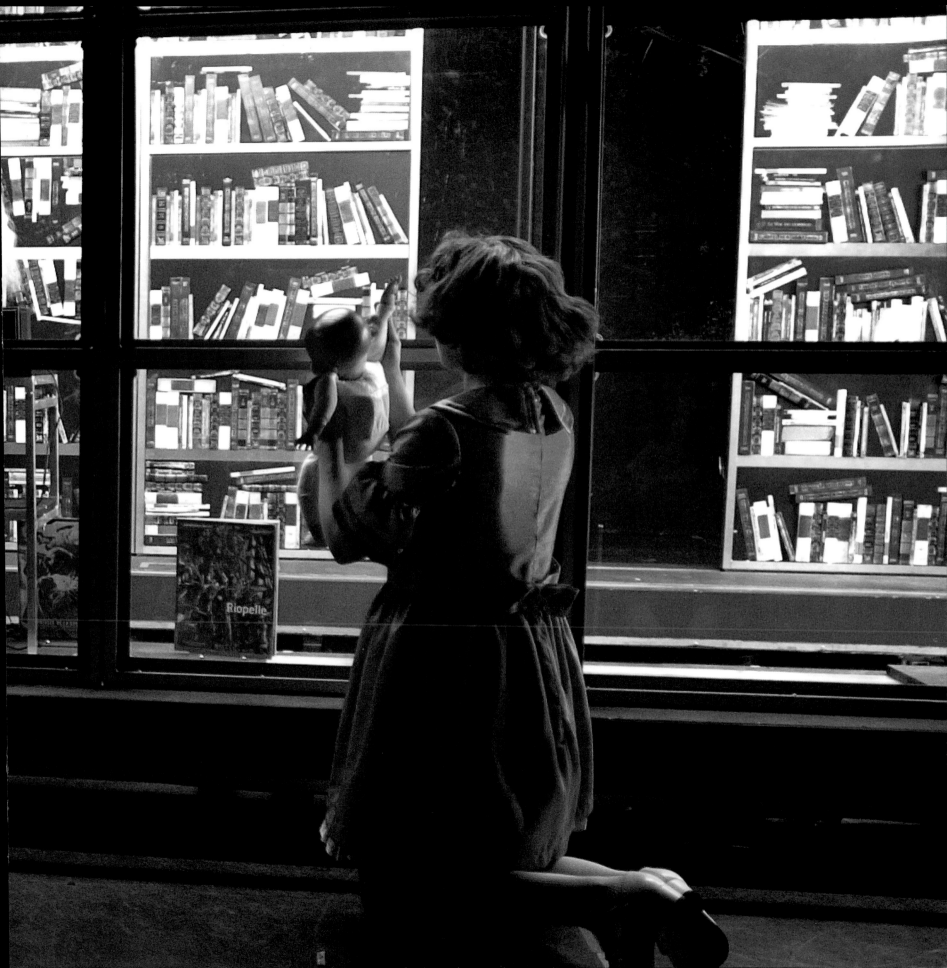

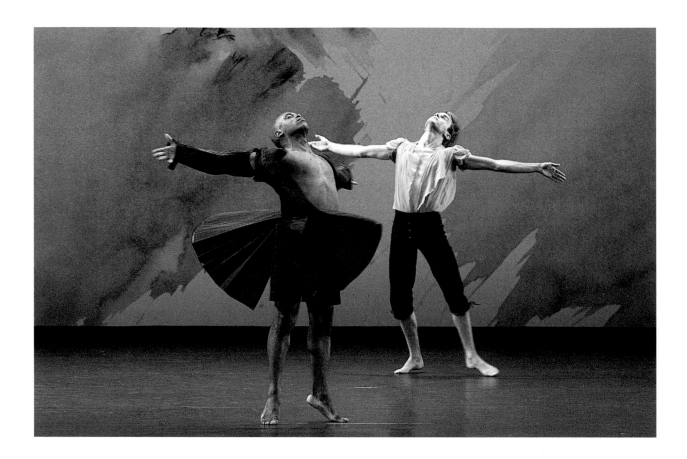

Standing at the podium on stage at Massey Hall opening the Festival in June 2010, Gagliano found it difficult to imagine Luminato not being part of Toronto's life. He found it no easier to bring very vividly to mind a time when his face had gone blank at the mention of David Pecaut's name. In fact, he found it difficult to imagine that not very long ago there had been a time when he hadn't received e-mails and phone calls and messages from David Pecaut every day—a silence that he was having to come to terms with now.

Aside from the members of his own family and his closest friends, there was no one else who had taken on a more prominent role in his life. Addressing the capacity crowd, he described David Pecaut as his friend, his brother, his partner. Gagliano's tone made it clear that these were not terms he tossed around lightly.

"As many of you know," Gagliano said, "we lost David last December after his battle with cancer." But Gagliano maintained that now was not a time for mourning. That was the last thing David Pecaut would have wanted.

Gagliano continued: "Over its first three festivals, Luminato has presented more than 5,000 artists at almost 500 different events on many stages throughout the city serving an audience of almost 4 million people of which 500,000 were tourists…" In a surprisingly short time, Luminato had begun to establish itself as the city's annual marker of the beginning of summer, just as TIFF marks summer's end. The Festival was becoming what David Pecaut had said it would: "a dream that allows artists and audiences alike to share their innate creativity, and in so doing, connect with one another as a community in the most powerful way we know."

Mozart Dances; **Mark Morris Dance Group; the work of master choreographer Mark Morris and his extraordinary company was a highlight of the 2008 festival; MacMillan Theatre.**

By 2010, Luminato could lay legitimate claim (based on Ontario's Tourism Regional Economic Impact Model) to bringing over $550 million to local merchants, restaurants, and hotels in visitor expenditures since 2007. Over its first four years it had brought artists to Toronto from more than twenty different countries, including Brazil, Nigeria, Malaysia, China, India, Serbia, the United States, and the United Kingdom. It had featured the works of Aravind Adiga, Laurie Anderson, Randy Bachman, Cirque du Soleil, Leonard Cohen, Atom Egoyan, William Forsythe, Eric Idle, Kronos Quartet, Robert Lepage, David Michalek, Joni Mitchell, Nitin Sawhney, and R. Murray Schafer. The presence on Luminato stages of such varied artists as Clarence Ford, Tanya Tagaq, Sandra Laronde, and Maryam Toller was evidence of Gagliano's and Pecaut's belief that the festival should embrace "the very diversity that is the heartbeat of Toronto."

The single most striking aspect of Luminato's development is how consistent the original vision is with what the Festival has become. The idea of a multi-arts festival that would simultaneously bring the best of the world to Toronto and the best of Toronto to the world was in the Festival's DNA from its very beginning. And there was something else at its heart—something that speaks to the ability to create on a grand scale. It was apparent as the idea grew from that of two individuals, into a partnership, a team. At each step of the journey—as Gagliano and Pecaut joined forces, as they turned to Lucille Joseph, and as the co-founders then reached out to the city's arts leadership and then again to the professional expertise of Janice Price and her team—personal claim to the idea was let go again and again, in order to allow it to include an ever-stronger chorus of voices. And yet, as it grew, it somehow changed very little from its original inspiration. It remained remarkably consistent with a conversation that took place one Saturday afternoon in Toronto over calamari and red wine.

Gagliano would recall that when he and David Pecaut finished their lunch at Grano in December 2003, they rose from their table and agreed to an ambitious, wildly complex initiative. Two men who until then never met shook hands on a commitment to transform the city. And then, heading out into a chilly downtown afternoon, they both began to work toward exactly that objective.

The festival's founding community on stage at the July 2006 launch event, at the Young Centre for the Performing Arts.

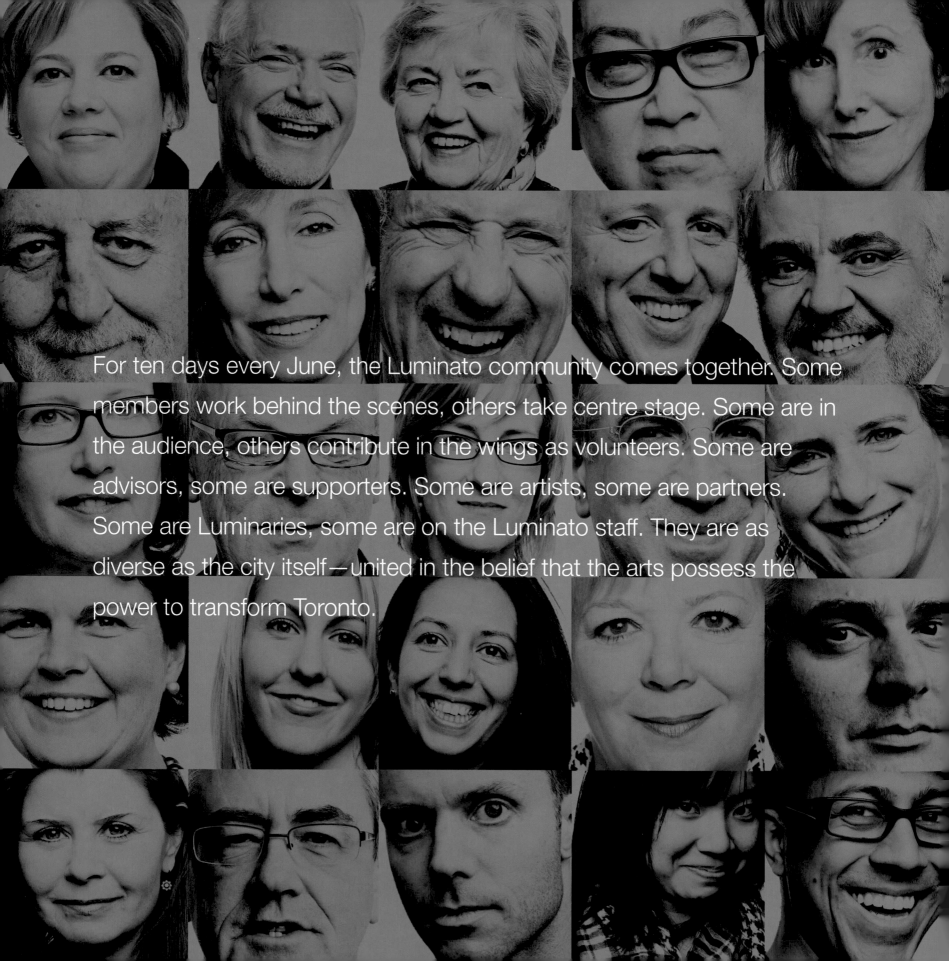

For ten days every June, the Luminato community comes together. Some members work behind the scenes, others take centre stage. Some are in the audience, others contribute in the wings as volunteers. Some are advisors, some are supporters. Some are artists, some are partners. Some are Luminaries, some are on the Luminato staff. They are as diverse as the city itself—united in the belief that the arts possess the power to transform Toronto.

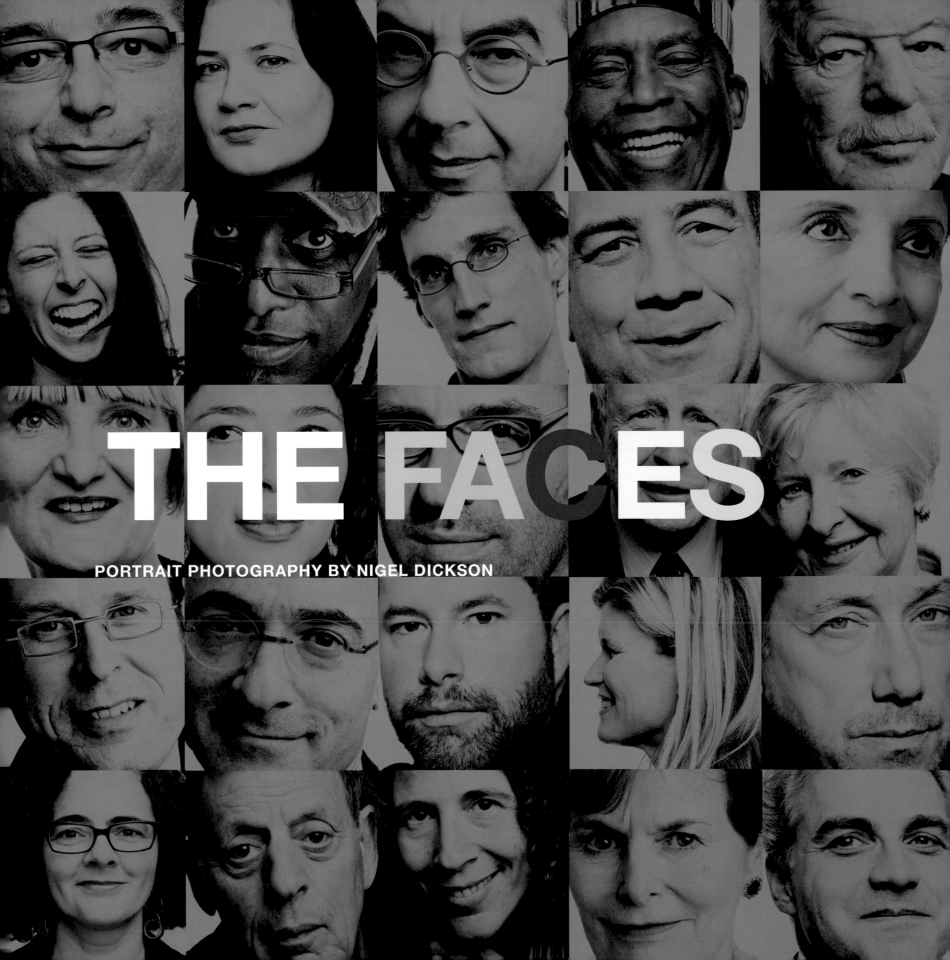

THE FACES

PORTRAIT PHOTOGRAPHY BY NIGEL DICKSON

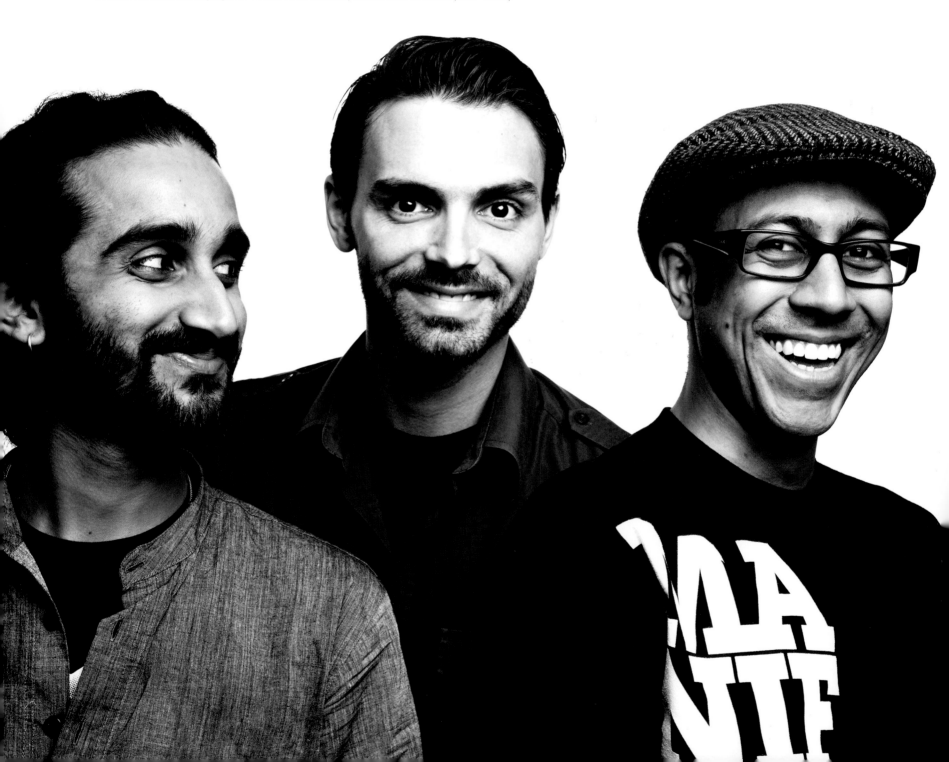

StreetScape, Luminato 2008, was created and produced with
assistance by Toronto's Manifesto Community Projects
(left to right) **Che Kothari, Executive Director; Ryan Paterson,
Creative Director; Ravi Jain, Workshop Facilitator** *(StreetScape)*;
Seema Jethalal, Managing Director; Devon Ostrom, Visual Arts Director (2007–2009)

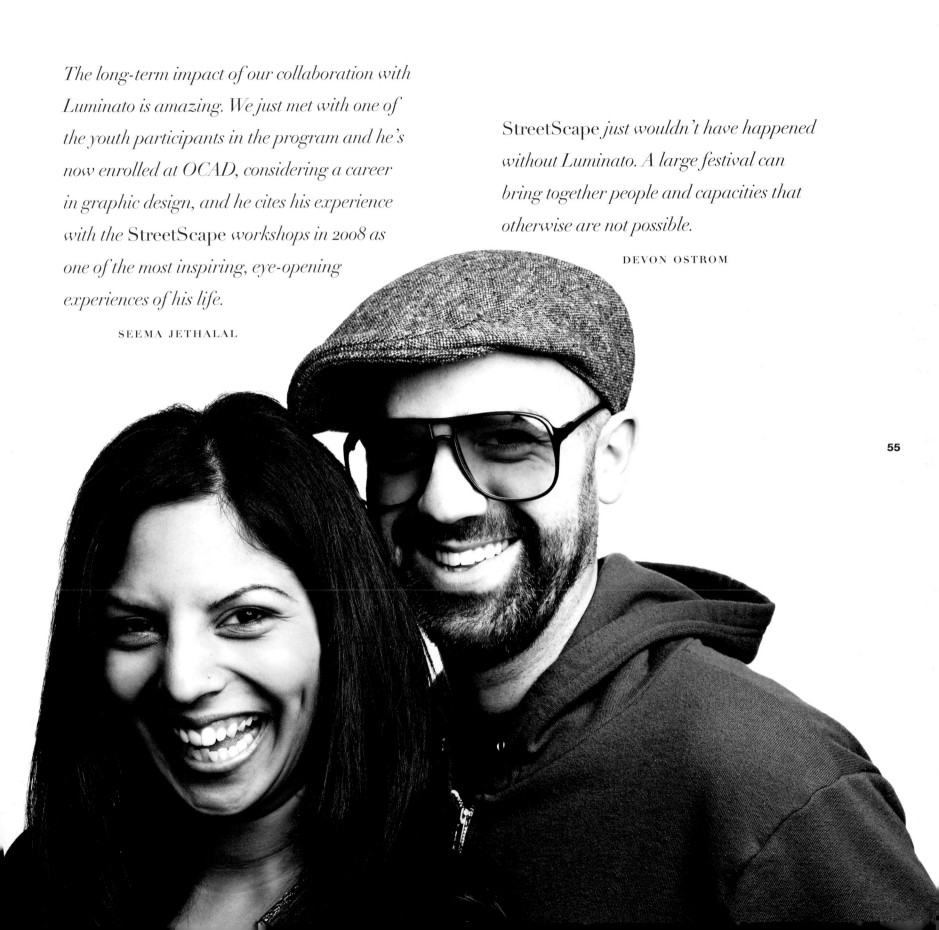

The long-term impact of our collaboration with Luminato is amazing. We just met with one of the youth participants in the program and he's now enrolled at OCAD, considering a career in graphic design, and he cites his experience with the StreetScape *workshops in 2008 as one of the most inspiring, eye-opening experiences of his life.*

SEEMA JETHALAL

StreetScape *just wouldn't have happened without Luminato. A large festival can bring together people and capacities that otherwise are not possible.*

DEVON OSTROM

55

The SARS epidemic in 2003 was a really low point for Toronto. Tourists weren't coming, and the people who live here weren't going out. I've lived in the city all my life, but I'd never seen anything like it. But at the same time, something else was going on. Something just as unprecedented. Those of us who were working with the city's cultural institutions could see that we were at the early stages of enormous change. The Ontario government's stimulus program meant that the AGO, the ROM, the opera house, the conservatory — the infrastructure of a whole sector of Toronto's arts community was being revitalized. So if the city was in crisis, it was also on the brink of unbelievable opportunity. And I remember thinking: "This is our moment, this is the time to unleash a transformation."

TONY GAGLIANO

56

Luminato, to me, means ten glorious days with my husband, children, and friends when we immerse ourselves totally in what the world has to offer in the arts and culture. For a few days we forget about everything else. It's a total cleansing of the soul.

LINA GAGLIANO

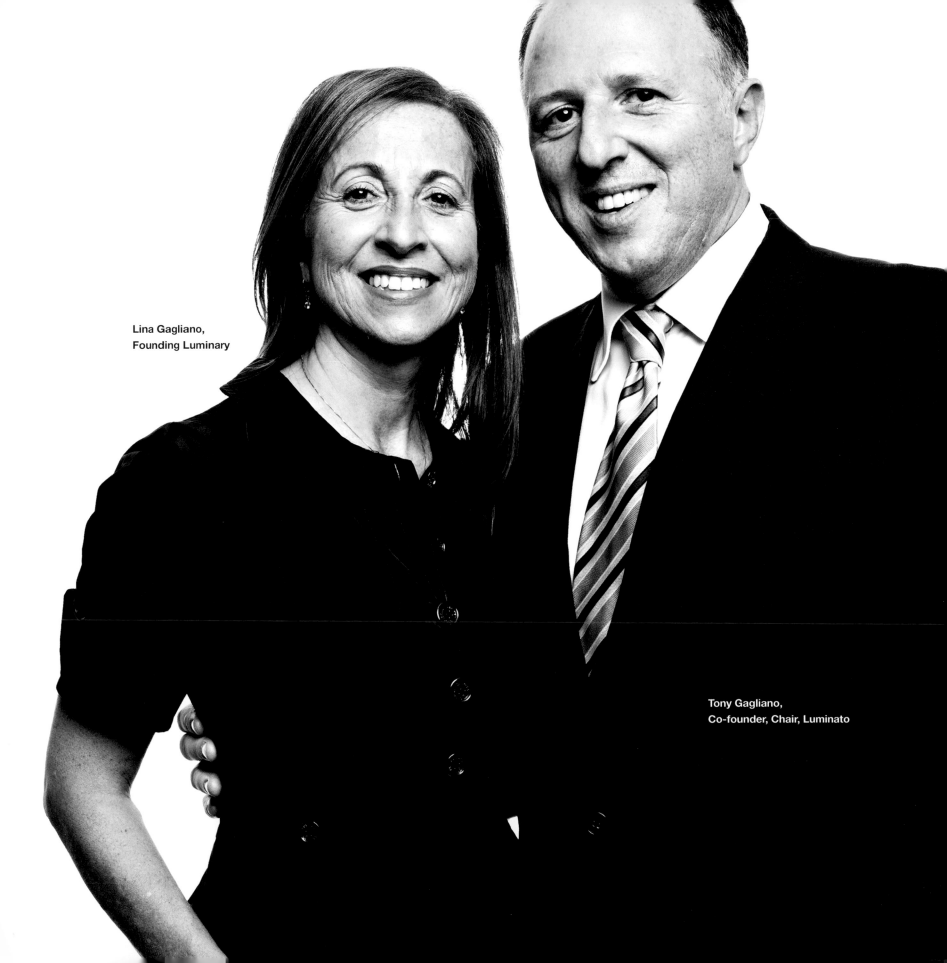

Lina Gagliano,
Founding Luminary

Tony Gagliano,
Co-founder, Chair, Luminato

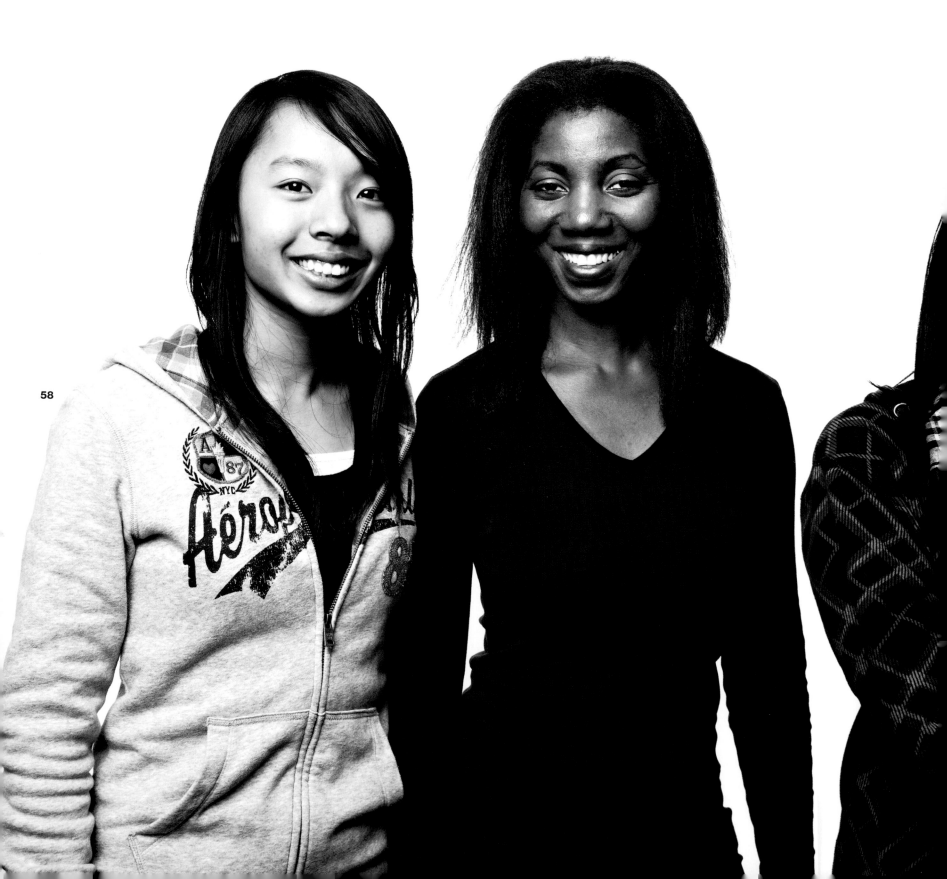

Uth Ink, Luminato 2010 Youth Program participants,
(left to right) **Jessica Su, Alicia Payne** (playwright & program facilitator),
Becky Lee, Xu Lan Ta, Amy Singh

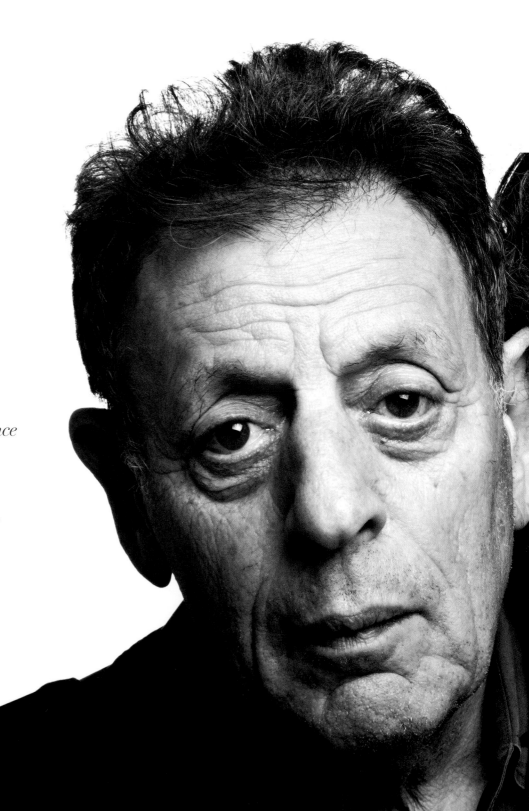

After Book of Longing
premiered at Luminato, I told
Leonard Cohen how grateful I was to
him for being so supportive. His presence
at the rehearsals in Toronto had been
very important. He smiled and said,
"I'm glad you found my poems useful."

PHILIP GLASS

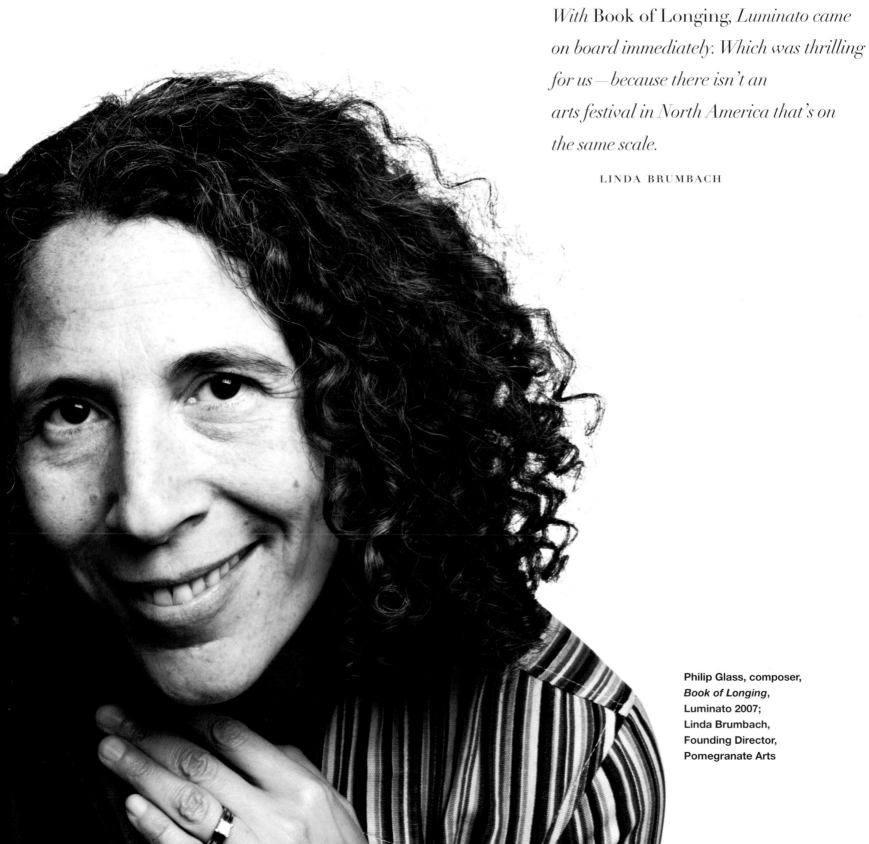

With Book of Longing, *Luminato came on board immediately. Which was thrilling for us—because there isn't an arts festival in North America that's on the same scale.*

LINDA BRUMBACH

Philip Glass, composer,
Book of Longing,
Luminato 2007;
Linda Brumbach,
Founding Director,
Pomegranate Arts

Tereza Coutinho,
Luminato volunteer

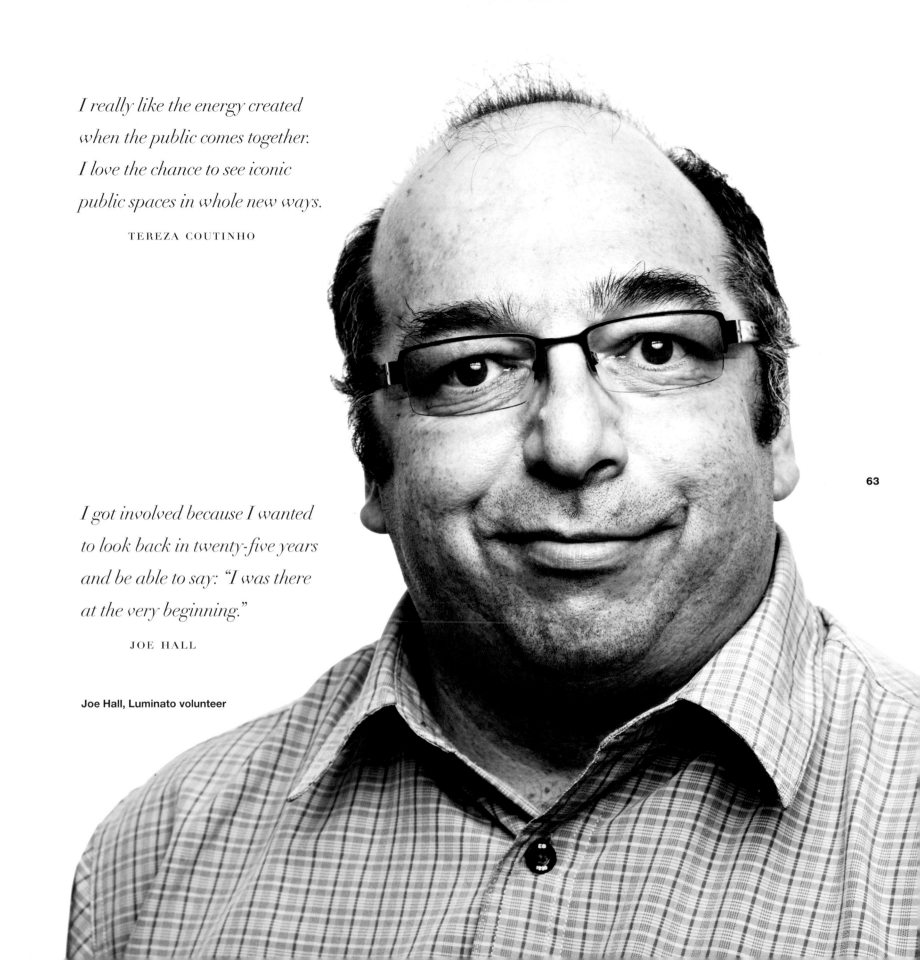

I really like the energy created when the public comes together. I love the chance to see iconic public spaces in whole new ways.

TEREZA COUTINHO

63

I got involved because I wanted to look back in twenty-five years and be able to say: "I was there at the very beginning."

JOE HALL

Joe Hall, Luminato volunteer

**Bruce Kuwabara, architect,
Kuwabara Payne McKenna
Blumberg Architects;
member, Luminato Festival
Advisory Committee**

Luminato was conceived during Toronto's Cultural Renaissance, a phenomenon that, through unprecedented public and private support, has endowed the city with an exciting series of new cultural spaces. Recharged and expanded platforms for Toronto's major arts organizations have transformed the face of the city in less than ten years. For ten days in June, Luminato rocks the city with an explosion of creative performance and expression, igniting venues and public spaces across Toronto. Luminato supplies the creative software for the city's hardware, its institutions, and public spaces, allowing people to encounter art in both an intimate way and as communal experience. Ongoing public and community engagement with the arts is essential to the future of the city. By fostering and expressing creativity, Luminato stretches Toronto's ambitions to embrace the world from a level of artistic excellence.

BRUCE KUWABARA

65

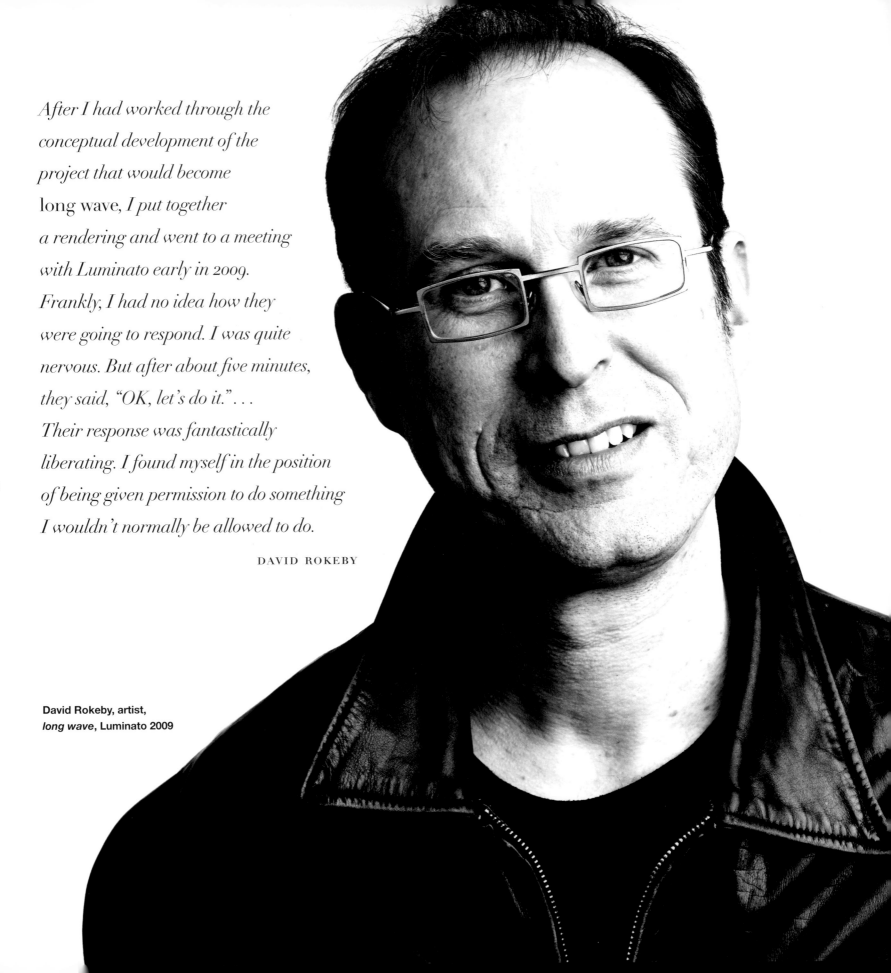

After I had worked through the conceptual development of the project that would become long wave, *I put together a rendering and went to a meeting with Luminato early in 2009. Frankly, I had no idea how they were going to respond. I was quite nervous. But after about five minutes, they said, "OK, let's do it." . . . Their response was fantastically liberating. I found myself in the position of being given permission to do something I wouldn't normally be allowed to do.*

DAVID ROKEBY

David Rokeby, artist,
long wave, Luminato 2009

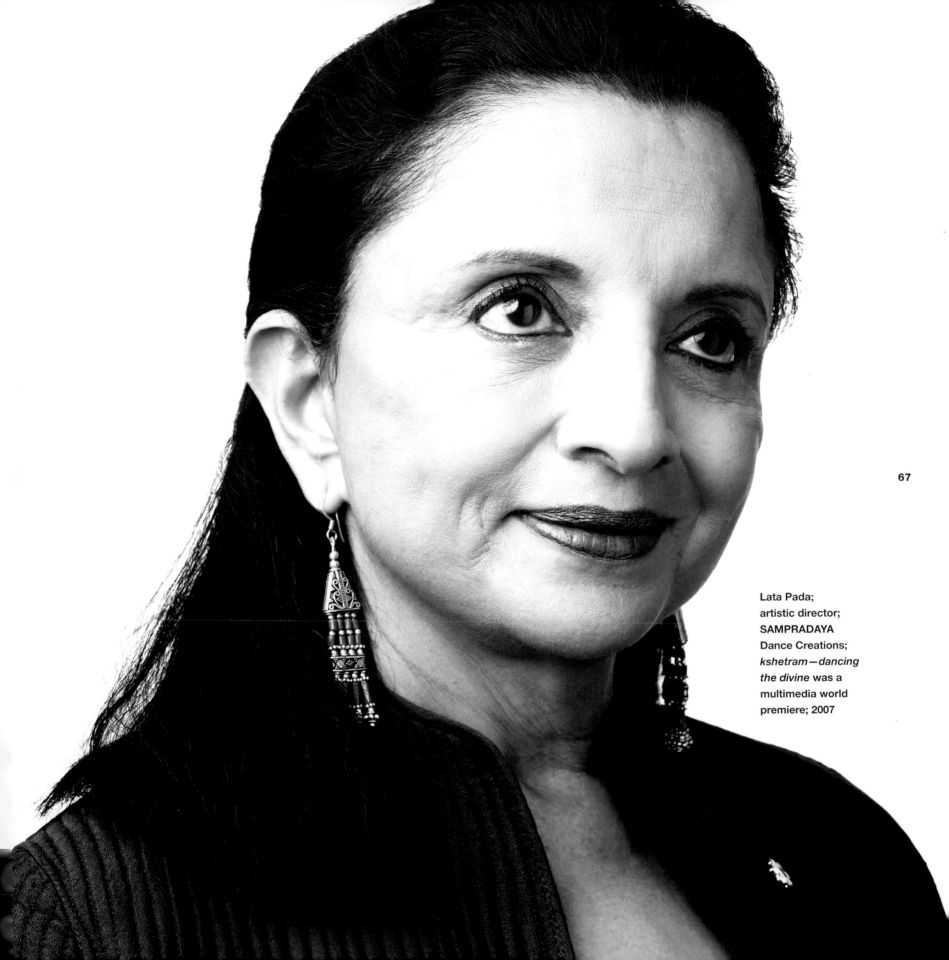

Lata Pada;
artistic director;
SAMPRADAYA
Dance Creations;
*kshetram—dancing
the divine* was a
multimedia world
premiere; 2007

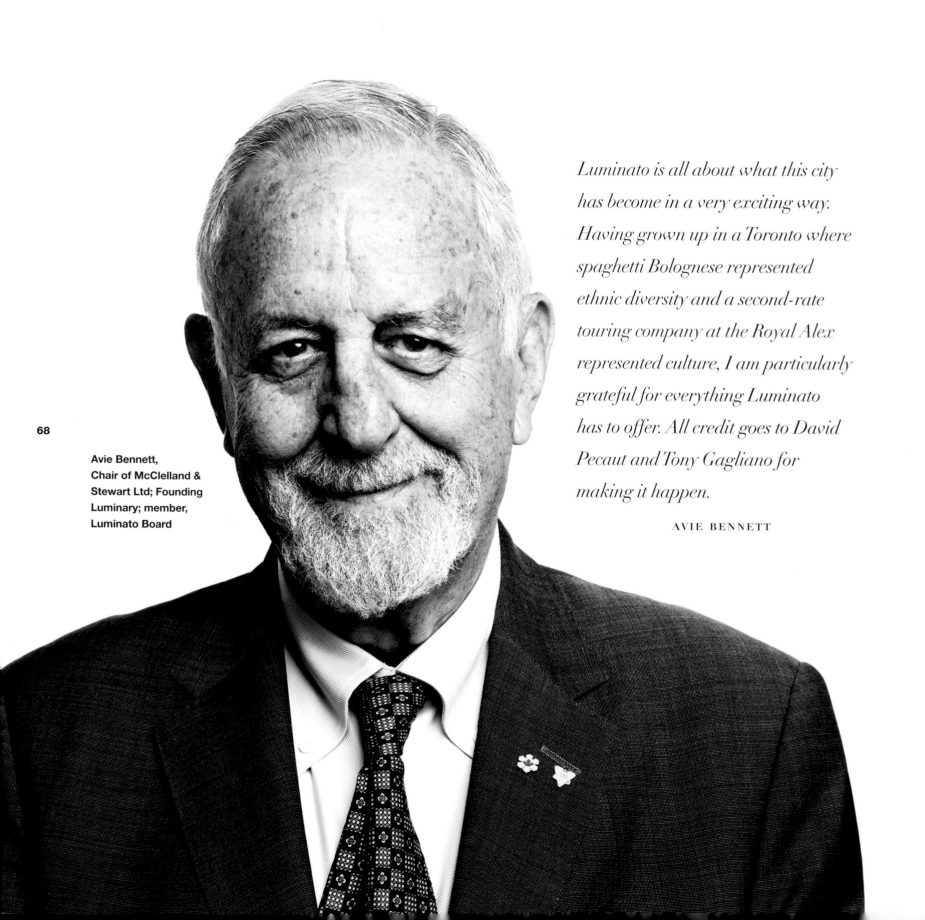

Avie Bennett,
Chair of McClelland &
Stewart Ltd; Founding
Luminary; member,
Luminato Board

Luminato is all about what this city
has become in a very exciting way.
Having grown up in a Toronto where
spaghetti Bolognese represented
ethnic diversity and a second-rate
touring company at the Royal Alex
represented culture, I am particularly
grateful for everything Luminato
has to offer. All credit goes to David
Pecaut and Tony Gagliano for
making it happen.

AVIE BENNETT

Clarence Ford, choreographer, director, producer, Ford Entertainment Inc.; *On the One Funk Festival*; Luminato 2008

We had 10,000 people at Nathan Phillips Square for On the One. *It was a funk festival that started at one in the afternoon and you know what . . . it went until five in the morning. Because after the show everybody went to Revival on College Street and jammed all night. It was that amazing.*

CLARENCE FORD

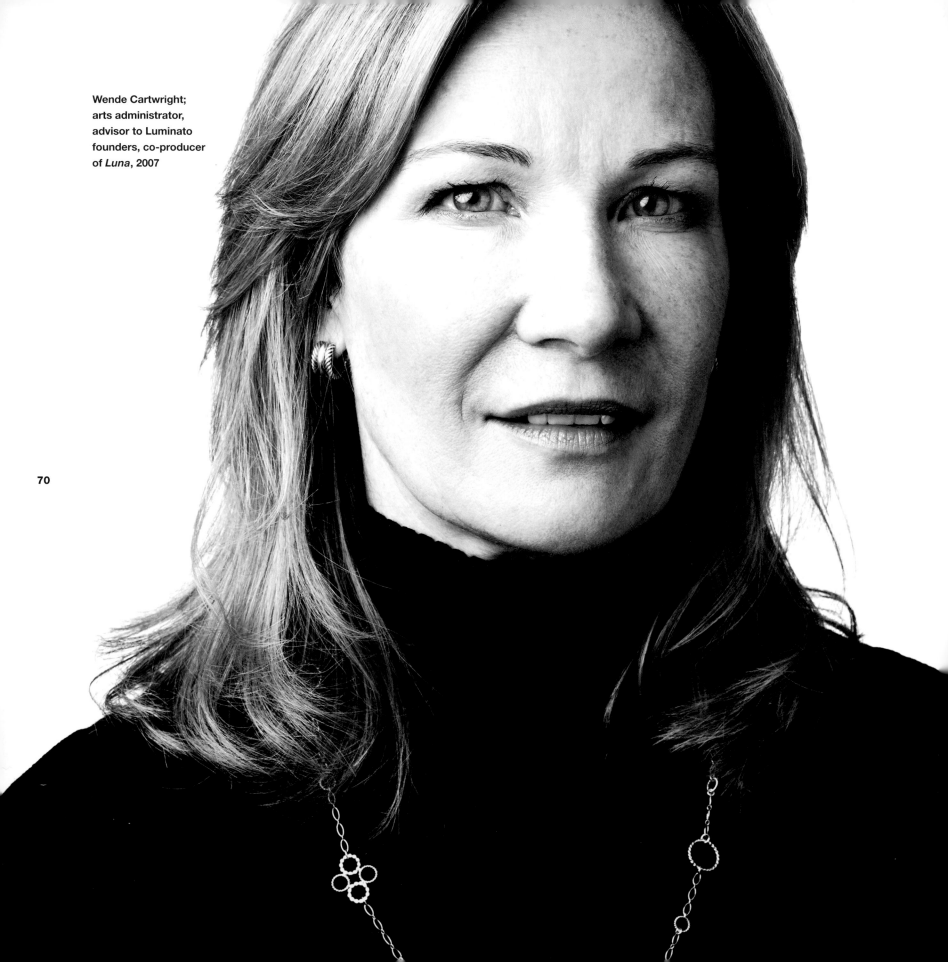

Wende Cartwright;
arts administrator,
advisor to Luminato
founders, co-producer
of *Luna*, 2007

70

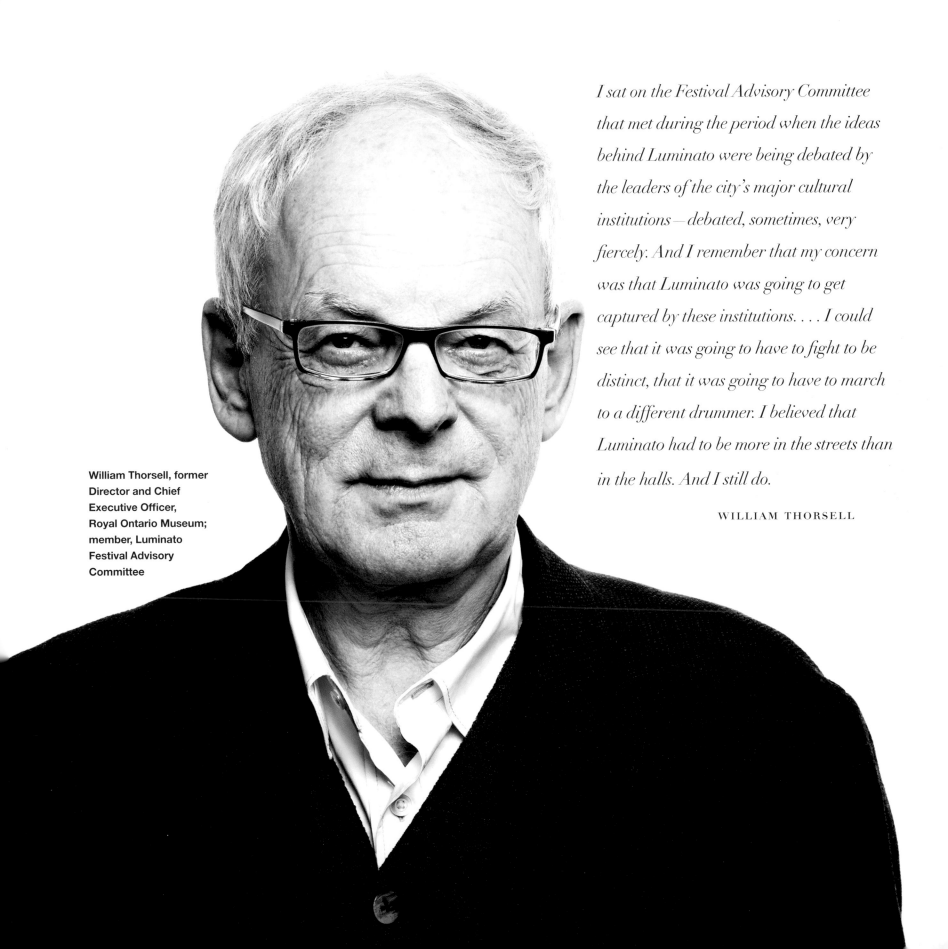

I sat on the Festival Advisory Committee that met during the period when the ideas behind Luminato were being debated by the leaders of the city's major cultural institutions—debated, sometimes, very fiercely. And I remember that my concern was that Luminato was going to get captured by these institutions. . . . I could see that it was going to have to fight to be distinct, that it was going to have to march to a different drummer. I believed that Luminato had to be more in the streets than in the halls. And I still do.

WILLIAM THORSELL

William Thorsell, former Director and Chief Executive Officer, Royal Ontario Museum; member, Luminato Festival Advisory Committee

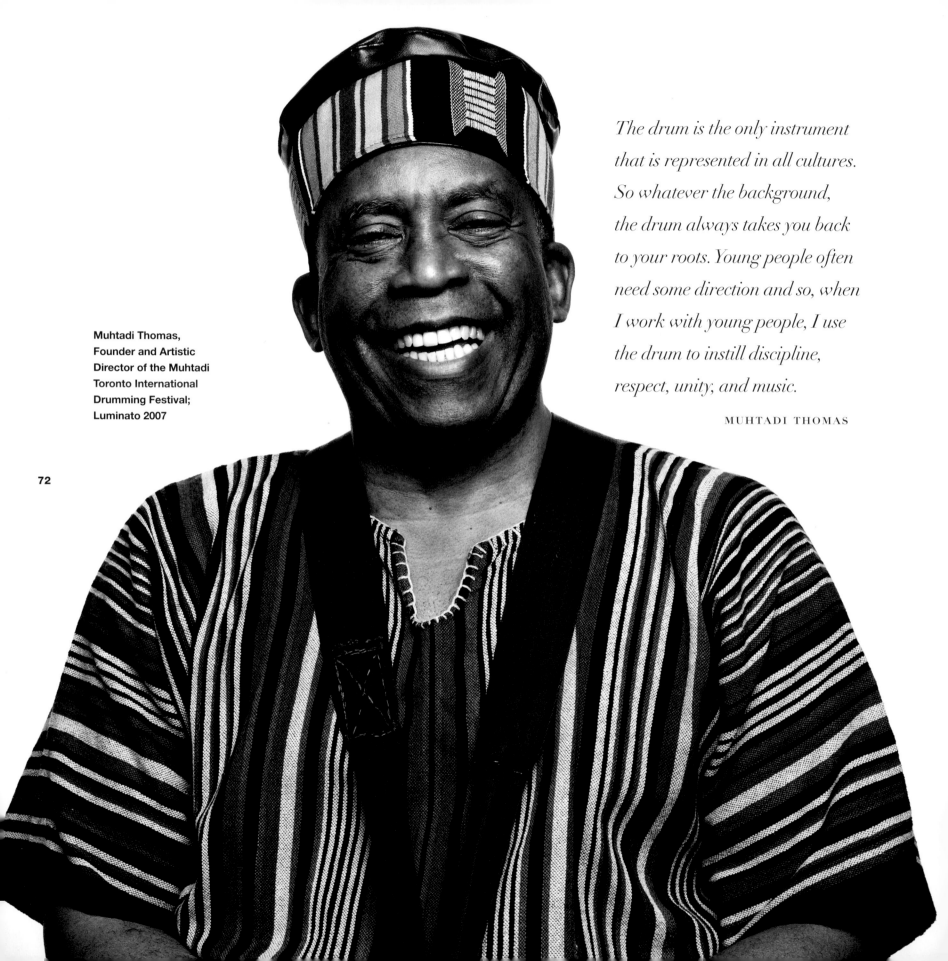

Muhtadi Thomas, Founder and Artistic Director of the Muhtadi Toronto International Drumming Festival; Luminato 2007

72

The drum is the only instrument that is represented in all cultures. So whatever the background, the drum always takes you back to your roots. Young people often need some direction and so, when I work with young people, I use the drum to instill discipline, respect, unity, and music.

MUHTADI THOMAS

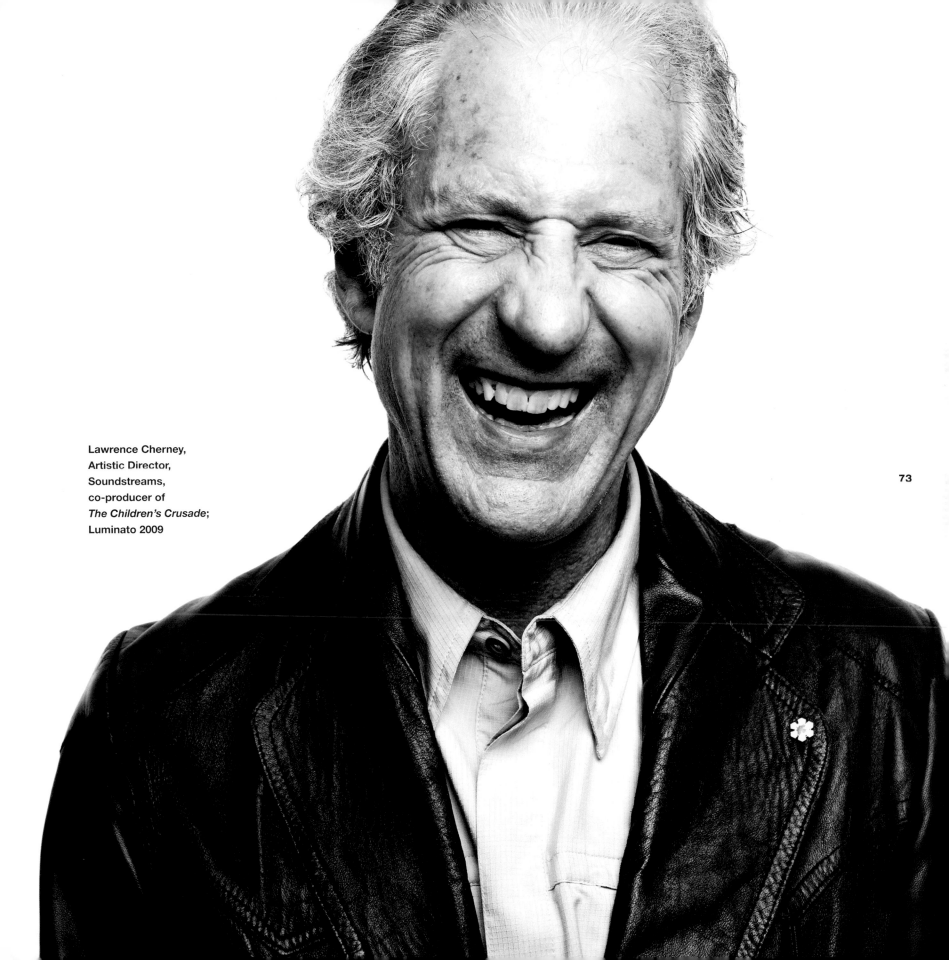

Lawrence Cherney,
Artistic Director,
Soundstreams,
co-producer of
The Children's Crusade;
Luminato 2009

73

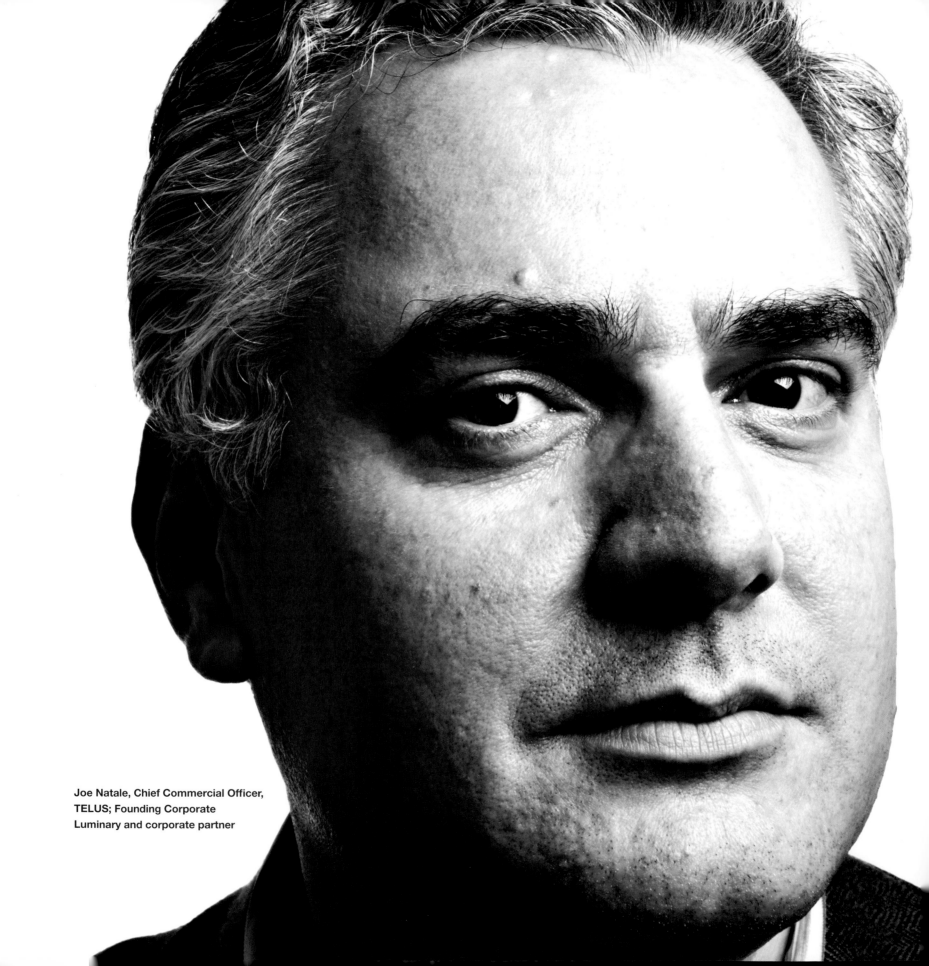

Joe Natale, Chief Commercial Officer,
TELUS; Founding Corporate
Luminary and corporate partner

TELUS got behind Luminato because we were inspired by David and Tony's vision, which was in terrific alignment with our corporate philosophy. For one thing, we believe that a business should give back to the community where it lives, works, and serves. And for another, we see the arts as being integral to society, not adjunct to it. In our own company, some of our most innovative people have backgrounds that originate, one way or another, with artistic passion or endeavour. We could see that Luminato's celebration of creativity fit perfectly with who we are and what we believe in.

JOE NATALE

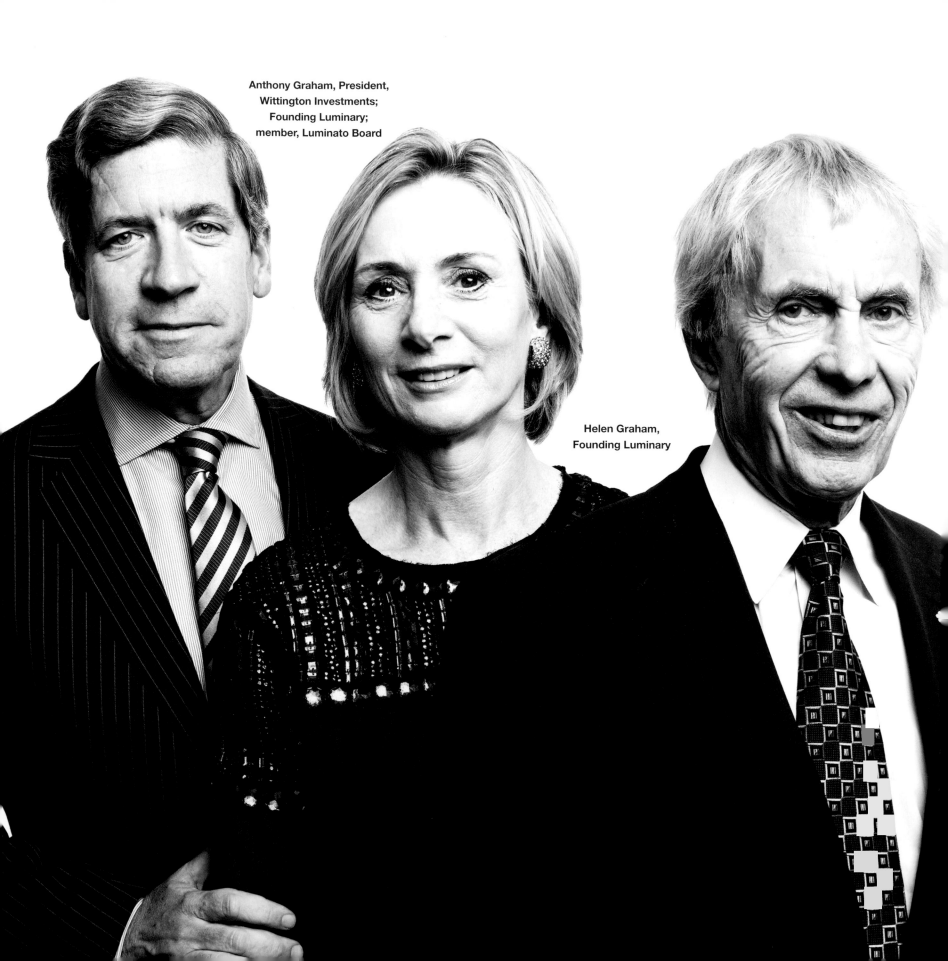

Anthony Graham, President,
Wittington Investments;
Founding Luminary;
member, Luminato Board

Helen Graham,
Founding Luminary

Jim and Sandra Pitblado,
Founding Luminaries

Donald and Gretchen Ross,
Founding Luminaries

78

Chetan Mathur, CEO,
Next Pathway Inc.;
Founding Luminary;
member, Luminato Board

Everyone knows what Luminato is, and everyone looks forward to it every year, everyone in the school knows that something's happening. There's a kind of Luminato buzz—and that kind of excitement really helps us to engage the students.

ELIZABETH SCHAEFFER

Elizabeth Schaeffer,
Cluster Lead Teacher,
Model Schools for
Inner Cities, Toronto
District School Board

In the early stages of developing Luminato, the Festival felt like a huge spaceship hovering over Toronto. Our job was to land it safely, translating the grand idea into a tangible experience that would enliven the city. We knew the outcome we wanted in terms of the impact of the Festival on Toronto. We worked backwards to design a festival that would achieve that outcome. It is perhaps unusual for an arts festival to be founded by business people, but in some ways that was its strength because the intention was always clear. The Festival wasn't a personal statement; it wasn't about us. It was always about the transforming power of the arts. We were there to convene the people, the resources, and the place to collectively realize the vision.

<div align="right">LUCILLE JOSEPH</div>

Lucille Joseph,
Vice-Chair, Board
of Directors,
Founding Luminary

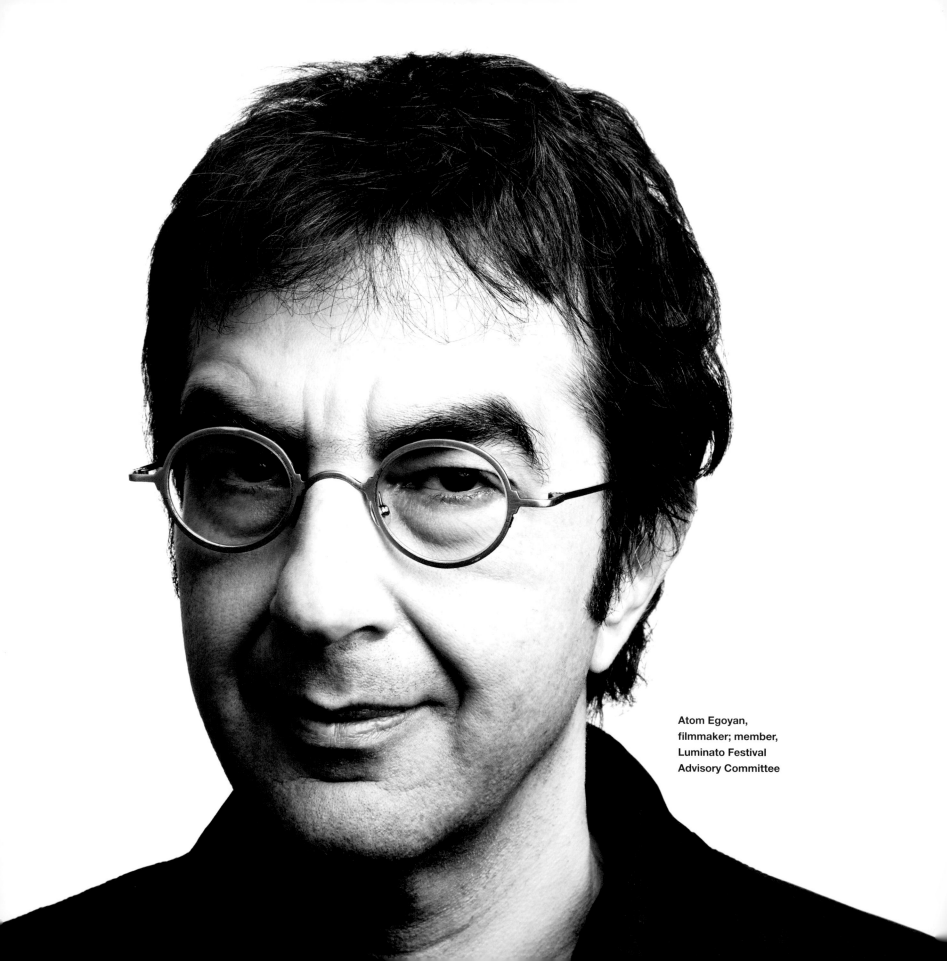

Atom Egoyan,
filmmaker; member,
Luminato Festival
Advisory Committee

It seemed that suddenly, Luminato was in high gear.
They wanted to plunge right in. I was one of the artistic
advisors, and my reaction was, "You're crazy." I just didn't think
it was possible to make something so ambitious happen so quickly.
But I didn't know David well enough then to understand that
this was entirely realistic. Because that's what David did.
He made the impossible happen.

ATOM EGOYAN

Cast of Volcano Theatre's *The Africa Trilogy*, Luminato 2010.
(left to right) **Maev Beaty, Muoi Nene, Araya Mengesha, Dienye Waboso, Weyni Mengesha** (Dramaturge)

At the heart of the idea behind Luminato was a very profound and deep sense of community. David and Tony believed that there was something in Toronto that if it could just get unleashed by people working together, great things would happen.

MATTHEW TEITELBAUM

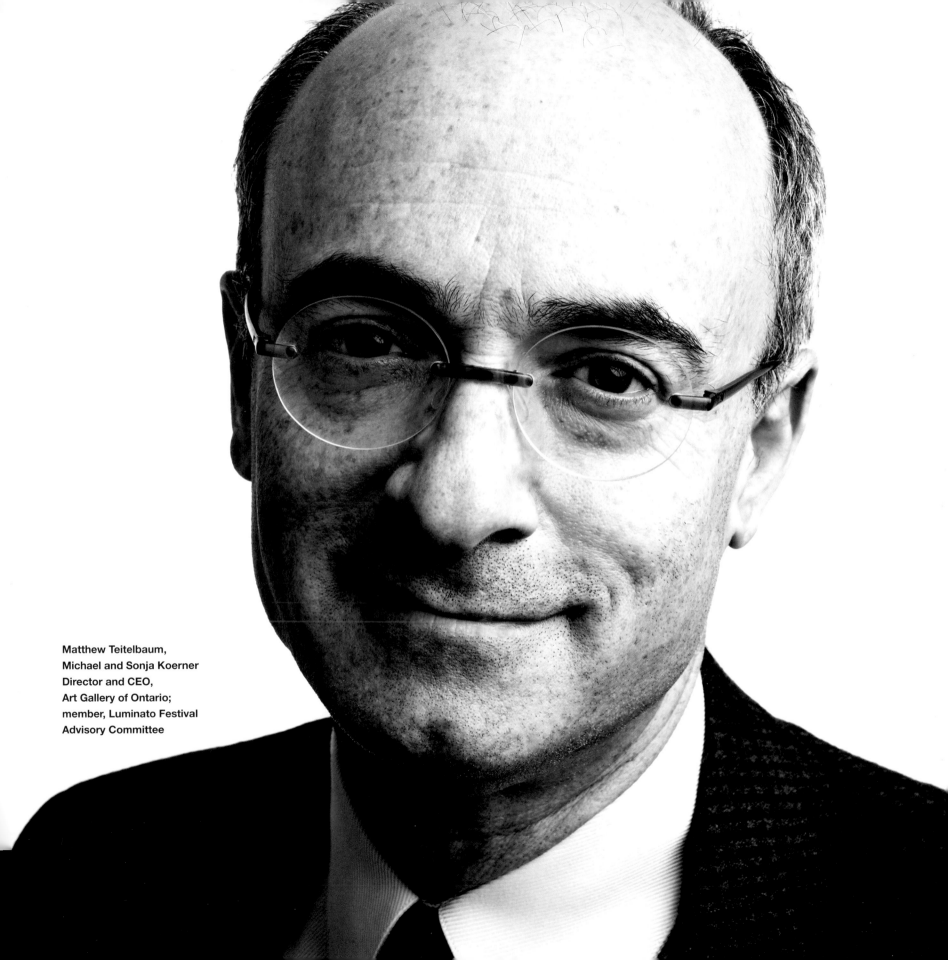

Matthew Teitelbaum,
Michael and Sonja Koerner
Director and CEO,
Art Gallery of Ontario;
member, Luminato Festival
Advisory Committee

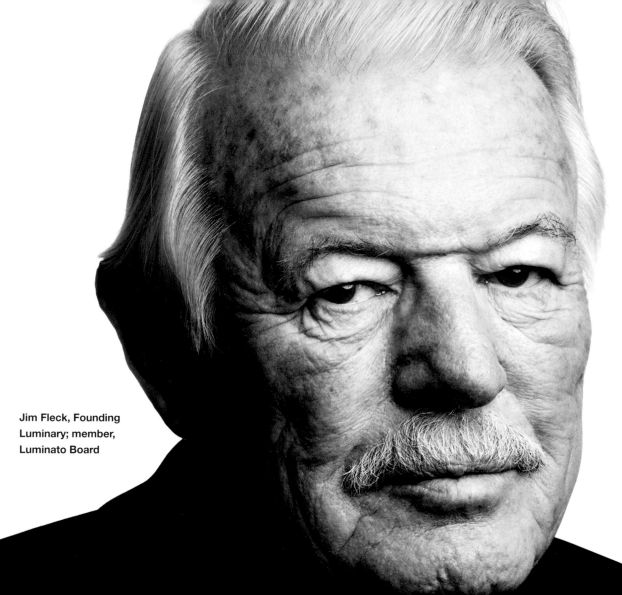

Jim Fleck, Founding Luminary; member, Luminato Board

I liked the ambition of it. I thought it was an audacious idea—with lots of risk. But with a lot of potential.

JIM FLECK

It's difficult for me to convey my role in the development of Luminato because the discussions I had with David about his ideas were so integral to our lives. Whether it was at the dinner table or at a boardroom table, Luminato was a running conversation we had as we worked, and travelled, and lived our lives. It was an idea—a very good idea—that we kept building and layering as it took shape. We never stopped talking, and challenging each other, and working together. That was our dynamic, not only as a couple, but as a family.

HELEN BURSTYN

89

Helen Burstyn,
Chair, The Ontario Trillium
Foundation; Founding Luminary;
member, Luminato Board;
wife of the late David Pecaut

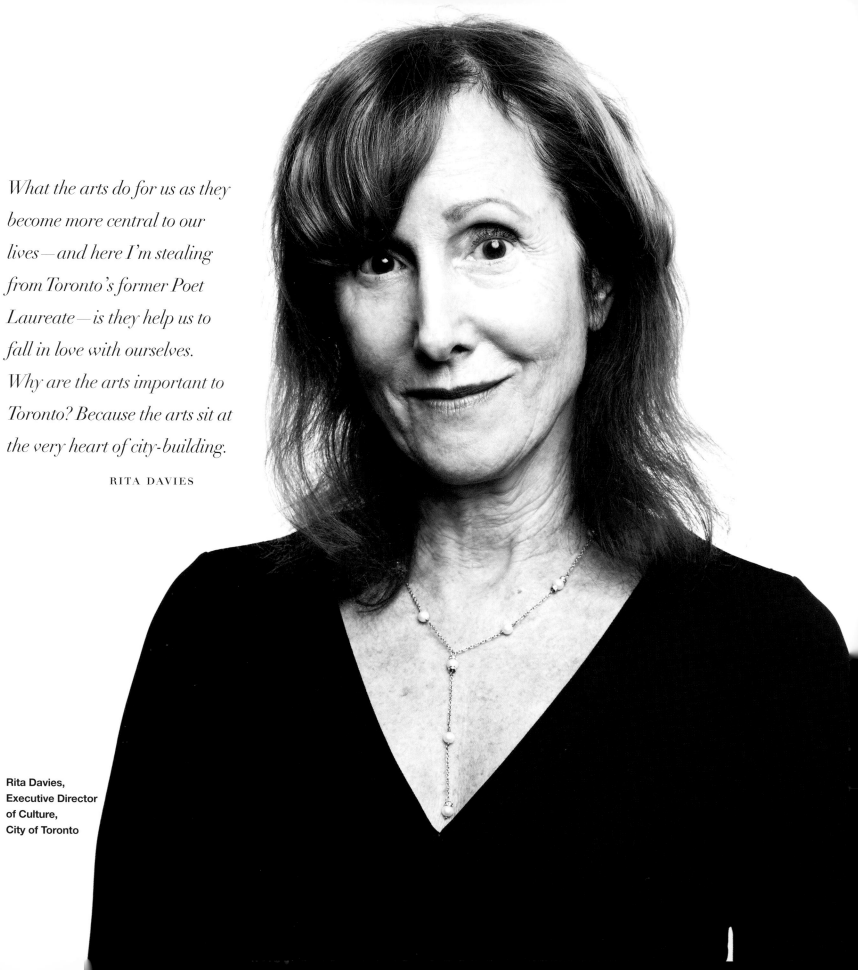

What the arts do for us as they become more central to our lives—and here I'm stealing from Toronto's former Poet Laureate—is they help us to fall in love with ourselves. Why are the arts important to Toronto? Because the arts sit at the very heart of city-building.

RITA DAVIES

Rita Davies,
Executive Director
of Culture,
City of Toronto

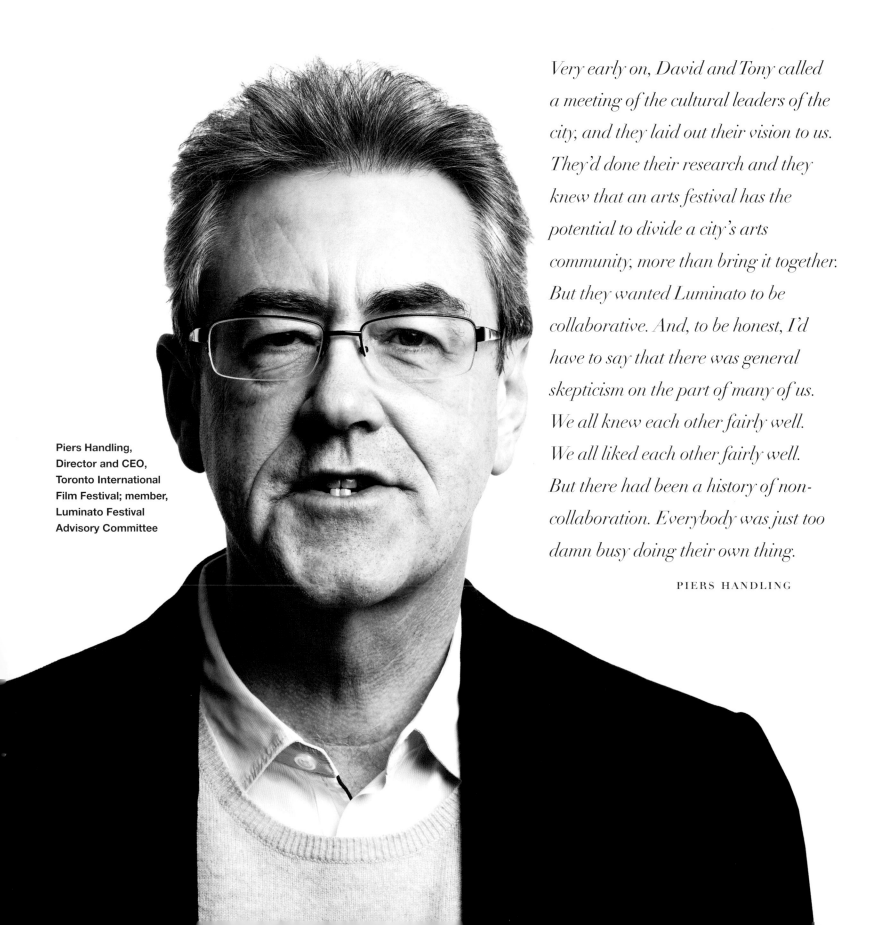

**Piers Handling,
Director and CEO,
Toronto International
Film Festival; member,
Luminato Festival
Advisory Committee**

*Very early on, David and Tony called
a meeting of the cultural leaders of the
city, and they laid out their vision to us.
They'd done their research and they
knew that an arts festival has the
potential to divide a city's arts
community, more than bring it together.
But they wanted Luminato to be
collaborative. And, to be honest, I'd
have to say that there was general
skepticism on the part of many of us.
We all knew each other fairly well.
We all liked each other fairly well.
But there had been a history of non-
collaboration. Everybody was just too
damn busy doing their own thing.*

PIERS HANDLING

Javier San Juan, President and Chief Executive Officer,
L'Oréal Canada, Luminato's Partner in Creativity

*When I first met with Tony Gagliano and Janice Price,
I was struck with their high ambitions and high expectations
for Luminato. They didn't have a PowerPoint presentation,
and they didn't have lots of charts and documents. What they
had was a great idea and a lot of passion. I was able to say "yes"
very quickly. It was a perfect match.*

JAVIER SAN JUAN

94

Marcia McNabb,
founding staff member,
Corporate Secretary,
V.P. Finance & Administration

Scott McVittie,
Director, Programming
& Partner Promotions

Robert VanderBerg, Associate Producer,
Visual Arts & Public Installations

Mitchell Marcus,
Associate Producer,
Special Projects

Natasha Udovic, Director,
Corporate Partnerships

Jessica Dargo Caplan,
Director, Education &
Community Outreach

Martha Haldenby,
Development Officer,
Individual Giving

95

Devyani Saltzman, Curator,
Literary Programming
& *Illuminations*

*What people see is the tip of the iceberg;
behind the curtain an army of incredibly
talented people work year-round to make
these ten days possible. I am blessed as
the GM to be surrounded by these
marvellous magicians every day.*

CLYDE WAGNER

Kathleen Sloan,
Director of Marketing

Clyde Wagner,
General Manager

Our job is the ten days of the Festival. No more, no less. Everything we do comes down to that. And essentially, what that job is about is creating an arts centre without walls. Which is an extraordinarily exciting idea—especially for a city. But putting it together is very complicated. It's a bit like playing chess in three dimensions. And I think the audience gets that. That's why when it works it is so glorious.

JANICE PRICE

Janice Price,
CEO, Luminato

Erika Batdorf, artist,
One Pure Longing: Táhirih's Search,
Luminato 2010

Luminato was very timely for me. I was really hungry to work on a larger scale, and when Luminato got behind my project I was able to extend into a broader community and reach a whole new audience.

ERIKA BATDORF

*Without our association with Luminato,
Tapestry would never have been able to afford two
performances at Koerner Hall—as we had in the
2010 season with* Dark Star Requiem. *But we've
been involved in a number of co-productions over the
years, and the beautiful thing about working with
Luminato is that our organizations now work together
so well. When you build this kind of relationship,
the trust factor becomes truly remarkable.*

WAYNE STRONGMAN

100

**Wayne Strongman, Founding
Managing Artistic Director,
Tapestry New Opera Works**

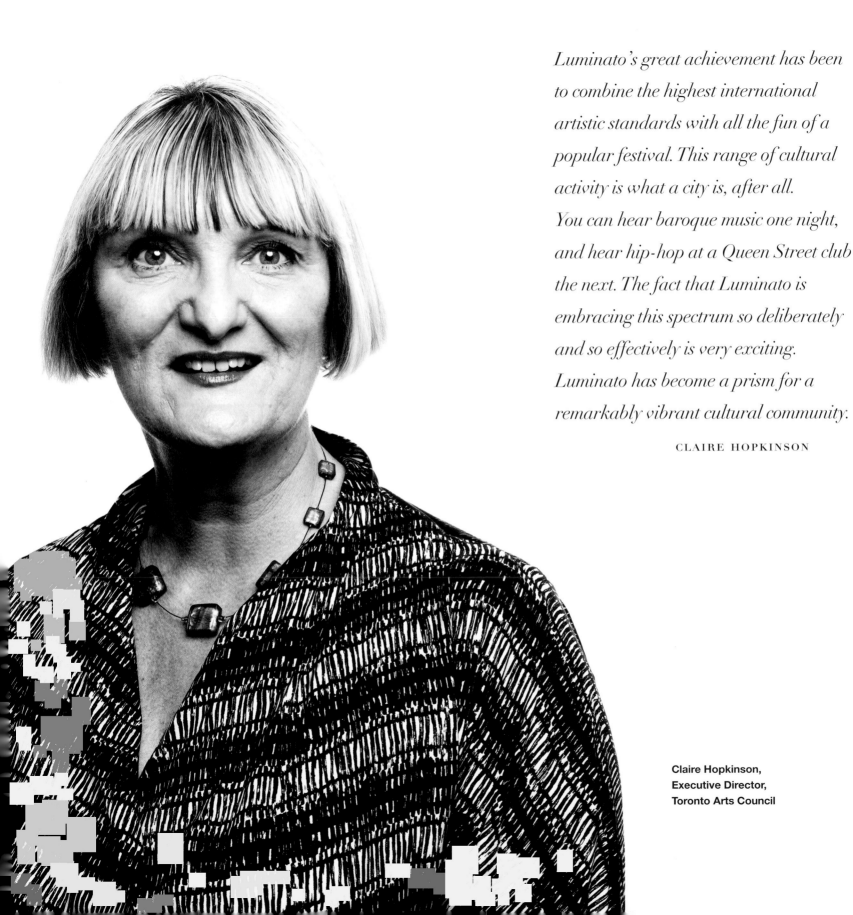

Luminato's great achievement has been to combine the highest international artistic standards with all the fun of a popular festival. This range of cultural activity is what a city is, after all.
You can hear baroque music one night, and hear hip-hop at a Queen Street club the next. The fact that Luminato is embracing this spectrum so deliberately and so effectively is very exciting.
Luminato has become a prism for a remarkably vibrant cultural community.

CLAIRE HOPKINSON

101

**Claire Hopkinson,
Executive Director,
Toronto Arts Council**

I spend an average of ten or fifteen hours a week in meetings with artists, talking with them about the projects they are working on and what's on their minds. In some ways I'm an aggregator, because I get to see what everyone is up to, I get to see connections when they first begin to appear. These connections help keep us pointed in new directions, and our success always depends on how willing we are to take risks. . . . When we've done our job, people are seeing something in their city that they've never seen before.

CHRIS LORWAY

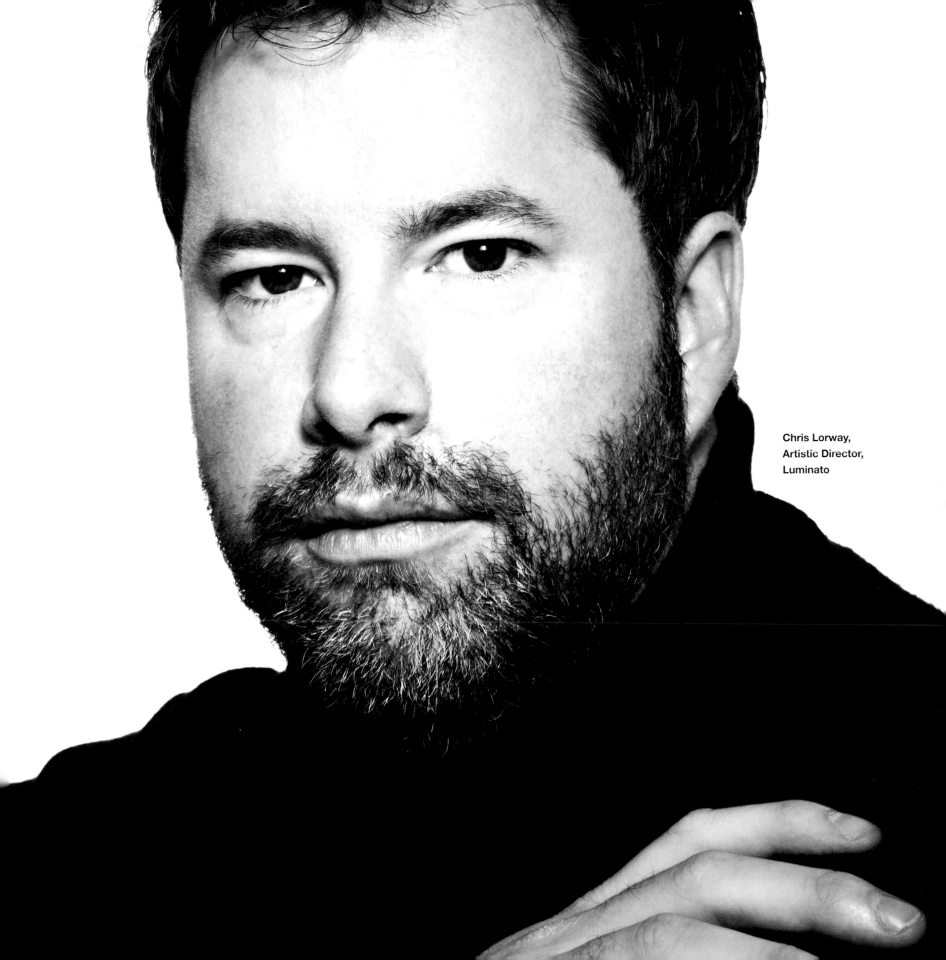

Chris Lorway,
Artistic Director,
Luminato

Luminato, through their co-commission with The Banff Centre, assisted in bringing Tono *to international stages and indigenous programming to the world.* Tono *has been performed at Beijing Cultural Olympiad, Meet-In-Beijing Festival, International Arts and Culture Festival in Inner Mongolia, The Banff Centre, 2010 Cultural Olympiad in Vancouver, High Performance Rodeo in Calgary, World Expo in Shanghai, Arden Theatre in Alberta, Place des Arts in Montreal, and the Yukon Arts Centre.*

SANDRA LARONDE

Sandra Laronde,
Artistic Director,
Red Sky Performance,
Tono, Luminato 2009

The mission, as we began to articulate it in the early days, was that Luminato should shine a light on Toronto's arts, without creating a competitive machine that would hurt local arts organizations. We felt it was important to make it clear that Toronto has an arts scene that is at least the equal of what is going on internationally. But it was also important to expose Toronto to the best of what's being done in the world. We hoped that these two principles could find a common ground in an arts festival and that lots of cross-fertilization would be the result.

KEVIN GARLAND

Kevin Garland, Executive Director, The National Ballet of Canada; Founding Luminary; member, Luminato Festival Advisory Committee

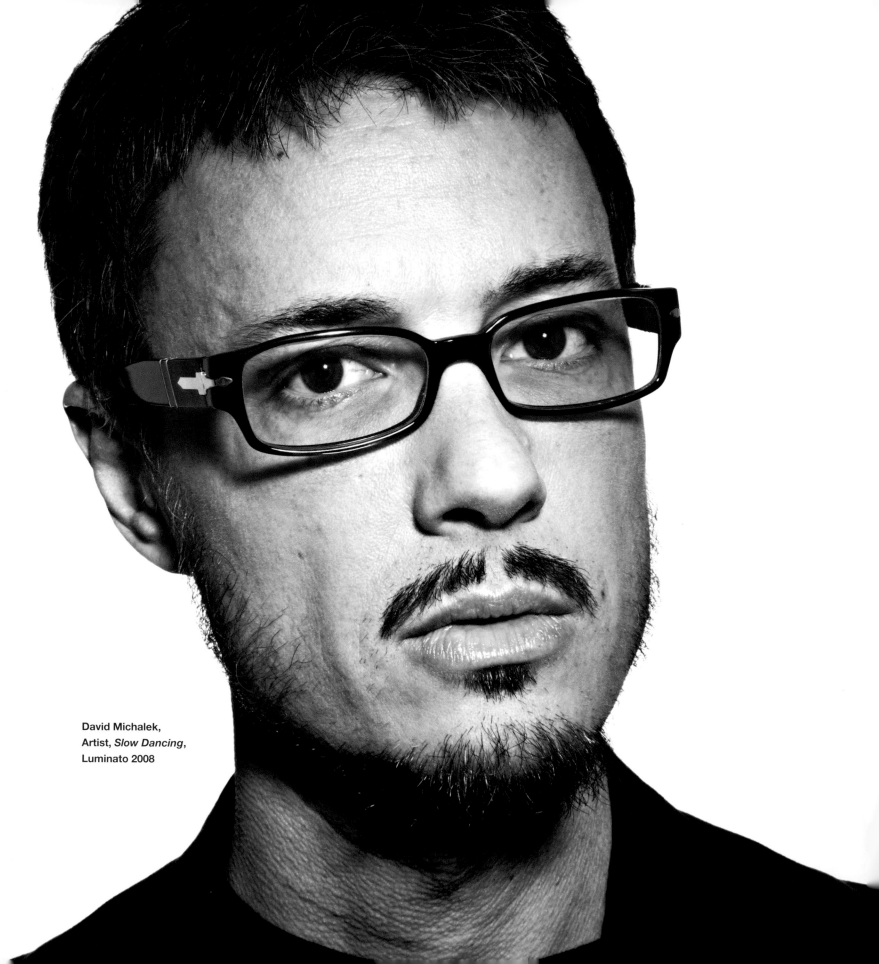

David Michalek,
Artist, *Slow Dancing*,
Luminato 2008

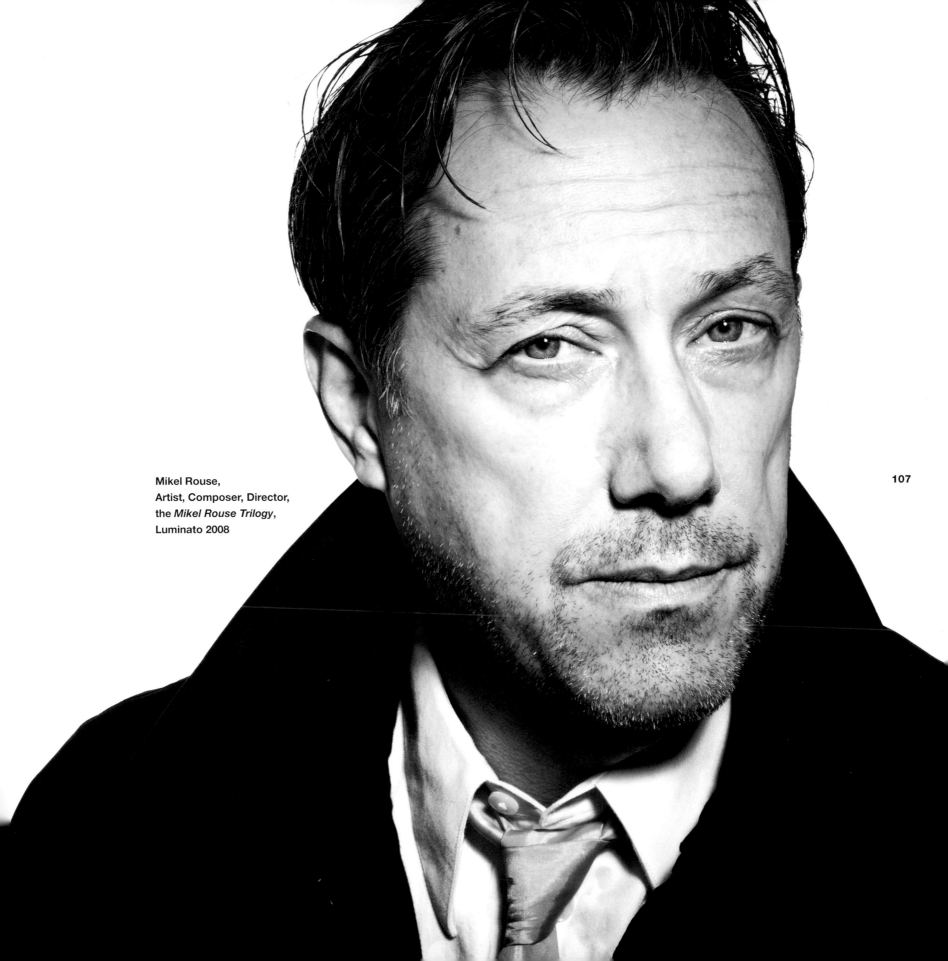

Mikel Rouse,
Artist, Composer, Director,
the *Mikel Rouse Trilogy*,
Luminato 2008

107

David knew that the most exciting things do happen quickly. He knew that people get caught up in that excitement and that they would see big results in a short period of time. There were some people who thought that David and Tony were naïve about what it took to put on an arts festival, but those critics underestimated how motivated and driven the two of them were. So their "naivety" helped—a lot.

JULIA DEANS

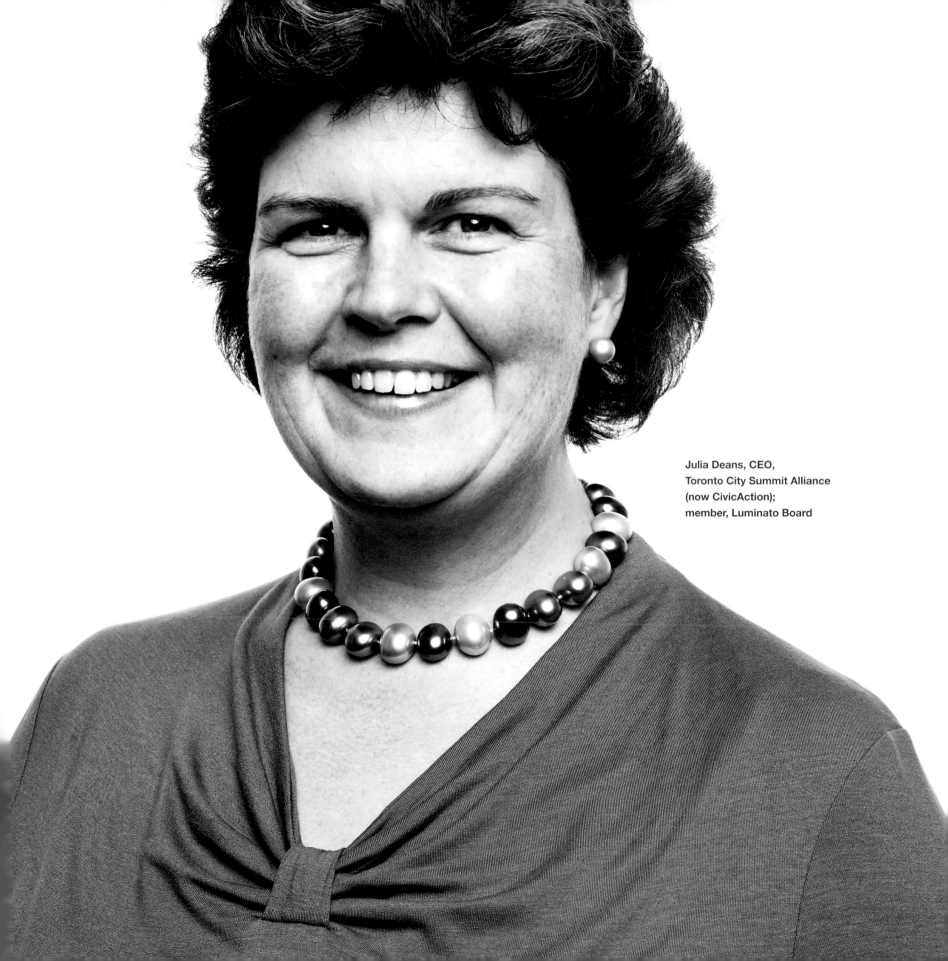

Julia Deans, CEO,
Toronto City Summit Alliance
(now CivicAction);
member, Luminato Board

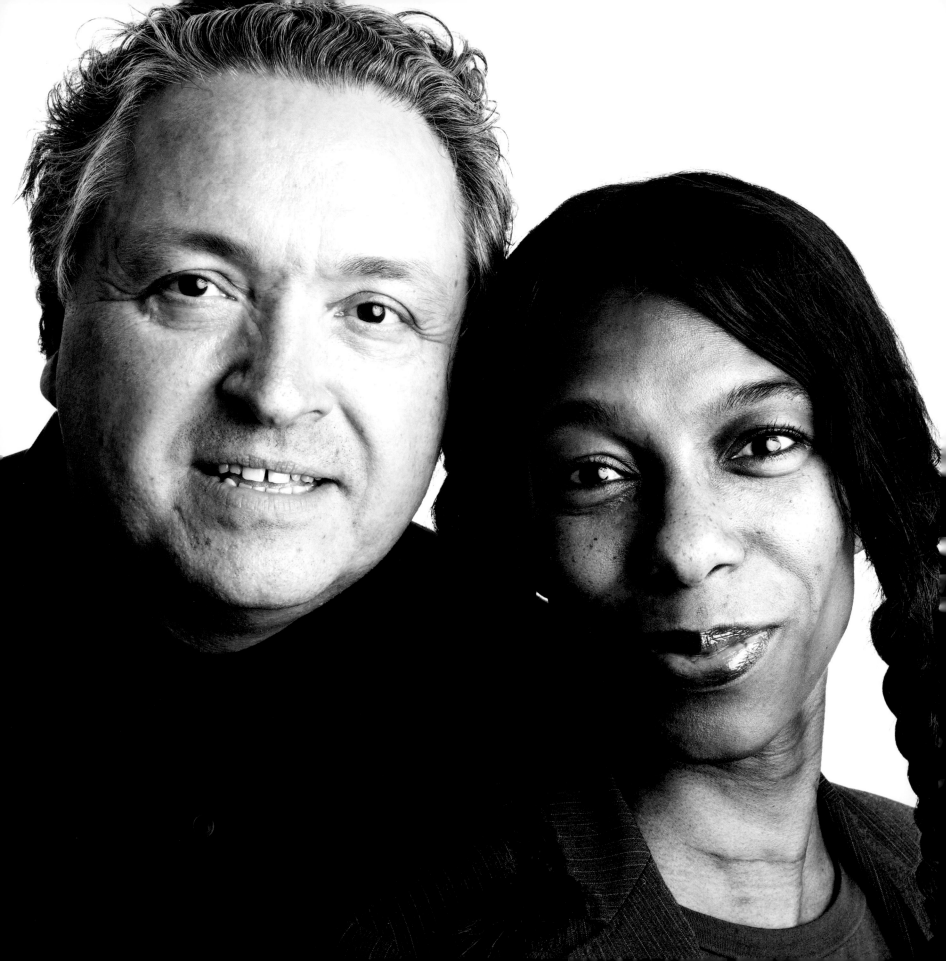

One of the master strokes of the process that created Luminato was Tony and David's bringing together people who were essentially competitors with one another in order to convince them that together they could create more pie — not divide up the existing pie into smaller pieces. And the reason this strategy worked was because their motivation came from the best possible place. It was always all about giving to the city.

BRUCE MAU

Bruce Mau,
Chief Creative Officer,
Bruce Mau Design;
Bisi Williams, member,
Luminato board

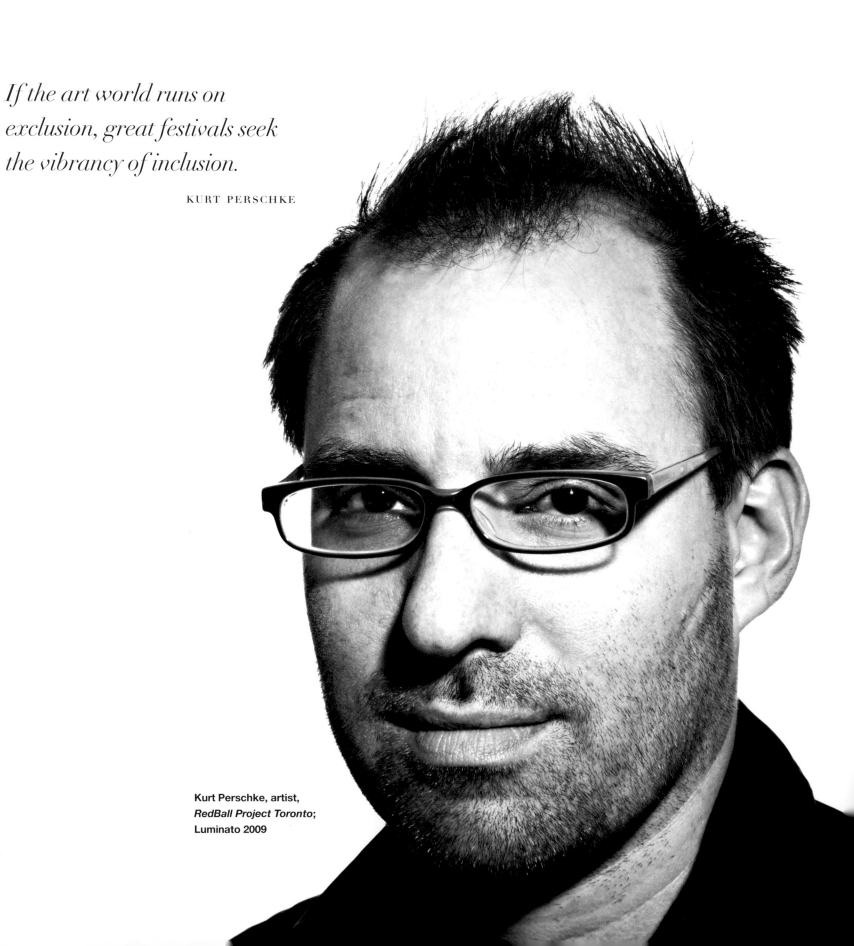

*If the art world runs on
exclusion, great festivals seek
the vibrancy of inclusion.*

Kurt Perschke, artist,
RedBall Project Toronto;
Luminato 2009

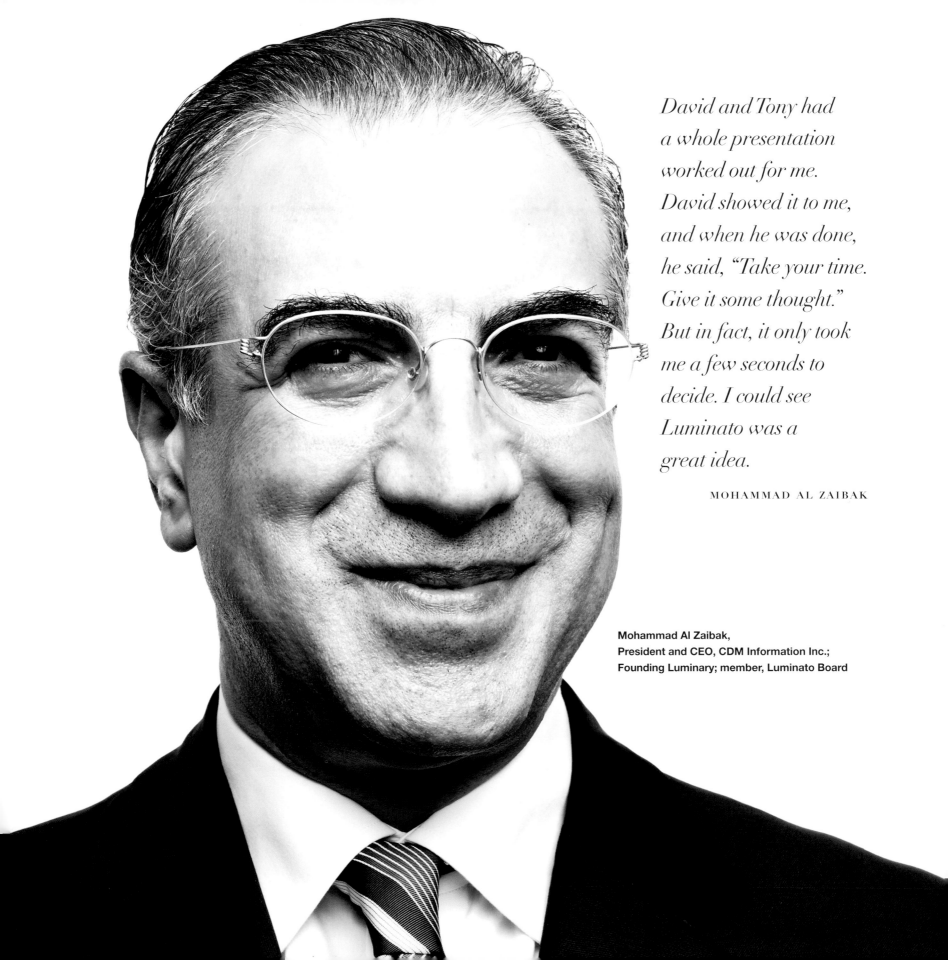

David and Tony had a whole presentation worked out for me. David showed it to me, and when he was done, he said, "Take your time. Give it some thought." But in fact, it only took me a few seconds to decide. I could see Luminato was a great idea.

MOHAMMAD AL ZAIBAK

**Mohammad Al Zaibak,
President and CEO, CDM Information Inc.;
Founding Luminary; member, Luminato Board**

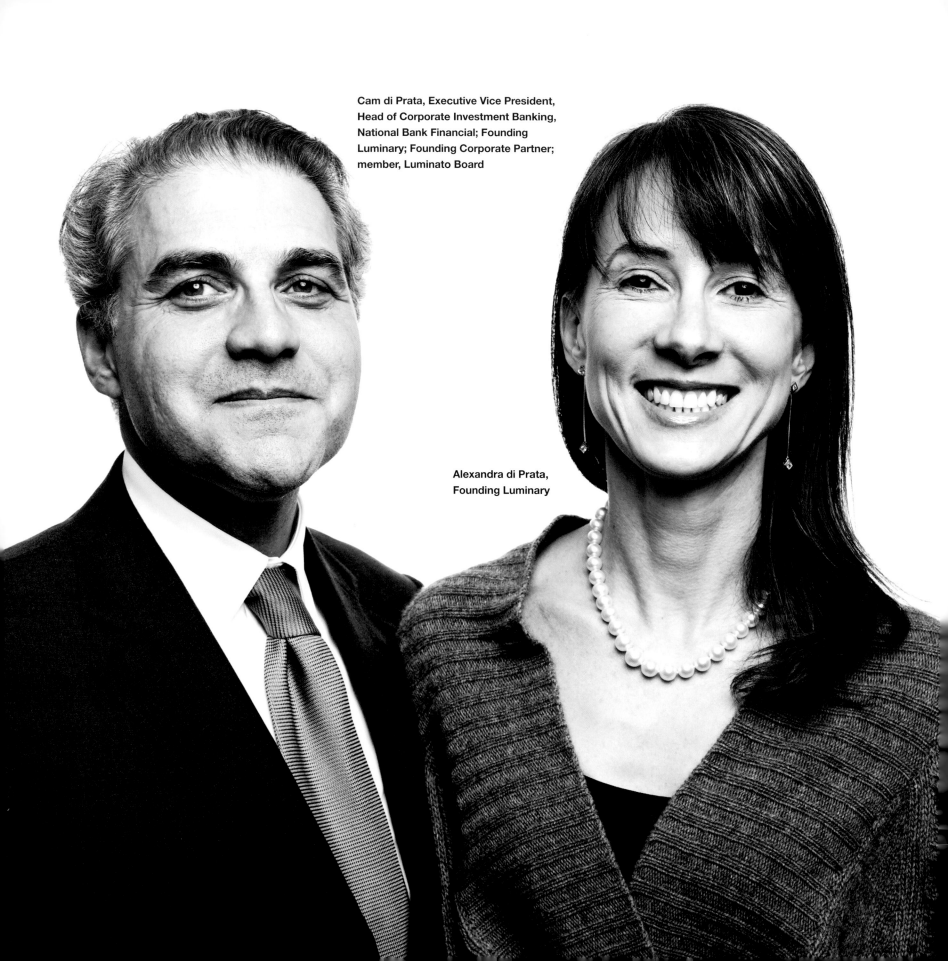

Cam di Prata, Executive Vice President, Head of Corporate Investment Banking, National Bank Financial; Founding Luminary; Founding Corporate Partner; member, Luminato Board

Alexandra di Prata, Founding Luminary

115

Susan McArthur,
Managing Director,
Jacob Securities Inc.;
member, Luminato Board

116

Luminato is a multi-disciplinary festival with fare that is overwhelmingly ticket-free. It takes aim at the grand diversity which is our region and beyond. The best is yet to come.

ROBERTO MARTELLA

Roberto Martella,
owner, Grano restaurant;
member, Luminato Board

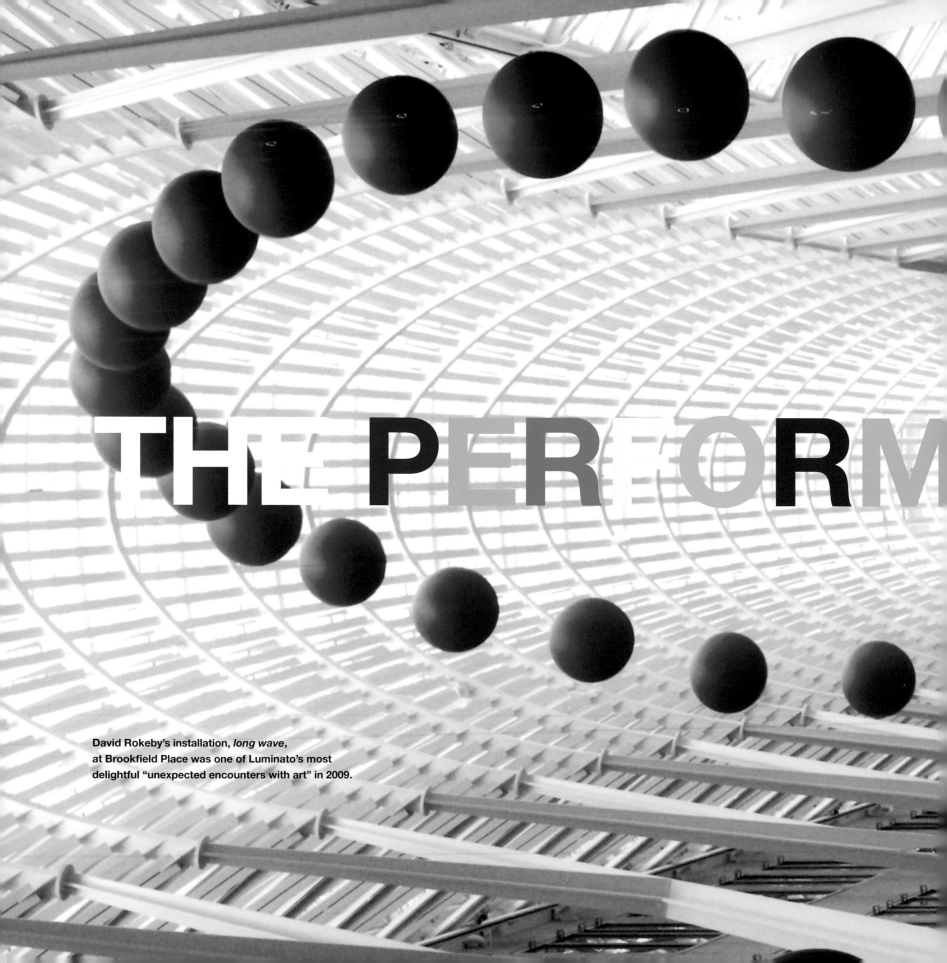

THE PERFORM

David Rokeby's installation, *long wave*,
at Brookfield Place was one of Luminato's most
delightful "unexpected encounters with art" in 2009.

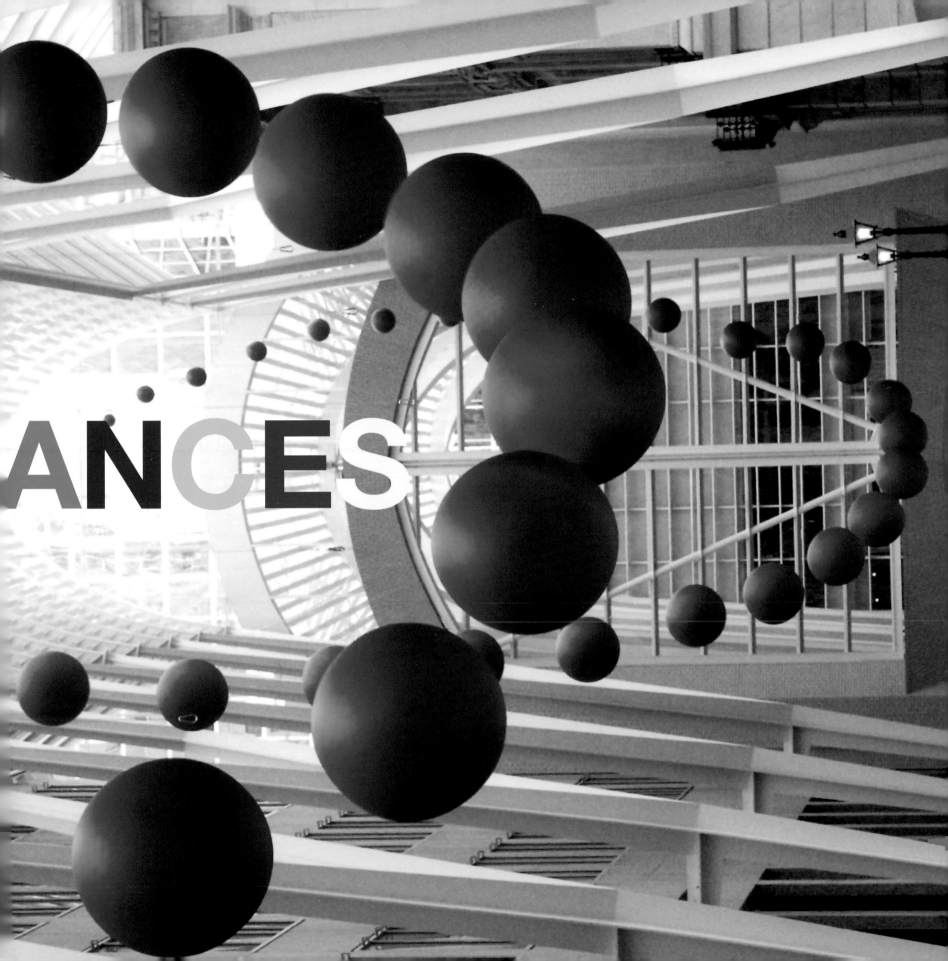

ANCES

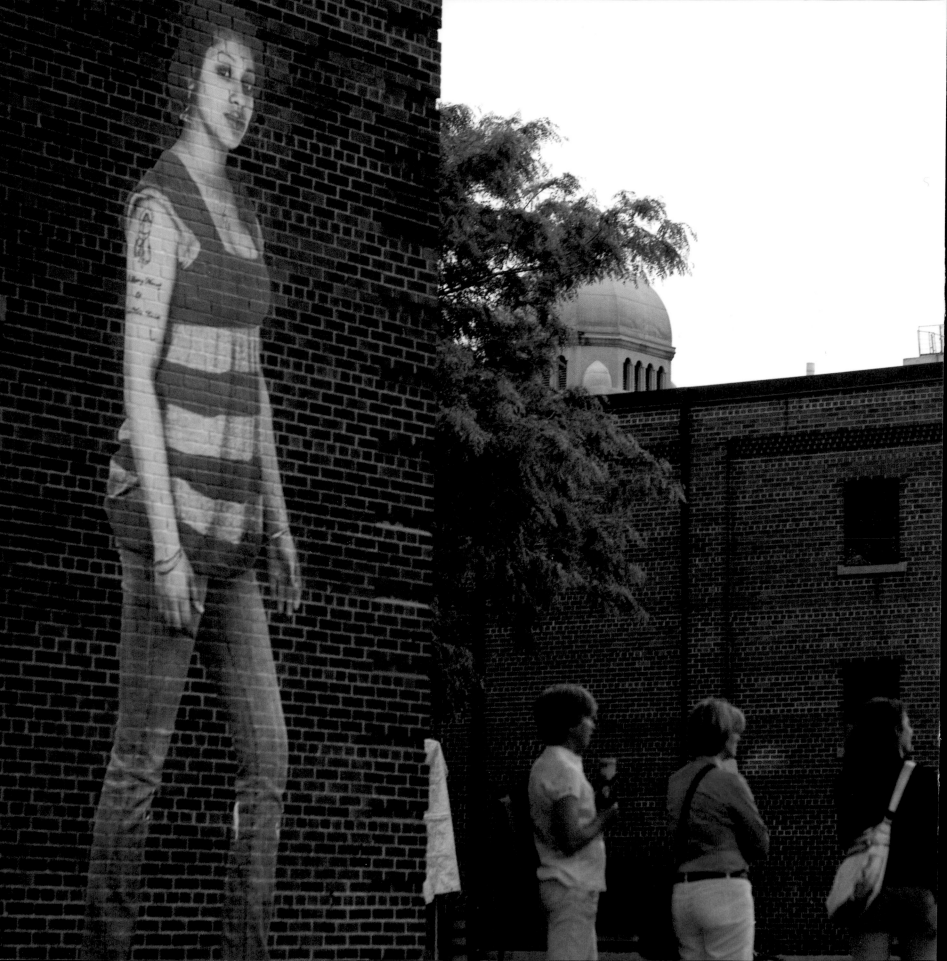

Collaboration, diversity, and accessibility—these three touchstones have been intrinsic to Luminato from its inaugural season. "For us," says artistic director Chris Lorway, "it's about excellence. It's about presenting local and international work that would not otherwise be seen. And it's about being able to collaborate on new commissions and reach as wide an audience as possible."

StreetScape: In Dan Bergeron's *Regent Park Portraits*, larger-than-life images of student participants in Luminato's education and outreach programs were pasted onto soon to be demolished buildings. Conceived in association with Bruce Ferguson and the AGO; created and produced with assistance by Manifesto.

When Janice Price accepted the invitation to come to Toronto on the Victoria Day weekend in May 2006, she did so with no expectation of taking a new job. For one thing, she was quite happy working in the United States. She was President and CEO of the Kimmel Center for the Performing Arts in Philadelphia and had been Vice President of Communications and Marketing and Interim Executive Director at New York's Lincoln Center for the Performing Arts. And for another thing, there was the Canadian spring.

"The magnolias were out in Philly," she recalls, "and it was cold and wet in Toronto." In the taxi from the airport, on the way to David Pecaut's home, she found herself staring at the grey city where she had grown up, remembering the Victoria Day weekends of her Ontario childhood. "Standing in my Scottish grandfather's back garden in my winter coat with a lit sparkler. In my mittened hand. In the snow."

Long before she was invited to Toronto to meet with the founding co-chairs and the founding executive director of Luminato, Price was rumoured to be the leading candidate for the job of heading up the new festival—most persistently by the *Toronto Star*'s Martin Knelman. A long-established, well-connected arts reporter, Knelman could see the potential for Toronto of an annual multi-arts festival, and his professional curiosity kept him well ahead of the rest of the city's press during the Festival's development. Indeed, on more than one occasion, a Luminato announcement had to be moved forward because Knelman was going to break the story.

In the unpredictable world of arts and arts administration—where nutty schemes were . . . often hard to distinguish from strokes of genius— Sills' counsel to Price was: "Always take the meeting."

The Canadian Songbook: 40 Years of Bruce Cockburn; one of Canada's most celebrated singer/ songwriters, Cockburn, along with some of the country's best performers, took part in the 2010 celebration of his career; Massey Hall.

Before any of his colleagues had even contemplated a list of candidates, Knelman was reasonably sure Price's name would be on it. As a Canadian who had been living and working in the United States since 1996, she had the right combination of an outsider's and an insider's perspective for the position. She had worked as an arts administrator in Toronto and in Stratford, but her more-recent years in New York and Philadelphia meant that she did not carry with her any possible perception of bias as a result of a recent working relationship with an existing Toronto cultural institution. At the same time, she understood the chemistry of the city's cultural community and knew its players.

As a further advantage, Price's experience had provided her with an impressive Rolodex—one that included Canadians, whom she drew on for her first key appointments: Chris Lorway, the Nova Scotia–born artistic director whom Price would bring back to Canada to oversee Luminato's programming, had been working in New York for nine years. Clyde Wagner, her appointed general manager, had been working in the United States for ten years. Trish McGrath a former DeVos Arts Management Fellow at the John F. Kennedy Center for the Performing Arts—would become Luminato's founding director of development.

But in May 2006, Price was a long way from dreaming of signing herself on, let alone anyone else. In fact, her reasoning in coming to Toronto was based solely on advice she'd once been given by her mentor and Lincoln Center board chairman, the celebrated soprano Beverly Sills. In the unpredictable world of the arts and arts administration—where nutty schemes were, in their early stages, often hard to distinguish from strokes of genius—Sills' counsel to Price was: "Always take the meeting."

"You never know," Price says, "and anyway, what was the worst that could happen? Either they'd learn something or I'd learn something."

Slow Dancing;
**hyper–slow motion
video portraits;
David Michalek; 2008;
University of Toronto.**

She expected to find three wide-eyed amateurs wait-ing for her at the address in Rosedale to which her cab was headed. She thought Pecaut, Gagliano, and Joseph would be "nice, well-meaning people who had no idea what they were talking about and what it was going to take to make this happen." Her guess was that she would listen to their plans, offer them some advice, graciously decline any invitation to become more involved, and be on a flight back to Philadelphia's blooming magnolias as soon as possible. But there was one thought that kept bubbling through her prudence—a thought that now, with hindsight, she can see as evidence that she was not quite as indifferent to the project as she thought she was. "Part of me was thinking: 'you mean, Toronto doesn't have an annual, multi-arts festival yet?' I'd been away for a while, but I knew what was going on with the city's cultural ren-aissance. And I was thinking: well, if it doesn't, it should."

Three and a half hours after she stepped through the front door of Helen Burstyn's and David Pecaut's home, the meeting ended—although "ended" is not precisely accurate. If the first part of the meeting had been cau-tious, its last two hours were anything but. By then, there was nothing stand-offish about Price's partici-pation. Pecaut, Gagliano, and Joseph rolled out their research, their plans, and their ambitions, and Price found herself caught up in their enthusiasm. She finally broke the meeting off only because she was in danger of miss-ing her flight. She remembers "the cab pulling out of the driveway with my window down because David Pecaut was still talking to me." Price had found not the wide-eyed naifs that she had expected, but three people who had done "more feasibility study, more thoughtful planning, and more considered strategizing than I've ever seen in an arts project, before or since."

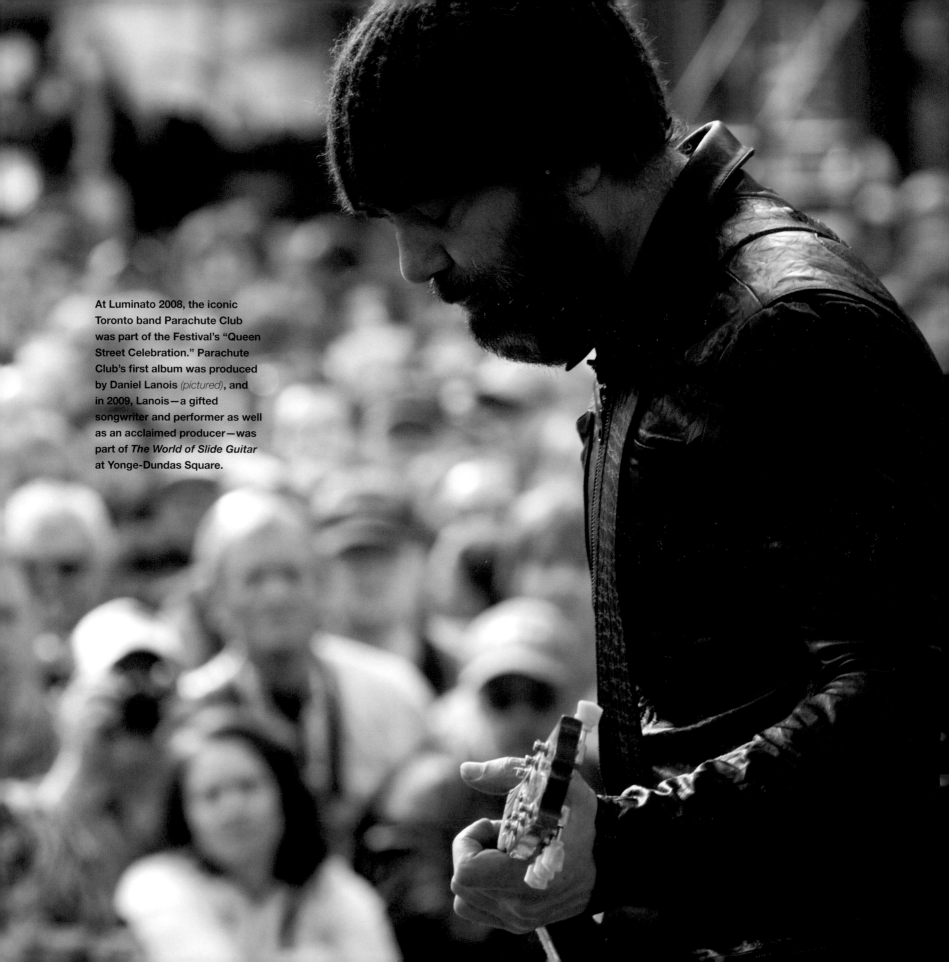

At Luminato 2008, the iconic Toronto band Parachute Club was part of the Festival's "Queen Street Celebration." Parachute Club's first album was produced by Daniel Lanois *(pictured)*, and in 2009, Lanois—a gifted songwriter and performer as well as an acclaimed producer—was part of *The World of Slide Guitar* at Yonge-Dundas Square.

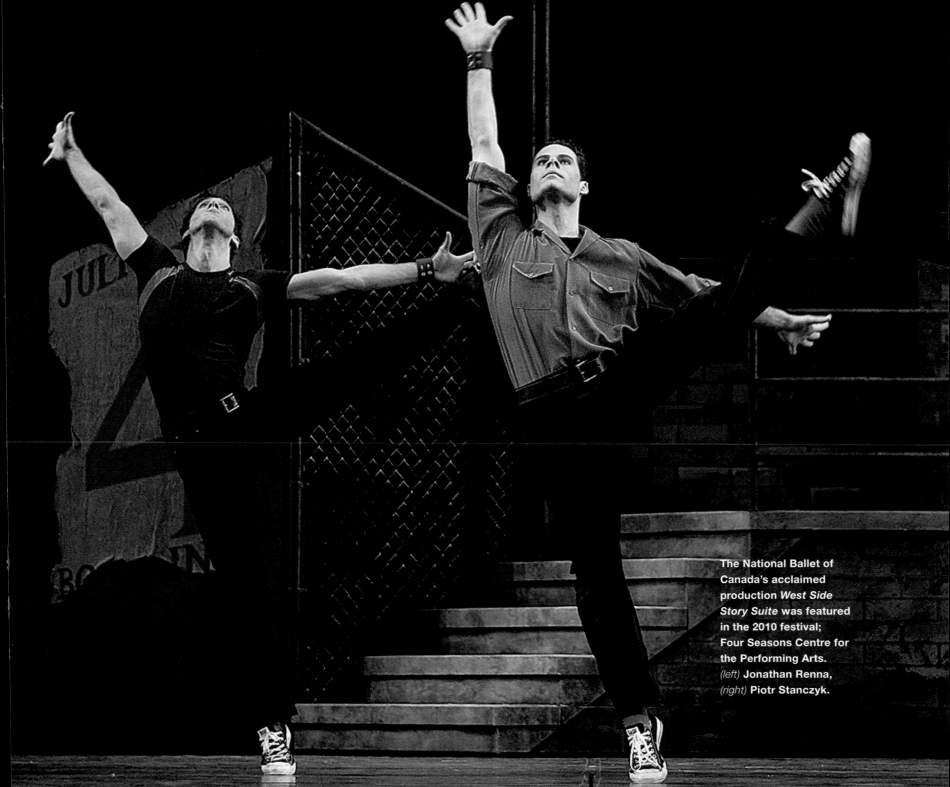

The National Ballet of Canada's acclaimed production *West Side Story Suite* was featured in the 2010 festival; Four Seasons Centre for the Performing Arts. *(left)* Jonathan Renna, *(right)* Piotr Stanczyk.

Two days later, back in her Philadelphia condominium, Price telephoned a friend in Manhattan. The idea of "a performing arts centre without walls" was something Price had been thinking of for a while—and her meeting in Toronto had brought this intriguing idea to the fore again. But her tone of voice during her phone conversation was almost plaintive. She was well aware of the challenges that so vast and blank a canvas presented. The Festival had no staff, no office—"no anything." And just because she was "a sucker for a big idea," she knew how difficult it would be to put together a team of energetic and experienced people who were willing to devote themselves to what still remained mostly an idea. The proposed opening was scarcely a year away.

She was happy with her life in the U.S. Her job in Philadelphia was satisfying and well-paid. She liked pleasantly snowless, early springs. "Damn it," she said to her New York friend, "I think I'm interested in this job in Toronto. I was really hoping I wasn't going to fall in love on this blind date. But I did."

The role of an arts administrator is rarely a calm occupation. The environment is inherently unpredictable, and because the outcome depends so greatly on a combination of quixotic elements such as inspiration, creativity, and imagination, an arts administrator has to be more flexible and resilient than managers of more buttoned-down businesses and more easily quantified industries. This is particularly true of a festival that defines itself not as a passive, cheque-issuing importer of product, but as an active creative partner—an organization that sees its mandate in large part as taking a proactive role in the conception and development of new work. Sometimes that role begins at the very earliest stages of a work's creation: *The Africa Trilogy*, *The Children's Crusade*, *A Poe Cabaret: A Dream Within a Dream*, and *One*

126

Thousand and One Nights are all examples of the developmental partnerships Luminato sees as one of its most important objectives. And sometimes that role is finding the right early moment to intervene—Chris Lorway, Clyde Wagner, and the co-commissioning partner, Sadler's Wells, worked with Tim Albery to restage Rufus Wainwright's opera *Prima Donna* after its premiere in Manchester. Arts administration is an occupation that comes with its share of sleepless nights.

"This isn't for the faint of heart," Price says. "It's very hard work, but the thing is, the moment the curtain goes up, it has to look as if it was all effortless. The audience has to think that the dream they are seeing has never been anything but polished, and beautiful, and perfect. All the grunt work that both the artists and our Luminato team have accomplished—all the late nights, all the budgets and schedules and planning meetings, all the last minute glitches and unpredictable crises—they all have to—poof—evaporate. People have to think it's just . . . well, magic."

Norman; Lemieux Pilon 4D Art; Michel Lemieux, Victor Pilon, and Peter Trosztmer; 2007; St. Lawrence Centre for the Arts. A multimedia, one-man show depicting the life and times of National Film Board filmmaker Norman McLaren.

It's easy for the audiences—the almost 5 million people who, in the Festival's first four years, enjoyed theatre, dance, classical and contemporary music, film, literature, fashion, and visual arts—to imagine Luminato as a kind of inevitability. Rafael Lozano-Hemmer's iconic *Pulse Front*, curated by the Power Plant and co-produced with Harbourfront Centre; the National Theatre of Scotland's *Black Watch*, and the Dash Arts Production of a multi-lingual *A Midsummer Night's Dream*; Robert Lepage's nine-hour-long multimedia epic, *Lipsynch*; and R. Murray Schafer's *The Children's Crusade* seem as if they were always meant to be. But that's far from Janice Price's perspective. She well remembers when the canvas of festivals to come looked very blank indeed.

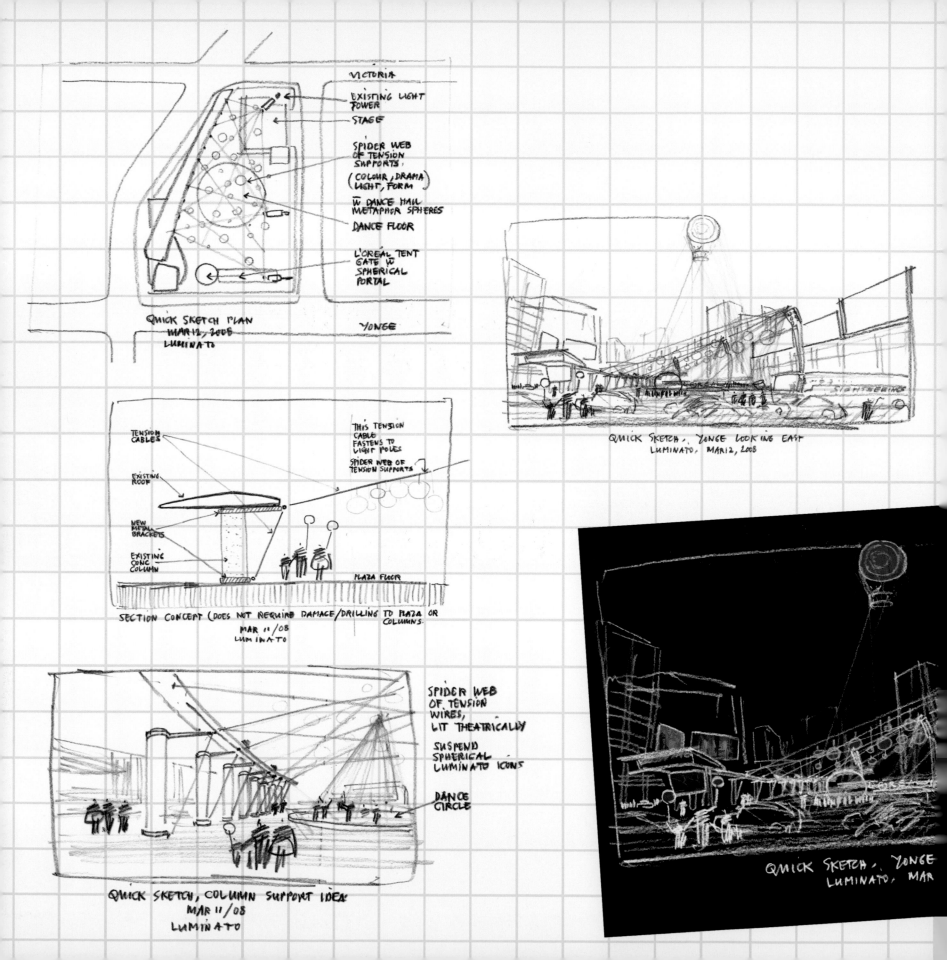

VICTORIA

EXISTING LIGHT TOWER

STAGE

SPIDER WEB OF TENSION SUPPORTS
(COLOUR, DRAMA)
LIGHT, FORM
w̄ DANCE HALL METAPHOR SPHERES

DANCE FLOOR

L'ORÉAL TENT GATE w̄ SPHERICAL PORTAL

QUICK SKETCH PLAN
MAR 12, 2008
LUMINATO

YONGE

QUICK SKETCH, YONGE LOOKING EAST
LUMINATO, MAR 12, 2008

TENSION CABLES

THIS TENSION CABLE FASTENS TO LIGHT POLES

SPIDER WEB OF TENSION SUPPORTS

EXISTING ROOF

NEW METAL BRACKETS

EXISTING CONC COLUMN

PLAZA FLOOR

SECTION CONCEPT (DOES NOT REQUIRE DAMAGE/DRILLING TO PLAZA OR COLUMNS)
MAR 11/08
LUMINATO

SPIDER WEB OF TENSION WIRES, LIT THEATRICALLY

SUSPEND SPHERICAL LUMINATO ICONS

DANCE CIRCLE

QUICK SKETCH, COLUMN SUPPORT IDEA
MAR 11/08
LUMINATO

QUICK SKETCH, YONGE
LUMINATO, MAR

For Luminato 2008, architects Thomas Payne and Bruce Kuwabara joined forces with the internationally acclaimed set designer Michael Levine to transform Yonge-Dundas Square. "Luminato can create communal experiences in a city, a kind of outdoor living room, by defining familiar spaces in a new way," says Kuwabara.

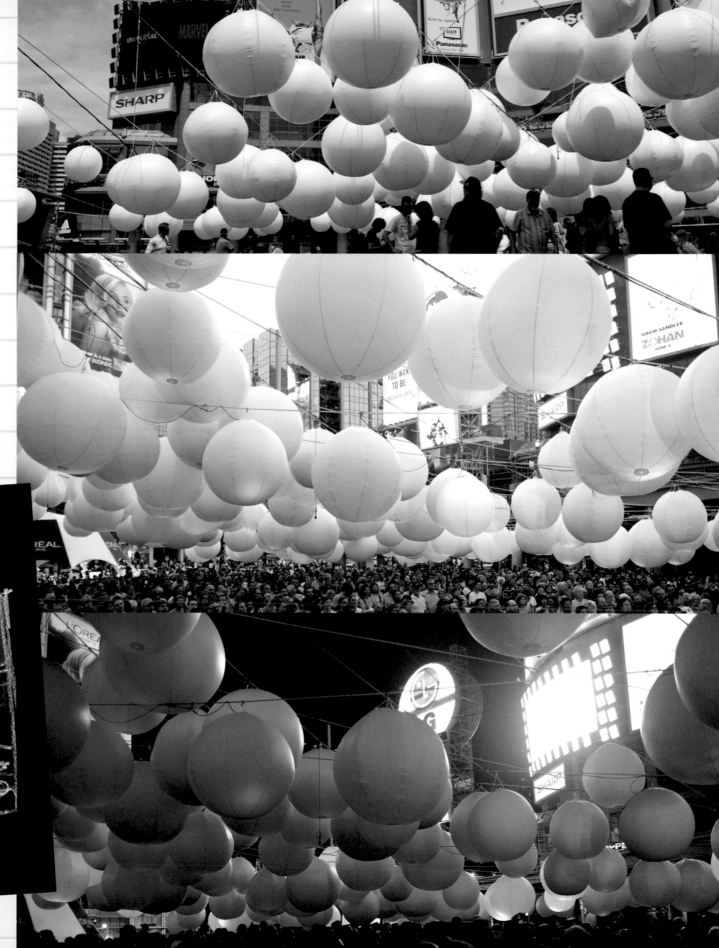

On July 1, 2006, Price met with Lucille Joseph and Sarah Simpson in the lobby of the Hudson Hotel in New York City. Price remembers that Joseph brought with her four bindersful of the work the founders had already done, plus the news that, as Joseph says, "I had booked every theatre in Toronto" for the projected ten days of the festival in June 2007. "We had done a lot of work," says Joseph with a chuckle, "but what I didn't know was how to actually produce an arts festival. It was a small gap in my background."

Price knew she had a formidable ally in Joseph. "All the same," Price recalls, "I could see these really practical operational questions—staff, offices, budget, fundraising, ticketing, scheduling—coming at me like a huge wave. There were times during the rest of that year when I'd wake up in cold sweats, thinking 'how are we going to pull this off?'"

At its core, the role of an arts administrator is to articulate the mandate of an arts institution and then to bring together the people—the programmers, producers, directors, managers, financial officers, marketers, education and outreach coordinators, publicists, volunteers, and community liaison officers—who would most effectively fulfill that mandate. Price knew that building the Luminato team had to be her first priority. "We needed to find people who were willing to take a risk," she says. "In a funny way, that became one of the key ways we measured people's suitability for the various positions we needed to fill. We talked to lots of people who had all kinds of qualifications, but who weren't really prepared to make a leap of faith. And then it didn't matter what their resume was like. If they weren't willing to join with us in imagining what the Festival could be—as opposed to being shown what it was—we decided they weren't right for Luminato."

Our volunteers are our ambassadors. They are in many respects the first faces of Luminato the public meets. Their role is very important and their contribution to each season is always highly valued.

<div align="right">

JANICE PRICE

</div>

As Price put together her team, she made sure that the overall festival became everyone's business. She believed in keeping all members of her staff on the same page. She liked to create an organizational structure in which programmers felt comfortable weighing in on matters of marketing or sponsorships, and where marketers and general managers were not shy in offering comments on programming.

This was not always painless. "Every now and then," comments Chris Lorway, "we have to chase one another back into our respective corners." But Price believed that so long as the goal was clear to every member of her team, the difficult process of being what she called "an arts enabler" was best undertaken in a spirit of collaboration. It was the kind of approach that she would come to call "very Luminato."

Running a festival, in Price's description, "is like playing chess in 3-D. So if we can leverage our parts into a more creative whole, I'm all for it. With the arts there is always, always an element of risk. That's why they can be so exciting. But you have to have the right team. Because it's never easy. Art never is—not for the artist and not for those of us who are working toward bringing what artists create to an audience. But that's why when it works, it's so glorious."

Price makes it her business to recruit staff, create clear lines of reporting and responsibility, establish benchmarks, and articulate goals with the rigor and expectations of any corporate executive. Her reports to her boards and her senior staff attend closely to programming—in the end, she says, everything depends on content—but she is no less focused in her attention to attendance, marketing and demographics, sponsorships, media relations, revenue sources, and strategic planning. Luminato's education and outreach programs are extremely important to her, but then, there isn't very much that isn't. Joe Hall, a Luminato volunteer since the first season, says: "Janice makes the volunteers feel that they are an essential part of the operation."

SURPRISED BY ART

Robert VanderBerg, associate producer, visual arts and public installations, gives a short answer when asked about Luminato's visual arts program. "Your path to work will be interrupted." Certainly, anyone walking to work through Trinity-Bellwoods Park during Luminato 2010 would have been surprised to find a thirty-foot Chinese junk—Janet Cardiff's and George Bures Miller's installation, *Ship O' Fools*—suddenly part of Toronto's scenery.

VanderBerg's not-quite-so short answer is, "you will see art in places you never thought you'd see it. Luminato's visual arts program is committed to going beyond gallery walls and finding ways to place art in public spaces. We want to offer artists—both emerging and established—new opportunities to exhibit, to get them thinking about how to engage with the city and to push their work beyond the confines of traditional exhibit space."

From its first year, Luminato has made the visual arts central to the festival experience. Lozano-Hemmer's interactive light sculpture *Pulse Front*, Max Streiger's *QUADRIGA*, along with a variety of other works exhibited at various sites in the downtown core, established free, unexpected encounters with art as a Luminato signature. "Art in public spaces," says Alexander Neef, the General Director of the Canadian Opera Company, "is the most amazing thing about Luminato."

David Michalek's *Slow Dancing*, the multimedia *StreetScape*, conceived in association with Bruce Ferguson on behalf of the Art Gallery of Ontario, and Pierre Maraval's *Mille Femmes*, portraits of 1,000 creative and inspiring women of Toronto, produced in partnership with Lancôme and exhibited at Brookfield Place, delighted Torontonians. "It's about appropriating spaces," says Atom Egoyan, whose video work *Auroras*, shown together with Kutlug Ataman's *Testimony*, transformed a Distillery District space in Luminato 2007. "In a city such as Toronto, this is a kind of magical act."

Then, after stops in Chicago and Barcelona, came Kurt Perschke's *RedBall Project Toronto* in 2009. "The ball creates permission to play," explains the artist. Toronto's citizens happily took up his offer and hundreds photographed themselves with *RedBall*, which reappeared in a surprising new location each day. David Rokeby's *long wave* fascinated passersby in Brookfield Place. "My young daughter started skipping when she first saw it," Rokeby recalls. "And that was a good sign. And I think a lot of people got the same kind of giddy joy from it that she did."

Rafael Lozano-Hemmer's interactive light installation *Homographies, Subsculpture 7* (2007; Toronto-Dominion Centre) was purchased by Founding Luminary Jim Fleck and donated to the AGO.

Public spaces are being transformed with new art installations that must be in place before morning rush hour. The Festival's staff has to work "like the shoemaker's elves, finishing our work just as the sun is coming up and the commuters are beginning to stream in."

Throughout her career she has surrounded herself with people who are energetic and devoted. Her staffs tend to be young, dedicated, and capable of "intensely hard work"—which means that she often adds counsellor, coach, and team captain to her job description. Crises inevitably arise, and when they do, it is usually general manager Clyde Wagner who is the designated troubleshooter. Mounting art in public spaces is an often-complicated business. R. Murray Schafer's *The Children's Crusade*, directed by Tim Albery, was almost closed down at the eleventh hour because city inspectors deemed the warehouse in which it was being performed unsuitable for public occupancy; an enraged local restaurateur threatened to call the police when he found his lane access blocked (temporarily) by Kurt Perschke's *RedBall Project Toronto*; getting Janet Cardiff's and George Bures Miller's Chinese junk through downtown traffic for its installation in Trinity Bellwoods Park, required all of Wagner's logistical prowess.

When the inevitable crises do occur, Price needs troops who can rally with imagination and determination. In the weeks before each festival, the Luminato offices take on the busy, intensely preoccupied air of a college dorm at exam time. And on the night before Luminato's openings—when, throughout the city, public spaces are being transformed with new art installations (none more striking, perhaps, than that of the collaboration of architects Thomas Payne and Bruce Kuwabara with set designer Michael Levine, to transform Yonge-Dundas Square for Luminato 2008) that must be in place before morning rush hour—the Festival's staff, overseen by a severely sleep-deprived Clyde Wagner, has to work "like the shoemaker's elves, finishing our work just as the sun is coming up and the commuters are beginning to stream in."

These were the kinds of challenges Price knew awaited her as she looked ahead, from the summer of 2006, to the blank slates of the festivals before her. Still, for all her concerns, Price was impressed with the work that had been done before she signed on. She was impressed with the Festival's business plan. She was impressed with the marketing plan, impressed with the strategic plan, impressed with the fact that, thanks to the Province of Ontario, Luminato had $1 million in seed funding. She was impressed with the select group of families, individuals, and companies, known as Founding Luminaries, who not only contributed substantial funding but whose stature in the community, extensive connections, and commitment to Luminato helped to establish the Festival's gravitas.

135

Green Flag Song;
**Joni Mitchell; 2008; CTV
on Queen Street: The
mixed-media canvases
of the popular
singer-songwriter
offered a poetic
discourse on human-
ity's struggle with
itself. In the same
season, Mitchell
collaborated with the
Alberta Ballet to
create *The Fiddle and
The Drum*, produced
in association with
the National Ballet
of Canada.**

Above all, Price was impressed with how thoroughly the Festival was consulting Toronto's arts leaders. It was a process that was part of Luminato's philosophy from the very beginning, undertaken because it seemed only natural to seek the guidance of the community's experienced arts leaders. But the Festival's founders also recognized a second purpose to these consultations: they saw the Festival as both an opportunity and a vehicle for new and innovative collaboration among Toronto's cultural institutions. As a result, the Festival Advisory Committee met regularly at Luminato's invitation, and to a considerable extent, the inaugural festival grew out of these gatherings.

More than a few people describe Luminato's first season as the result of David Pecaut's disarming question to the city's cultural leaders: "Is there something that you've always wanted to do that you have not yet been able to do?" Certainly nobody had ever jumped quite so enthusiastically as David Pecaut when Peter Oundjian, in response to Pecaut's query, had said he and his cousin, Monty Python alumnus Eric Idle, had always wanted "to do something together." The result—*Not the Messiah*—was a hit of Luminato's first season, and a production that, following its Luminato premiere, continued on to worldwide acclaim. "It's probably our biggest hit to date," says Chris Lorway. "It even made it to pay-per-view television."

Quite apart from the benefits to Luminato, the meetings of the Festival Advisory Committee were the first times that the leaders of the city's largest arts institutions had gathered together formally to discuss a creative project, and this in itself was instructive.

At the broadest and most ambitious level, all the city's cultural institutions shared the same objective. As Kevin Garland, the Executive Director of the National Ballet, put it, "the mission for all of us is always to shine a light on the Toronto arts scene—to expose what is being done here." Or, as Claire Hopkinson, Executive Director of the Toronto Arts Council, said, "Everyone was working in their separate spheres, of course, but the common goal of everyone was to make the arts an important component of the city's pride."

David Pecaut, his wife, Helen Burstyn, and daughters, Amy, Becca, and Sarah, at the opening night party, 2009.

On the printed agendas for the Festival Advisory Committee meetings that remain in David Pecaut's files (and that carry the characteristic scrawl of the notes he scribbled on any piece of paper within his reach during a meeting), the names of those in attendance outlined, with only a few notable exceptions, the cultural life of Toronto in the first decade of the twenty-first century: Bill Boyle, Charles Cutts, Atom Egoyan, Kevin Garland, Piers Handling, Karen Kain, Bruce Kuwabara, Bruce Mau, Peter Oundjian, Albert Schultz, Matthew Teitelbaum, William Thorsell. All of the attendees remarked that while they all knew one another, and tried to keep tabs on what each institution was doing from year to year, they had never convened such a meeting before. "Basically," says Piers Handling, the director and CEO of the Toronto International Film Festival, "there was a history of non-collaboration."

These meetings were not always placid. The relationship of Matthew Teitelbaum and Albert Schultz was described by Lucille Joseph as "congenial sparring." Karen Kain's voice was often that of calm, thoughtful reason, and Piers Handling brought the wealth of his long experience with the Toronto International Film Festival to the table. Bruce Mau paced back and forth at the back of the Boston Consulting Group's boardroom. Bruce Kuwabara was passionate about how art in public spaces could transform a city.

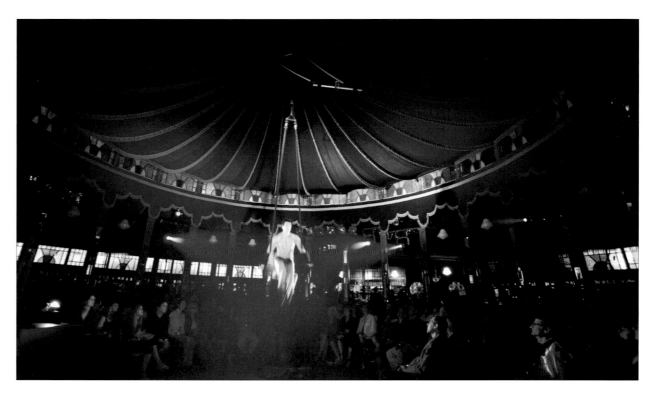

Speigeltent'ntavern;
2007; world premiere;
Harbourfront Centre.

William Boyle, the CEO of Harbourfront, was out-spoken: the proposed festival veered most closely to Harbourfront's cross-discipline, multi-arts approach to its programming, and Boyle's extensive international experi-ence made him well aware that festivals and the artistic communities of the cities that hosted them were not always allies. Boyle—as tough-minded as he is congenial, and the Toronto arts administrator who probably had the most intense discussions with David Pecaut during the Festival's development—was not reticent about express-ing his skepticism that Luminato might be different.

To the founders, a festival offered Toronto's arts institu-tions the opportunity to create new work, to be seen by new audiences, and to gain international exposure through the many foreign journalists, artists, and impresarios a fes-tival would attract.

However, if ever they had imagined smooth sailing with the city's arts institutions, the Festival's founders' illusions were quickly dispelled—and promptly replaced with a new understanding of the community into which they were about to step. Gradually, their view became the realization that tumultuous debates were bound to be part of the ongoing life of something as lively as an arts festival in something as dynamic as a city.

Karen Kain's concerns were not unfounded. The company's move into the Four Seasons Centre for the Performing Arts in the fall of 2006 meant that its first year ever of June programming coincided with the inaugural season of Luminato. Kain worried that the inaugural festi-val's attendant hoopla would distract both audiences and press from her company's exciting start in its beautiful new venue. Kain—an artist herself, a renowned dancer, a pas-sionate believer in the importance of dance, and a fierce champion of her company—worried about the Festival's long-term impact on the National Ballet's audiences.

I always saw the idea of a multi-arts festival as an extraordinary opportunity to showcase emerging talent in Toronto. Even people who regularly attend theatre, or dance, or concerts, are not always aware of just how skilled the new generation of local artists is. We see what we do each year at the Young Centre during Luminato as a chance to show off the future.

ALBERT SCHULTZ
Actor and Founding Artistic Director, Soulpepper Theatre Company;
General Director, Young Centre for the Performing Arts

Luminato, while sensitive to the worries of the arts community, took the position that the National Ballet and Harbourfront Centre offered the potential for exciting synergies—as collaborations such as Rafael Lozano-Hemmer's *Pulse Front* would later prove. To further ease concerns, Luminato incorporated the National Ballet's annual June programming into the Festival lineup, making an exception to the Festival's principle that Luminato programming would consist only of work otherwise not seen in Toronto.

Pecaut had never been much interested in letting disagreement become a barrier. His talent at convening the right people was augmented with a skill at helping them find their common ground—often when none appeared to exist. "He was amazing that way," says film director Atom Egoyan, a member of the Festival Advisory Committee. "Sometimes it was actually humbling to watch him work toward a shared goal that nobody had seen until David exposed it." It was in Pecaut's nature to think of disagreement as something that creative parties would figure out how to get around, and that this cooperation would often produce its own new and unpredicted benefits.

Price was well aware that a big arts festival "plunking itself down" in a community was not always welcomed by existing cultural institutions—and sometimes for good reason. Existing institutions were generally of the view that neither audiences, revenue, nor funding were likely to expand to accommodate a big, brassy newcomer. "Basically," said Kevin Garland, "we are all working with a finite number of people." Arts leaders, toughened by their own long battles for survival, were not shy about expressing their concerns and their fears to anyone who asked. Luminato asked.

However extraordinary the infusion of infrastructure funding had been, there wasn't much security in the boardrooms and offices of Toronto's leading cultural institutions in the mid-point of the first decade of the twenty-first century. Cutbacks, layoffs, and cancelled projects were not things of the distant past. "The precarious nature of the Mike Harris years still persisted," explained Claire Hopkinson of the Toronto Arts Council. "People have to understand that we all felt as if the rug could be pulled out from under our feet at any time."

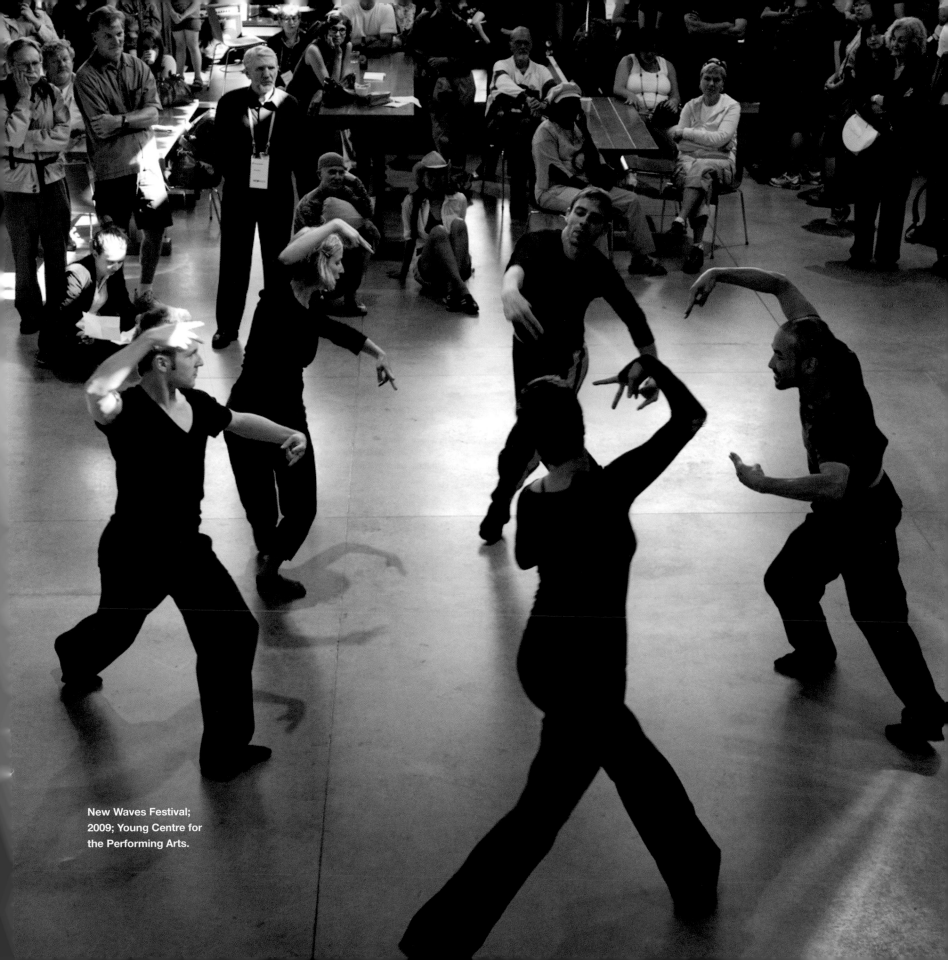

New Waves Festival;
2009; Young Centre for
the Performing Arts.

ON WHICH THEY SERVE: THE LUMINATO BOARD

Volunteers are the best paid people in the world. Whether their contributions are modest or grand, crucial or incidental, they are able to participate in the soul-expanding work of building human community. They help create the essential connecting tissues that link up our private worlds and our generations— the glue that holds us all together.

THE HONOURABLE DAVID CROMBIE, MAYOR OF TORONTO, 1972–1978

The appointment of Janice Price as CEO in June 2006 meant that the programming for the 2007 festival fell officially under her purview. Even by then, the arguments concerning the Festival's launch date had not abated. There were still voices advising a more cautious approach toward an opening night two years away, not eleven months. Finally, in order to resolve the matter once and for all, Tony Gagliano called Price in Philadelphia and asked her to make the decision about 2007. "We felt it was important," says Gagliano, "that the incoming CEO own that decision."

Price was sensitive to the growing energies around the idea of Luminato, and its internal propulsion was not something with which she wanted to interfere. As well, she was aware that a start-up always came with its own steep learning curve and its own inherent challenges. "I knew," she said, "that at some level we'd only be postponing difficulties if we put the start date off to 2008. I knew that a delay wouldn't make things any easier. It was a tough call, because the timeline was really, really tight. But what I decided was that we shouldn't peel it off slowly. We should just go ahead and rip off the band-aid."

Over the months leading up to Luminato's first opening night, the original Luminato board of directors would come together. It was, in Price's description, "stellar." The donations of the founding patrons of the Festival—Luminaries such as Gary and Donna Slaight, Howard Sokolowski and Linda Frum, Michael and Sonja Koerner, Richard Rooney and Laura Dinner, the Ivey Foundation, and TELUS—not only provided much-needed investment, but also demonstrated to the various levels of publicly funded agencies that supported the Festival that individuals, families, and the private sector were behind the idea of Luminato. The Province of Ontario's lead role had made it the Festival's founding government partner, and its ongoing invstment has been critical to the Festival's success.

The search for a presenting partner—a corporate sponsor who would not only provide financial support but would take on an active partnership in the annual festival—was underway, and would result in a meeting in Montreal, in January of 2007, with Javier San Juan, the president and CEO of L'Oréal Canada. It was Sunni Boot, the president and CEO of Zenith Optimedia, who had first come up with the idea of connecting Luminato and L'Oréal. On the face of it, an international company with a Spaniard as the head of its Montreal-based Canadian arm did not seem an obvious match for a Toronto multi-arts festival—but San Juan saw things differently. "I was looking for a unique opportunity," he says. He wanted a partnership, as opposed to a sponsorship, and he was impressed with the number of private individuals who had already pledged their support to the endeavour. "I wasn't used to seeing that in Canada," he says.

What was unlikely on the surface made perfect sense at a deeper, more creative, more innovative level. "Very seldom do you find a perfect match of this kind," San Juan says. "But L'Oréal has twenty-five different brands. It's like a kind of festival in its own way, and in Luminato, I found everything I was looking for. I listened to Tony and Janice when they came to Montreal to see me. I loved the idea of becoming a partner in creativity, and very quickly I decided, 'Okay, let's go for it.' The timelines came as a shock to my executive committee, I have to say. June wasn't very far away. But we all worked together, and that first festival was magical, almost miraculous. It went far beyond my expectations."

Under its President and CEO, Javier San Juan, L'Oréal Canada signed on from year one as Luminato's partner in creativity. "We were instantly seduced," said San Juan.

It was unusual for an arts administrator to step into a season—particularly an inaugural season—with the planning so well underway. A successful launch was not only a question of getting performers on stages and bums in seats—it was also a matter of establishing what the personality of the Festival would be, not just in year one, but in subsequent seasons. It was a question of creating something that was so clearly identified and branded that it would resonate immediately with the public, but that was flexible enough in its conception to expand naturally into its own future.

This was especially critical to a festival that had city-building as its mandate and something as immodest as the transformation of Toronto as its objective. The festival that developed in seasons two, three, and four featured the Count Basie Orchestra and jazz prodigy Nikki Yanofsky as part of the TELUS *Light on Your Feet* program at Yonge-Dundas Square; the Mark Morris Dance Group's *Mozart Dances*; Emmylou Harris; the North American premiere

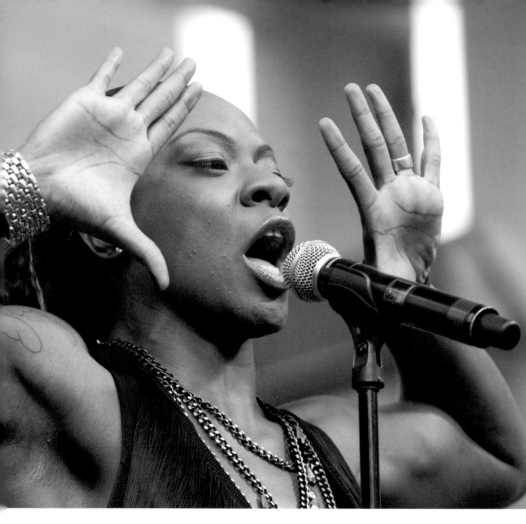

of Robert Lepage's *Lipsynch*; readings by Ann-Marie MacDonald and Andrew Pyper at the Music Gallery; a tribute to Neil Young's 1971 Massey Hall solo concert; the Nederlands Dans Theater's first Toronto appearance in fourteen years; and the world premiere of Erika Batdorf's majestic and disturbing *One Pure Longing: Táhirih's Search* at Buddies in Bad Times. In 2008, Luminato's successful partnership with Tapestry New Opera Works produced *Sanctuary Song*—a weaving together of opera, dance, and theatre. In 2010, Luminato and Tapestry again joined forces to co-produce the world premiere of *Dark Star Requiem*. These subsequent seasons differed in both process and in content from Luminato's first, but they shared a common source. They all had the same idealism at their heart. They all were ways of imagining the Toronto of the future.

Jully Black (above left) **and the stars of** *Luminato First Night 2010* **hit the stage at Yonge-Dundas Square.** (above right) **Jill E. Allen performed with Kelly and the Kelly Girls;** *Light on Your Feet— Queer Divas***; 2010; Yonge-Dundas Square.**

One of the Festival's strengths is that its vision has been clear from the very beginning, and it has remained remarkably consistent over the years: free performances in public spaces, the mix of popular and high culture, the visual animation of public locations, and the commitment to education and outreach programs were part of Luminato's DNA. It was apparent to Price that, when she came on board, she would not have to renovate the work already accomplished by the Festival's founders. She could build on what was already there.

Price could see that the programming already in place expressed the eclecticism at the heart of the Festival. She approved, and brought her own contributions to the table—a blending that worked as well as it did in part because the Festival was inherently eclectic, but mostly because she shared the goal expressed to her by the Festival's founders. Their objective was to animate, enliven, and transform the city through a bold intervention of the arts, and so it was hardly surprising that the Festival itself was built with a mixture of elements that were altogether urban in their diversity. Martin Robertson's *Summer of Love*—a musical recreation of Yorkville's hippy heyday in the streets of the contemporary Yorkville neighbourhood—rubbed shoulders with Muhtadi International Drumming Festival in Queen's Park. Commuters arriving in Union Station's Great Hall looked up to see Toronto artist Max Streicher's *QUADRIGA*—four magnificent, inflatable horses—floating in the lofty space above them. Stockbrokers and bankers at the Toronto-Dominion Centre stopped, with their coffees and cellphones in hand, to interact with Mexican-born, Montreal resident Rafael Lozano-Hemmer's *Homographies, Subsculpture 7*— "an interactive installation featuring robotic fluorescent light fixtures controlled by computerized surveillance systems." Luminato's commitment to school and community

144

programs, overseen by its dynamic director of education and community outreach, Jessica Dargo Caplan, and supported by the Ontario Trillium Foundation, was in place from the beginning. "I'm very proud of what we are doing in education and outreach, especially with at-risk neighbourhoods in the city," says Price. "It was never something we saw as an add-on."

A priority for Price was to shift Luminato's first burst of enthusiasm to a cycle of commissioning, planning, and scheduling that allowed for a more carefully premeditated lineup and a more carefully delineated personality for the Festival. Lucille Joseph admits that she and David Pecaut and Tony Gagliano had enjoyed the pace of organization that the first season imposed. They didn't have the time to worry very much about whether or not they knew what they were doing. So, they just went ahead and did it—confident that their instincts and their belief in the Festival's vision would prove to be adequate guides as they entered into the difficult terrain of festival organization. Price now faced the challenge of keeping the original passion alive while corralling it into a more cohesive management structure. It was necessary for Luminato to think about a future that reached far beyond the next approaching deadline. It was critical "to build the right team."

It made headlines in Barcelona. It made headlines in Chicago. And the Canadian premiere of Kurt Perschke's *RedBall Project Toronto*—part street performance, part art installation— was no less of a hit at Luminato 2009.

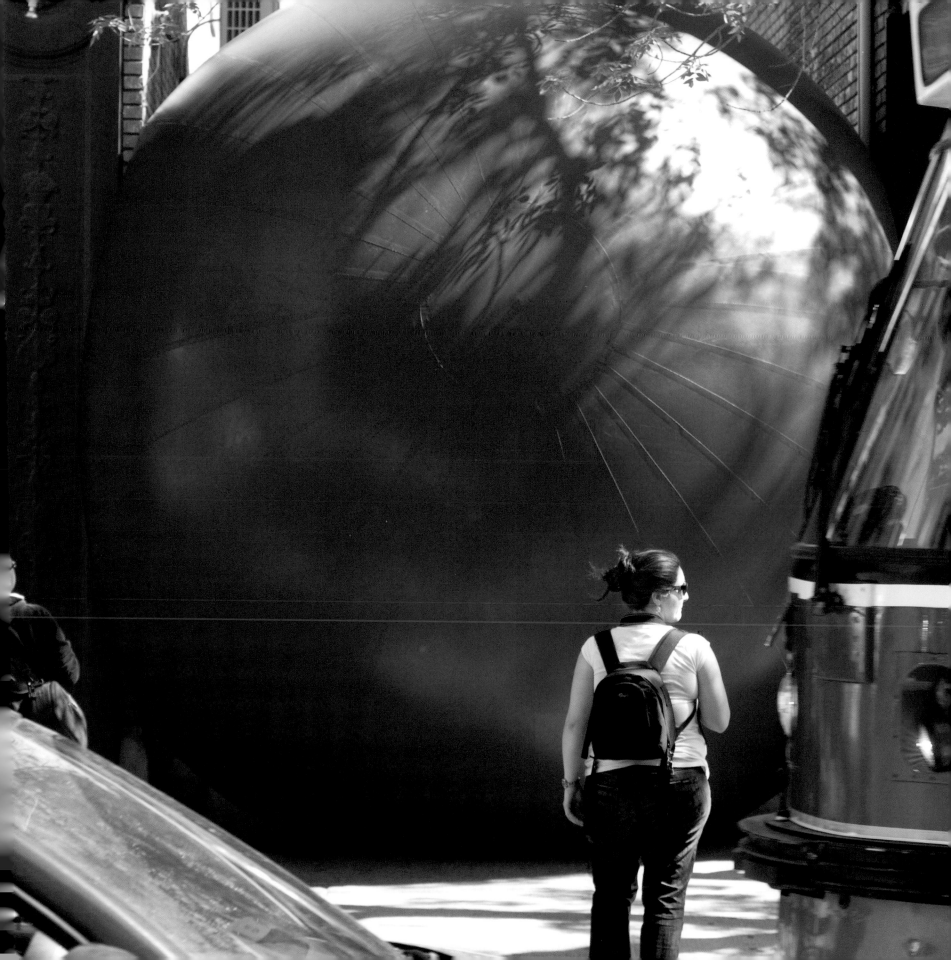

The dialogue with Luminato was extraordinary. Their willingness to be attentive to us made a huge difference. And once they were committed, they were fully committed. They gave us as much marketing prominence as they gave Robert Lepage.

EVA CAIRNS
Managing Producer, Catalyst Theatre

At its most fundamental level, running an arts festival involves two separate, but mutually dependent activities: identifying content and realizing it. Chris Lorway, Luminato's artistic director, and Clyde Wagner, the Festival's general manager, cover these two broad areas of responsibility. They are pivotal players on Price's team.

Lorway had considerable experience with festivals before joining Luminato. The Lincoln Center Festival, the *New Yorker* Festival, the Henson International Puppet Festival, and Nova Scotia's Celtic Colours International had all been stops along his way. Working with AEA Consulting Group, he had played a role in strategic initiatives at Carnegie Hall, the Royal Shakespeare Company, and the Edinburgh Festival. He came on late in the planning of the first season. "Basically," he says, "I grabbed onto the space shuttle as it was being launched." But even in that first festival—one in which he had only modest involvement—he was looking for what he calls "the dialogue" between programming elements. The first festival—one in which he had played only a belated role in programming—was challenging. "The steepest learning curve of my career," he says. The second festival, in programming terms, came very hard on the heels of the first— the window available once everyone had recovered from the first was not wide enough for Lorway to do as much commissioning as he would have liked. Still, he was thinking in strategic terms from his first day on the job, beginning to create the recurrent threads, such as *The Canadian Songbook* series and the Young Centre for the Performing Arts's unique position in the Luminato lineup, which would connect festival to festival while still retaining Luminato's essential eclecticism. He was also embarking on commissions that would take much longer to come to fruition than Luminato's early cycles of production had allowed. Volcano Theatre's *The Africa Trilogy*—an ambitious collaboration by three playwrights, from Kenya, Germany, and the United States, with three directors from South Africa, Sweden, and Canada—was performed at the Fleck Dance Theatre to considerable acclaim in the 2010 festival. Co-commissioned by Luminato and the Stratford Shakespeare Festival, it was a project that Chris Lorway had been developing since 2007.

Co-commissioned by Luminato and the Stratford Shakespeare Festival, Volcano Theatre's *The Africa Trilogy* involved three playwrights, three directors, eleven performers, and a production team from around the world. The world premiere took place at Fleck Dance Theatre at Luminato 2010.

Few members of the sold-out audience at the Elgin Theatre during Luminato 2010 will forget Rufus Wainwright's dramatic performance of his song cycle, All Days Are Nights: Songs for Lulu*: "Oh, I was definitely aware of a heightened significance," Wainwright would later say. "Luminato was the North American premiere of my opera and of my song cycle. It was an extraordinary event for me."*

CHOOSING THE RIGHT WORDS

When Devyani Saltzman speaks about Luminato, she sometimes sounds like a musician. As the curator of the Festival's literary programming, Saltzman commissions and organizes the readings, the Q&As, and the "Illuminations" talks and panel discussions that have been features of the Festival since its inaugural season. When she describes her work, it is easy to imagine Luminato as a rich, complex symphony and its literary programming domain as one of the Festival's intriguing melodic threads.

Saltzman's mandate is to harmonize with the creative connections that Chris Lorway's cross-genre programming establishes each year—but harmonize as creatively and as unpredictably as Saltzman—a writer herself—sees fit. Her program echoes, reinforces, amplifies, embroiders, and provides counterpoint to Lorway's lineup. She pays particular attention to the Festival's plays and dramatic works as a source of inspiration and direction. She believes that this association—established in close, ongoing discussions with Lorway as each festival takes shape—allows her program to be "a little different in a city with a sea of literary events."

In Luminato 2010, the world premiere of Volcano Theatre's *The Africa Trilogy* (co-commissioned by Luminato and the Stratford Shakespeare Festival) inspired a literary season that, in part, featured the 1991 Man Booker Prize–winner, Nigerian poet and novelist Ben Okri, and readings at the Isabel Bader Theatre by Brian Chikwava, Carole Enahoro, and Ngũgĩ wa Thiong'o, and hosted by Toronto's Poet Laureate, Dionne Brand. Luminato 2009's world premiere of *A Poe Cabaret: A Dream Within a Dream* inspired readings of Gothic fiction by Patrick McGrath, Monique Proulx, and Sarah Langan. Neil Gaiman read that same year at the Jane Mallett Theatre, and Naolo Hopkinson, Tasleem Thawar, Ann-Marie MacDonald, Andrew Pyper, and Margaret Atwood contributed to *Gothic Toronto: Writing the City Macabre*. Luminato's 2011 production of *One Thousand and One Nights* led Saltzman to the story of Shahrazed, and from the mythic spinner of tales to readings and talks built around the motif of the female storyteller.

However, in the spirit of all gifted soloists, Saltzman also enjoys bringing writers, both Canadian and international, to Luminato's stages for no reason other than "they're great." Roddy Doyle, Michael Helm, Eleanor Catton, Azar Nafisi, Tash Aw, Aravind Adiga, Yiyun Li, Daniel David Moses, Alissa York, and Gore Vidal are a few of the names that fit into this free-floating category of brilliance. In bringing in the twenty to twenty-five authors Luminato features each year, Saltzman's first priority—she says very firmly—is always "keeping the emphasis on really strong programming."

Man Booker Prize—winner Ben Okri is one of the many superstars who have read and discussed their work as part of Luminato's literary program; 2010; Al Green Theatre.

I will never forget doing The Children's Crusade. *Ever. And I don't think that a lot of the people involved will ever forget it, either. That's when Luminato really works — when people see something that couldn't have happened anywhere else, that could only happen here.*

TIM ALBERY
Director, *The Children's Crusade*, Luminato 2009;
Prima Donna, 2010

By the third festival, Lorway had established what felt to him like the right balance. "By then we had a good internal team working well with our external partners." In future festivals he would be able to encourage and to foster "threads." (Lorway and Luminato steer clear of the term "theme." It feels to them too much like an artificial imposition, and not enough like the kind of linkages and dialogues that he believes make a festival "sing.") To a great extent his job, which involves equal parts international travel and consultation with local artists, is about keeping his eyes open — not only in regard to the companies, artists, and performers he encounters, but to the ideas that seem by some mysterious process to accrue to a particular time and place. "I'm in a privileged position," he says. "Because I spend so much time talking to so many different artists, I can sometimes get a sense of what's in the air before the connections become apparent to others. Albert Schultz at Soulpepper can mention to me that a group of his actors is interested in doing something on Edgar Allan Poe, and that makes a connection for me, because I'm already beginning to think about the idea of Gothic as a possible thread. *A Poe Cabaret* at Buddies in Bad Times, Edmonton's Catalyst Theatre's *Nevermore*, at the Winter Garden, and a series of readings called *Gothic Toronto* at the Music Gallery in Luminato 2009 were the result of this synchronicity."

Best known as guitarist for the celebrated band The Police, Andy Summers came to Luminato 2009 to exhibit and to talk about his obsession with photography.

151

Goran Bregovic, superstar of the Balkans: the Sarajevo-born musician and composer was joined at Yonge-Dundas Square by his twenty-piece Wedding and Funeral Orchestra in Luminato 2009, attracting more than fifteen thousand fans.

Whether a season featured a production of *A Midsummer Night's Dream*, spoken in English, Tamil, Malayalam, Sinhalese, Hindi, Bengali, Marathi, and Sanskrit, or Rufus Wainwright's opera, *Prima Donna*, co-commissioned by Luminato, the Manchester International Festival, Sadler's Wells, and the Melbourne International Arts Festival; whether it featured the Kronos Quartet or the Vienna Academy Orchestra, or a Massey Hall tribute to Bruce Cockburn; whether Azar Nafisi was reading from her award-winning novels as part of the festival's literary evenings, or Roddy Doyle was visiting a local public school to talk to students about being a writer, or Binyavanga Wainaina, one of the playwrights of *The Africa Trilogy*, was speaking at the George Ignatieff Theatre on the subject of "African Issues and the Challenge of Artistic Response," or the fortieth anniversary of George Ryga's

The Ecstasy of Rita Joe was being celebrated at the Factory Theatre; whether Jane Bunnett, and Kenny Wheeler, and Don Thompson, and Jon Hendricks were performing at the Distillery District; or whether Randy Bachman was rocking Yonge-Dundas Square, or the crowds in Queen's Park were savouring delicacies prepared by the city's finest chefs as part of President's Choice *1000 Tastes of Toronto*—Luminato was always about the future. "I think that Luminato was an act of building confidence in the city," David Pecaut said. "Actually, Bill Boyle used those terms at one point: how do you get people confident enough to take something like this on? I think each of these steps . . . has built the confidence in the arts community, has built the confidence that government, and private sector, and individuals, and the arts leadership can work together, and the audiences will come."

The announcement of Alexander Neef's appointment as the general director of the Canadian Opera Company in June 2008 coincided almost exactly with Luminato's second season. He brought an interesting perspective. Neef's own background—he worked as an administrator at the Salzburg and RuhrTriennale festivals in Germany before joining the Opéra national de Paris—had given him first-hand experience of a festival's positive impact on communities. "Art in public spaces" remains for Neef what is "the most amazing thing about Luminato"—and not only because it can bring public spaces to life. Neef describes the interaction of installations in unexpected places as part of the "big obligation" of arts institutions to overcome the fear of the arts that many people feel. Opera is often portrayed, mistakenly, as something that is not accessible to everyone—which may be why Neef is so supportive of Luminato's broad aim. He believes that the beauty and the playfulness of the installations Luminato has commissioned over the years—Kurt Perschke's *RedBall Project Toronto*, David Rokeby's *long wave*, and Janet Cardiff's and George Bures Miller's *Ship O' Fools* have been among the most popular—have within them the implicit message that art is not something difficult, esoteric, and confined to the big, forbidding buildings where it usually is stored. Art is part of civic life—a philosophy that has been part of Luminato from its first season, and that all of the city's cultural institutions recognize the need to embrace.

The opening of Luminato's inaugural season linked with the spectacular opening of the Royal Ontario Museum's Michael Lee-Chin Crystal—an institutional collaboration that reached back to the first conversation Tony Gagliano had with William Thorsell about his idea for an arts festival. This was precisely the celebration that the two men had originally discussed, and that Gagliano and Pecaut later outlined over their lunch at Grano: the emergence of a Toronto that would be known as an arts and culture destination in the way that it had once been known, primarily, as the home of Casa Loma and the CN Tower. This—as the crowds swirled through the museum's Bloor Street piazza and the spotlights cut through the June night sky—was suddenly no longer Toronto, the staid: it was the Toronto that could draw international arts journalists, presenters, and impresarios each year in order to see what the city was up to; that could bring tourists, by the tens of thousands, out to hear music, see plays and dance, and wander through its suddenly animated public spaces. It was the Toronto that could, in short, throw a wonderful ten-day celebration of creativity.

153

Queen's Park came alive with the cross-cultural beats of the Muhtadi International Drumming Festival in 2007.

DISAPPOINTING

A businessperson's notion of a festival

CHRISTOPHER HUME

It might seem ungrateful to complain, but there was something not quite right about Luminato.

No doubt the 10-day arts festival that ended yesterday had lots to recommend it. Any event that manages to bring the delightfully malicious, yet always honest, Gore Vidal to town can't be all bad.

And who couldn't help but love Xavier Veilhan's enormous black balls hanging in the atrium of BCE Place? Or Max Streicher's floating horses at Union Station? Not to mention Rafael Lozano-Hemmer's interactive light show that has been illuminating the night sky for days?

Still, there's no escaping the fact that Luminato failed to add up to more than the sum of its parts. Despite all the hype, many Torontonians still have no idea what it was all about.

It lacked authenticity; Luminato was more a businessperson's notion of what an arts festival should be than the thing itself.

Perhaps it was the official nature of Luminato, the fact that it's part of Toronto's latest civic fiction — namely that this is a city that truly supports the arts and culture — that it is, in fact, creative. Not that the arts aren't alive and well, sort of, in these parts, but that has precious little to do with events such as Luminato.

Here in Toronto, culture has suddenly become important because it's seen as a way to promote our international standing, of gaining the "world-class" status we yearn for so poignantly.

Indeed, there's a well-documented connection between the arts and economic health. Just look at New York, Paris or London. But the success of these cities comes out of a long-standing culture of culture. There are the artists, audiences, collectors, philanthropists, institutions and history that create a critical mass of activity.

Luminato, on the other hand, comes across as a top-down exercise in arts manipulation, an attempt to impose a festival on the

Crystal, for example, suddenly finds itself part of Luminato.

Civic politicians and bureaucrats stand by while developers buy up the old warehouses, factories and buildings that house artists, but pat themselves on the back for the great work they did in organizing Luminato in record time.

The result was a festival that sought to be all things to all people — never a good idea. Events such as this need focus, or a vision.

One couldn't help but get the impression that a small group of well-intentioned corporate types had been convinced that because culture is good for business, all they had to do was pull something together. The bigger the better.

The vision behind Luminato needs to be more organic, authentic and plugged in to local reality. It must be more specific and less an omnibus. And it needs to be better marketed. Luminato ended up being everywhere and nowhere. It became hard to distinguish what was included and what wasn't.

Even after 10 days of non-stop activity, few if any could say what was unique about Luminato. What was its signature event?

The unexpected success of Nuit Blanche last year signals the hunger that exists in Toronto for the new and novel, the remarkable and the genuine. It lasted one night and attracted more than 400,000.

Luminato's figures aren't in yet, but even if it managed to draw larger numbers, one wonders whether it actually made a difference to the way residents and visitors view the city.

DELIGHTFUL

Culture at front of city's mindset

> Luminato lacked authenticity, says one Star critic; another says that the cultural festival was right on the money

MARTIN KNELMAN

Luminato wrapped up year one on a positive note over the weekend, with happy crowds jamming Carnivalissima, a free family event at Harbourfront, and bigger spenders enjoying such hot-buzz ticketed events as *Luna*, the opera gala, and *Vida!*, the Cuban dance show.

After 10 days of Luminato's coming-out party, the verdict is in. Despite a few glitches, this first edition of an annual 10-day arts festival was a bigger success than most observers, including me, expected.

Downtown Toronto was alive and buzzing with culture at the front of the city's mindset in a way that is rare except at film festival time. Luminato is a winner, and it's here to stay.

Co-founders David Pecaut and Tony Gagliano and CEO Janice Price will release final numbers tomorrow — and declare victory. But it's already clear to insiders that the festival met or exceeded the targets in its business plan.

That means about half a million people had a Luminato experience, even if for many of them it was as fleeting as accidentally encountering a floating art object in Union Station or BCE Place.

The total includes 25,000 people

who visited the Royal Ontario Museum's new Crystal wing on opening weekend, the 8,000 people who attended a free concert on Front St. on June 1, and the thousands who visited the Distillery District throughout the week or wandered around Yorkville for the June 1 Summer of Love event.

Ticket buyers represent a fraction of the total number. But by Wednesday, barely past the halfway point of the festival, Luminato staff were celebrating that the festival had passed the $1 million mark in ticket sales. So it was well-positioned to hit the budgeted target of $1.2 million and wound up selling about 70 per cent of available seats.

Ticket revenue accounts for only about 10 per cent of Luminato's $12 million annual budget.

Eric Idle's spoof *Not the Messiah* drew near-sellout houses at Roy Thomson Hall. Almost 10,000 people saw *Vida!*, which will continue all this week at the Royal Alex.

Also staying in town for a while: the *Pulse Front* light show in the sky; Leonard Cohen's drawings at the Drabinsky Gallery; and the delightfully low-brow cabaret show *Spiegeltent* at Harbourfront.

Naysayers will focus on what went wrong. Neither Ottawa nor the City of Toronto gave money to Luminato, to their shame.

Adam Gopnick was the wrong guy to interview Gore Vidal and technical woes made it hard to hear. And a thousand people who showed up for a free simulcast of a National Ballet performance were told the technology had broken down.

But Price and retired ballet star Rex Harrington won the crowd over by offering free tickets to a live performance of *Don Quixote* as well as screening another ballet.

Winnie Madikizela-Mandela wasn't allowed into the country to see a show about her life, which may be just as well since it got terrible reviews.

One of my regrets is that I missed *Norman*, about the legendary animator Norman McLaren. It played to tiny audiences for three shows only and by the time word got around it had already closed.

But I have many great memories of a week that held too many choices. My favourites: *Not the Messiah, Luna, Pulse Front, Spiegeltent,* Cohen's drawings and Cohen's onstage dialogue with Philip Glass.

"I'm thrilled with the way the city embraced the festival," says Price.

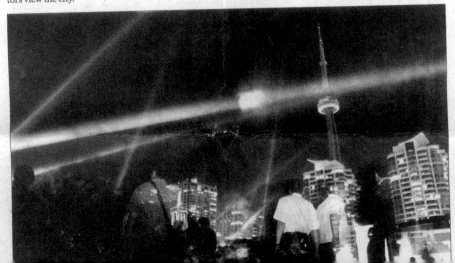

If we, as cultural organizations, believe that we consume one another's audiences, there is something deeply wrong in our thinking. We should be working toward building audiences for all of us, rather than worrying about keeping 'my' audience. . . . If there is a problem in Toronto, it's not that there is too much going on. It's that there is not enough. . . . We should be self-confident enough in Toronto to encourage the arts to grow.

ALEXANDER NEEF
General Director, Canadian Opera Company;
member, Luminato Festival Advisory Committee

"Luminato felt like a natural inhabitant of the city," said Graham Sheffield, the artistic director of London's Barbican Centre and an early advisor to Luminato. "It didn't feel imposed. It speaks to the diversity of the city itself." If nothing else, Luminato was provoking a response from that diverse audience—even the press reaction to the festival was multi-faceted. On June 11, 2007, the *Toronto Star* placed the opposing opinions of two of its columnists side by side on a single page of its entertainment section—as if to make it clear that the arts were never about conclusion so much as discussion. "Disappointing" was Christopher Hume's opinion—"A businessperson's notion of a festival"—while Martin Knelman hailed Luminato's inaugural season as "Delightful." The headline for Knelman's column read: "Culture at front of city's mindset." "Price is looking forward to Luminato 2, The Sequel," Knelman concluded. "So am I."

Janice Price is perfectly clear about the goals of her staff. "Our job is the ten days of the Festival," she says. "No more, no less. Everything we do comes down to that." Clyde Wagner's responsibilities—the jigsaw of budget, schedule, and logistics that is the preoccupation of the general manager—is no less focused. Chris Lorway's ongoing conversations with Toronto artists and his busy travel schedule—to Melbourne, to Hong Kong, to London, to New York, to Cairo, to Paris—have the same objective: planning the Luminato festivals yet to come.

Even so, somewhere at the heart of everything they do is the outcome that the Festival's founders addressed in their earliest plans. Creating the Festival has always been about imagining a Toronto that would celebrate its creativity as central to its civic personality. When Chris Lorway delights in bringing Goran Bregovic, "musical superstar of the Balkans" to Yonge-Dundas Square—and thereby drawing whole new audiences to a Luminato event; when he describes with pride the "beyond Luminato lives" of commissions such as *Not the Messiah*, David Michalek's *Slow Dancing*, and the break-out Luminato performance of Nikki Yanofsky with the Count Basie Orchestra; when,

two years before its Canadian premiere, there is a buzz of anticipation surrounding Luminato 2012's production of Philip Glass's and Robert Wilson's *Einstein on the Beach, An Opera in Four Acts*; when Janice Price remarks on the "very Luminato" connections that began with conversations between Philip Glass, Leonard Cohen, and Glass's producer, Linda Brumbach, and resulted in Cohen's drawings being exhibited in public for the first time at the Drabinsky Gallery in Luminato 2007; when Chris Lorway—whose blog on Luminato's website keeps Festival fans up to date on his thoughts and planning—writes: "One of the anchors of the 2011 Luminato Festival will be Tim Supple's *One Thousand and One Nights*… Over the past couple of months, Tim has been travelling to North Africa, the Middle East and Central Asia to meet with actors, dancers and musicians as the first step in creating the production"—all of these activities, though focused on the complex and difficult details of mounting a festival, point toward the civic personality that the founders always thought Luminato would help Toronto become. It was always their objective that for ten days every June, the city's future personality would be brought vividly to life.

Luminato took the position that a multi-arts festival was not an aberration in an otherwise humdrum metropolis. Luminato proposed that it was itself a glimpse of what Toronto is in the process of becoming—an exuberant cross-pollination that the city's artists and its cultural institutions large and small had been working toward all along: a city enlivened by its own creativity, its own remarkable diversity, and its capacity for collaboration; a city where an old warehouse might suddenly become the venue for R. Murray Schafer's opera *The Children's Crusade*, where any public space might suddenly be playfully occupied by Kurt Perschke's *RedBall Project Toronto*, where a public space might be all about the guitars of Derek Trucks and Colin Linden one day and Bollywood dancers the next.

In a long conversation David Pecaut had with Lucille Joseph a few months before his death, Pecaut talked about his aspirations for the Festival's future. "As I look back over the last five or six years," he said, "I think Luminato is one of the most important things I've been involved with in my whole life, and one of the things I am proudest of. I really hope it lasts fifty, a hundred years, forever. I hope it becomes an emblem to the world of what Toronto's all about."

At the conclusion of the 2010 Festival, the *Toronto Star*'s Martin Knelman expressed a similar sense of optimism. "In its early years," Knelman wrote, "Luminato has made life richer and more stimulating for those who live here and love the arts…" But he concluded his column by looking forward and by describing what he called "an intoxicating sense that for Luminato, the best is yet to come."

The aspiration to transform Toronto is no small ambition. Certainly, it is something that no other city in North America has taken on so boldly—but it was an objective that had been Luminato's from the beginning. The Festival's early years had to be planned with its legacy very much in mind. Luminato has its artists, and its corporate partners, and its founders, and its Luminaries, and its staff. But in the end it has always been an arts festival about the city it inhabits. It has always been about the audience—and that seems to be what has caught people's imagination. That seems to be why the first of many creative sparks to come have been so exciting. As Joe Hall, one of Luminato's most devoted volunteers put it, "I want to be able to look back twenty years from now and say, 'I was part of this at the beginning.'"

Nearly sixty actors and musicians travelled to a Jesuit monastery outside of Alexandria, Egypt, to work with director Tim Supple, in preparation for Dash Arts' world premiere of *One Thousand and One Nights* at Luminato 2011.

(on page 158) **The Great Canadian Tune**; Yonge-Dundas Square; Luminato 2009.

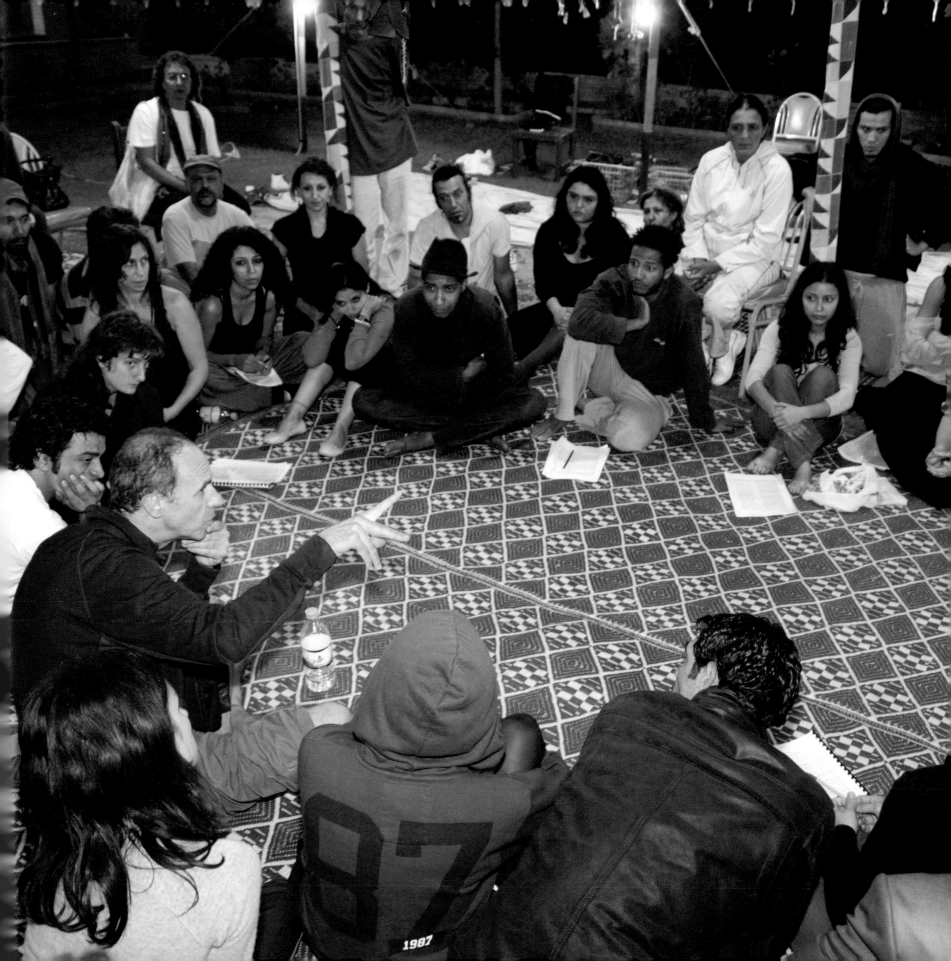

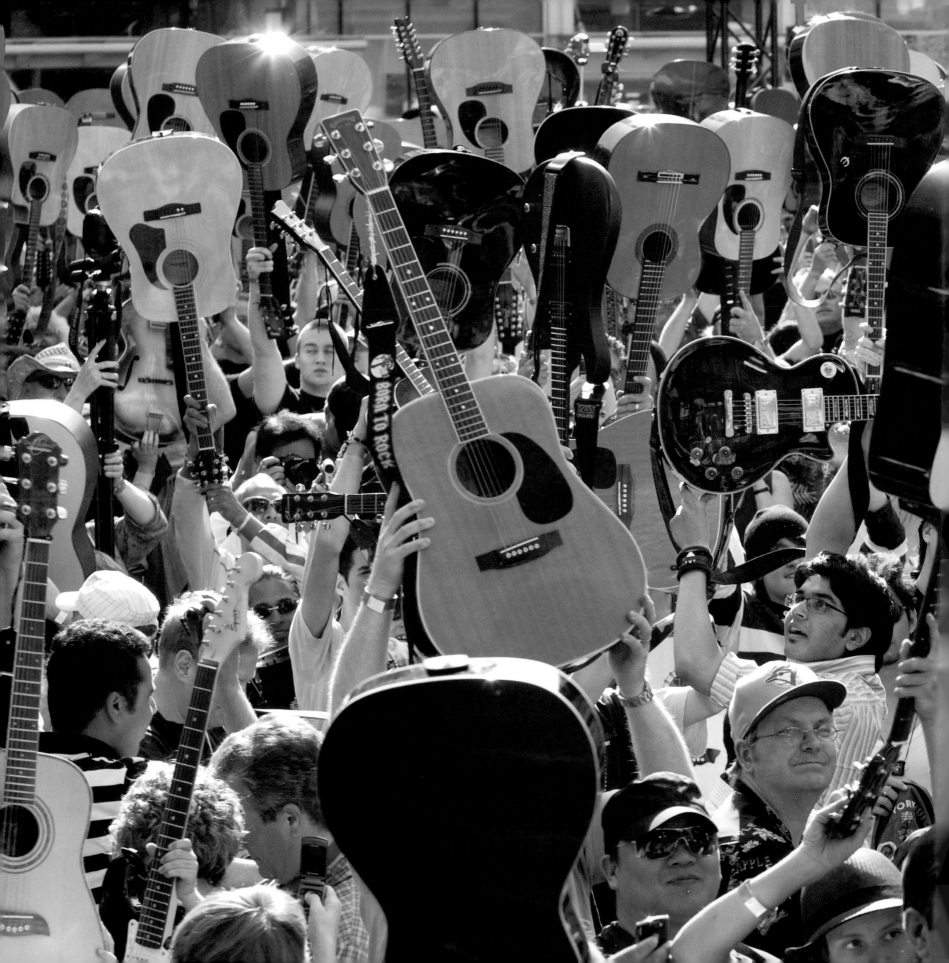

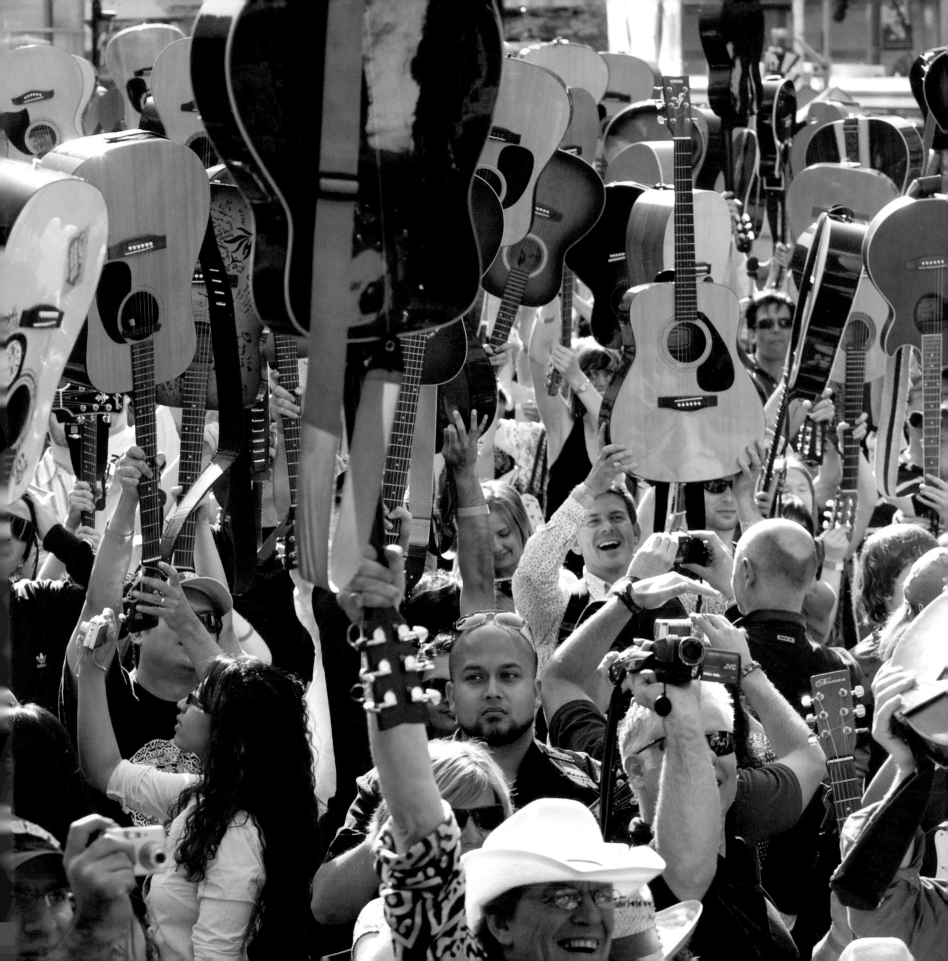

President's Choice *1000 Tastes
of Toronto*; 2009.

LUMINATO BY THE NUMBERS | Based on the first four 10-day festivals, 2007–2010

Artistic Reach

- 5,760 artists have appeared.
- 81% of these artists are Canadian.
- 37 new works have been commissioned or co-commissioned by Luminato.

 26 of these were created by Canadian artists or companies.

 31 works commissioned by Luminato have gone on to tour in Canada and around the world.

- In 2010, 200+ events were presented at 36 venues across the Toronto. The vast majority of events are presented free of charge.
- Each year, 30–60 international presenters and impresarios and about 30 international journalists come to Toronto for the Festival.

Tourism and Economic Impact

- On average 140,000 tourists participate in Luminato each year; in 2010, 75% of those surveyed at ticketed events said they had come to Toronto specifically for the Festival.
- Luminato has generated $553 million in visitor expenditures, with a tax impact of $232 million, as calculated by the Government of Ontario's Tourism Regional Economic Impact Model (TREIM).
- Some of Toronto's most iconic tourism images are of Luminato, such as *Pulse Front* at the Harbourfront Centre, *Light Play* at Yonge-Dundas Square, and *long wave* in Brookfield Place.

Toronto Festival-goers

- Each year, Luminato reaches about 1 million people.
- Of these, about 40,000 attend the ticketed events.
- In 2010, 73% of festival-goers were under the age of 44, and 59% identified themselves with a background other than Canadian.
- Market research indicates that Luminato helps support the arts year-round with 60% of Festival ticket-buyers responding that because of Luminato they are more interested in other arts and cultural events in Toronto.

Luminato Budget

- The annual operating budget is $12 million.
- There are approximately 20 permanent employees, a number that more than doubles in the months before the Festival with contract employees and interns.
- Each year about 500 volunteers of all ages and backgrounds give generously of their time to help create a welcoming Festival environment.
- Sources of revenue are:

 32% Government of Ontario, founding government partner

 26% Corporate sponsors

 21% Other government funding

 11% Individual donors and foundations

 10% Ticket sales

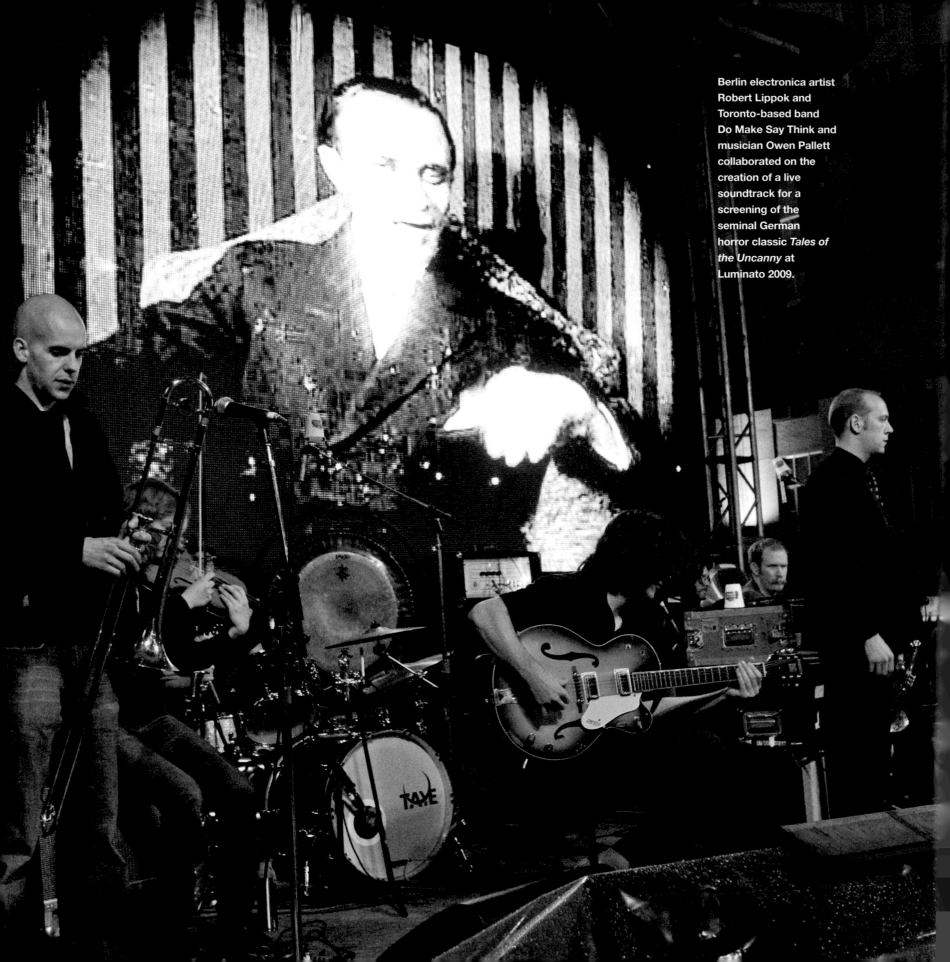

Berlin electronica artist Robert Lippok and Toronto-based band Do Make Say Think and musician Owen Pallett collaborated on the creation of a live soundtrack for a screening of the seminal German horror classic *Tales of the Uncanny* at Luminato 2009.

LUMINATO PROGRAMMING | 2007–2011

* = Commission and Co-commission, C = Canadian

Year	Genre	Program Title	Artist/Company
2007	Celebrations	Gala Opening and Concert C	Chantal Kreviazuk, Gordie Sampson, Molly Johnson
		Muhtadi International Drumming Festival C	Various Artists
		Lee-Chin Crystal Opening C	Paul Gross, Gordon Pinsent, K'naan, Jann Arden, Natalie McMaster, David Foster
		Summer of Love C	Various Artists
		Luminato at the Distillery C	Various Artists
		L'Art Boat C	Various Artists
		Carnivalissima C	Various Artists
	Music	Not the Messiah (He's a Very Naughty Boy) * C	Eric Idle and John Du Prez; Performed by the Toronto Symphony Orchestra
		Book of Longing * C	Philip Glass and Leonard Cohen
		Live@Courthouse C	Various Artists
		Art of Jazz C	Various Artists
		Constantinople C	Gryphon Trio; Composed by Christos Hatzis
		The Passion of Winnie (Part One) C	Warren Wilensky
		Luna C	Various Artists; Created by Wende Cartwright and Neil Crory
		Masters of World Music	Various Artists
	Dance	Vida! A Celebration of Life * C	Lizt Alfonso's Danza Cuba; Produced by Mirvish Productions
		Petrouchka & Kshetram—Dancing the Divine C	Motus O Dance and Sampradaya Dance Creations
		Rite of Spring	Shen Wei Dance Arts
		Re	Shen Wei Dance Arts
	Film	Brand Upon the Brain C	Guy Maddin
	Literature	Well Read	Various Artists
	Theatre	Spiegeltent'ntavern C	Various Artists
		Under Milk Wood C	By Dylan Thomas; Featuring Kenneth Welsh
		An Evening with Glenn Gould C	By John McGreevy; Featuring Ted Dykstra
		The Walker Project C	By George F. Walker; Directed by Ken Gass
		Risk Everything C	By George F. Walker; Directed by Grzegorz Jarzyna
		Back Home	Urban Theare Projects
		Norman * C	Lemieux Pilon 4D Art
		Spirit Horse C	Roseneath Theatre Company
	Visual Arts	Pulse Front: Relational Architecture 12 * C	Rafael Lozano-Hemmer
		Floating Artworks: Le Grand Mobile	Xavier Veilhan
		QUADRIGA	Max Streicher
		Homographies, Subsculpture 7 C	Rafael Lozano-Hemmer
		Canon enigmatico a 108 voces C	Abraham Cruzvillegas
		Untitled	Dan Steinhilber
		Scattered Crowd	William Forsythe
		Untitled	Jenny Holzer
		The Robotic Chair C	Max Dean
		Ryerson University's Black Star Collection C	Various Artists
		Drawn to Words C	Leonard Cohen
		Auroras / Testimony (Auroras) C *	Atom Egoyan; Kutlug Ataman

Year	Genre	Program Title	Artist/Company
2007 (con't)	Illuminations	A Conversation with Leonard Cohen & Philip Glass C	
		Passion, Politics & Power: South Africa Revisited	
		Norman Discussions C	
		An Evening with Gore Vidal	
		What is a Festival? C	
		24 Frames Per Second Animation Workshop C	
		3,600 Films for Free C	
		A Conversation with Guy Maddin C	
		Guy Maddin's Cabinet of Wonders C	
		Onstage with The National Ballet of Canada C	
		A Conversation with Grzegorz Jarzyna	
		A Conversation with Shen Wei	
		Auto Emotion	
		Dance Innovators C	
2008	Celebrations	Luminato First Night C	Count Basie Orchestra; Nikki Yanofsky
		TELUS Light on Your Feet C	Various Artists
		Queen Street Celebration C	Various Artists
		On the One: Luminato Funk Festival	James Brown's Soul Generals; Morris Day and the Time
		Scottish Music Festival C	The Barra MacNeils, Ashley MacIsaac
		Luminato at the Distillery C	Various Artists
		Luminat'eau: Carnival H2O C	Various Artists
	Music	Mikel Rouse Trilogy	Mikel Rouse
		Homeland *	Laurie Anderson
		The Canadian Songbook C	Various Artists
		Colour…For the End of Time C	Gryphon Trio
		Nunavut	Kronos Quartet with special guest Tanya Tagaq
		Dan Zanes and Friends	Dan Zanes
	Dance	Mozart Dances	Mark Morris Dance Group
		All Fours / Violet Cavern	Mark Morris Dance Group
		Liebeslider Waltzes / Grand Duo	Mark Morris Dance Group
		The Fiddle and the Drum C	Alberta Ballet; Choreographed by Jean Grand-Maître
		Etudes	National Ballet of Canada; Choreographed by Harald Landers
		The Second Detail	National Ballet of Canada; Choreographed by William Forsythe
		Five Brahms Waltzes in the Manner of Isadora Duncan	Jennifer Fournier
	Film	A Throw of Dice	Nitin Sawhney; Performed by members of the Toronto Symphony Orchestra
	Food	Luminato Dinner Series C	Various Artists
		One City, One Table	Various Artists
	Literature	Diaspora Dialogues: Launch of TOK Book 3 C	Various Artists
		Celebration of Isaac Bashevis Singer	Various Artists
		Political Graphic Novel	Various Artists
		Festival of the Short Story C	Various Artists
		Spotlight on New South Asian Writing	Various Artists

Year	Genre	Program Title	Artist/Company
2008 (con't)	Theatre	BLiNK C	Soulpepper Academy
		Black Watch	The National Theatre of Scotland
		A Midsummer Night's Dream	Directed by Tim Supple; Produced by Dash Arts
		Where the Blood Mixes * C	By Kevin Loring; Produced by Playhouse Theatre Company
		The Ecstasy of Rita Joe C	George Ryga
		Sanctuary Song C	Tapestry New Opera and Theatre Direct
		Rocket and the Queen of Dreams C	Roseneath Theatre
		The Glass Eye * C	Louis Negin and Marie Brassard
	Visual Arts	Slow Dancing	David Michalek
		City of Abstracts	The Forsythe Company
		StreetScape * C	Various Artists
		Toronto's Mille Femmes * C	Pierre Maraval
		Green Flag Song C	Joni Mitchell
	Illuminations	The Dance of Life / The Life of Dance C	
		The Painted City: Public Space as Canvas C	
		Aboriginal Encounters C	
		The Dark City C	
		Crossing the Line: Disappearing Boundaries in the Arts C	
		South Asian Expressions: East Meets West C	
		The Luminato Reel	
2009	Celebrations	Closing Weekend Celebrations Featuring Cirque du Soleil® C	Cirque du Soleil
		Goran Bregovic	Goran Bregovic
		The Great Canadian Tune C	The Heartbroken
		Luminato First Night C	Randy Bachman, Various Artists
		Light on Your Feet C	Various Artists
		National Bank Yorkville Festival: Brazilian Guitar Marathon	Various Artists
		New Waves Festival C	Young Centre for the Performing Arts
		Tales of the Uncanny C	Robert Lippok, Do Make Say Think, Owen Pallett
		The Traveling Blues C	Taj Mahal, Various Artists
		The World Of Slide Guitar C	Daniel Lanois, Derek Trucks Band, Various Artists
	Music	A Poe Cabaret: A Dream Within a Dream * C	Mike Ross, Lance Horne, Patricia O'Callaghan
		Addicted to Bad Ideas: Peter Lorre's 20th Century	World / Inferno Friendship Society & Jay Schieb
		The Canadian Songbook: A Tribute to Neil Young's Live at Massey Hall C	Various Artists
		The Children's Crusade * C	Soundstreams Canada, Composed by R. Murray Schafer
		Three Girls and Their Buddy	Emmylou Harris, Patty Griffin, Shawn Colvin and Buddy Miller
	Dance	Carmen	National Ballet of Canada; Choreographed by Davide Bombana
		Skin Divers C	National Ballet of Canada; Choreographed by Dominique Dumais
		Shoot the Moon	Nederlands Dans Theater; Choreographed by Lightfoot / Léon
		Wings of Wax	Nederlands Dans Theater; Choreographed by Jiří Kylián
		The Second Person C	Nederlands Dans Theater; Choreographed by Crystal Pite
		Tono * C	Red Sky Performance

Year	Genre	Program Title	Artist/Company
2009 (con't)	Film	The Luminato Reel	Various Artists
	Food	President's Choice® 1000 Tastes of Toronto™	Various Artists
	Literature	An Evening With Neil Gaiman	Neil Gaiman
		Children's Books & Illustrations C	Various Artists
		Gothic Fiction C	Patrick McGrath, Sarah Langan, Monique Proulx
		Gothic Toronto: Writing the City Macabre * C	Various Artists
		World Voices in Fiction	Aravind Adiga, Yiyun Li, Sash Aw, Chimamanda Ngozi Adichie
	Theatre	5 O'Clock Bells C	By Pierre Brault; Produced bySleeping Dog Theatre
		Continuous City *	The Builders Association
		Lipsynch * C	Directed by Robert Lepage: Produced by Ex Machina
		Nevermore * C	Catalyst Theatre
		Zisele	Beit Lessin Theatre, Produced by Harold Green Jewish Theatre Company
	Visual Arts	Communication \| Environment: long wave * C	David Rokeby
		Binary Waves	LAb[au]
		Broken Arrow * C	Germaine Koh in collaboration with Ian Verchere
		Luminato Box C	Various Artists
		Raphael Mazzucco	Raphael Mazzucco
		RedBall Project Toronto	Kurt Perschke
		Shadow Notes	Danny Clinch, Ralph Gibson, Andy Summers
		Void or Everything Ever Wanted *	Tony Oursler
		Haze or Transparency with Friends and Colors *	Tony Oursler
	Illuminations	Robert Lepage in Conversation C	
		Why Fiction Matters	
		The Art of Children's Books C	
		Blurring Boundaries: The Interface Between Communication and Theatre	
		Darwin Exposed: Natural Selection and Sex— 150 years of Getting it On C	
		Kevin Breit Guitar Tour C	
		Lunchtime Conversations C	
		Panel Discussion: Shadow Notes	
		Six String Nation: Book Launch C	
		The Urban Playground C	
2010	Celebrations	Luminato First Night C	Melanie Fiona, Sass Jordan, Jully Black
		Light on Your Feet	Various Artists
		Coleman Lemieux & Compagnie * C	Coleman Lemieux & Compagnie
		Global Music: Rock the Casbah & An African Prom	Béla Fleck, Various Artists
		National Bank Festival: Global Divas and Global Blues	Various Artists
		Waves Festival C	Young Centre for the Performing Arts
		World Music Celebration	Various Artists

Year	Genre	Program Title	Artist/Company
2010 (con't)	Music	Dark Star Requiem * C	Tapestry New Opera; Composed by Andrew Staniland, Libretto by Jill Battson
		The Canadian Songbook: 40 Years of Bruce Cockburn C	Bruce Cockburn, Various Artists
		Prima Donna * C	Composed by Rufus Wainwright
		All Days Are Nights: Songs For Lulu C	Rufus Wainwright
		TSO Goes Late Night: Beethoven Symphony 9 C	Toronto Symphony Orchestra
		Vienna Academy Orchestra	Martin Haselböck, director
	Dance	Julia Domna	Enana Dance Theatre
		Two Faced Bastard	Chunky Move
		West Side Story Suite C	National Ballet of Canada; Choreographed by Jerome Robbins
		Pur ti Miro	National Ballet of Canada; Choreographed by Jorma Elo
		Opus 19 / The Dreamer	National Ballet of Canada; Choreographed by Jerome Robbins
	Fashion	The Ascension of Beauty * C	Mark Fast
	Film	The Luminato Reel	Various Artists
	Food	President's Choice® 1000 Tastes of Toronto™ C	Various Artists
	Literature	African Literature	Brian Chikwava, Carole Enahoro, Ngũgĩ wa Thiong'o
		Azar Nafisi: Reading and Writing Iran	Azar Nafisi
		Blue Metropolis Translation Slam C	Various Artists
		East / West in Canadian Fiction C	Lynn Coady, Lorna Crozier, Anosh Irani, Michael Winter
		Eleanor Catton, Michael Helm and Shaughnessy Bishop-Stall	
		Fiction in the Age of E-Books	Various Artists
		Monday Night Fiction—An Evening with Roddy Doyle	Roddy Doyle
		Monday Night Fiction—An Evening with Ben Okri	Ben Okri
		Scene of the Crime	John Brady, Deon Meyer
	Magic	Masters of Magic	Mac King, Max Maven, Bob Sheets, Juan Tamariz
	Theatre	The Infernal Comedy: Confessions of a Serial Killer	Written and directed by Michael Sturminger; Starring John Malkovich
		The Africa Trilogy: Peggy Pickit Sees the Face of God * C	Volcano Theatre; Written by Roland Schimmelpfennig
		GLO	Volcano Theatre; Written by Christina Anderson
		Shine Your Eye	Volcano Theatre; Written by Binyavanga Wainaina
		Best Before C	Rimini Protokoll
		Homage C	2b theatre company
		One Pure Longing: Táhirih's Search * C	Erika Batdorf
	Visual Arts	Solar Breath (Northern Caryatids) \| Light Air C (Light Air) *	Michael Snow and Mani Mazinani; Curated by Atom Egoyan
		Ship O' Fools * C	Janet Cardiff and George Bures Miller
		Conversation #4 C	Tom Bendtsen
		Nabaz'mob C	Antoine Schmitt and Jean-Jacques Birgé
		SWEATSHOPPE	Bruno Levy and Blake Shaw
		Wish Come True Festival *	FriendsWithYou
	Illuminations	African Issues and the Challenge of Artistic Response	
		Bamako in Toronto	
		In Conversation with Cardiff / Miller C	
		Lunchtime Conversations	
		Pop Divas C	
		Throw Down Your Heart—Film Screening and Discussion	

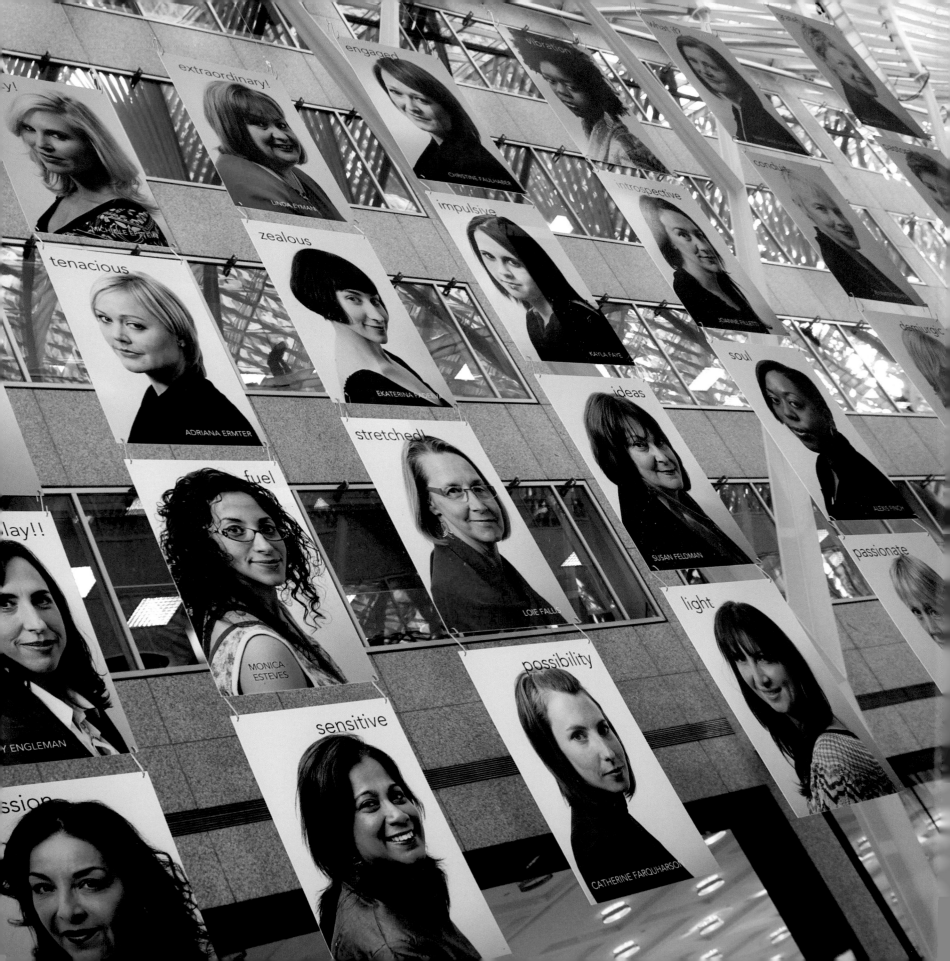

IMAGE CREDITS

ii–iii: **Kar Wai Ng**; *iv*: **Luis Raposo**; *v*: **Kar Wai Ng**; *vi*: **Luminato**; *vii*: **Mike Hough**; *viii–ix*: **Stephanie Berger, © 2008**; *xi*: **Luminato**; *xii*: **Robert VanderBerg**; *xiv–xv*: **Jason MacFarlane**; *xvi*: **Robert VanderBerg**; *xx–1*: **Mark Bradshaw**; *2*: **Nigel Dickson**; *5*: **David Lee Photography**; *7*: **Dale Brazao/GetStock.com**; *8*: **Photo by Andrew Oxenham. Courtesy of The National Ballet of Canada Archives**; *10*: **City of Toronto Archives, Fonds 1583, Item 68**; *10–11*: **Shawn Hutcheson**; *12*: **Luminato**; *13, left and right*: **Luminato**; *14–15*: **Luminato**; *17*: **Luminato**; *19*: **George Pimentel Photography**; *20–21*: **George Pimentel Photography**; *22, right*: **Sean Weaver**; *22, left*: **Tom Arban**; *23*: **Tom Arban**; *24*: **Sandro Altamirano**; *25*: **Roger Kao**; *27*: **GetStock.com**; *29*: **Luminato**; *30*: **Kar Wai Ng**; *31*: **Luminato**; *34, first from left*: **Peter Bregg Images**; *34, second from left*: **Sonia Recchia for Pimentel Studios**; *34, third from left*: **Martha Haldenby**; *34, fourth from left*: **Tom Sandler**; *35, left*: **Peter Bregg Images**; *35, right*: **Tom Sandler**; *36, Toronto Star articles*: **GetStock.com**; *36, base image from Toronto Sun*: **Sun Media**; *36, photos and ephemera*: **Luminato**; *38*: **Andrey Petrov**; *39*: **Stephanie Berger, © 2007**; *40*: **Tracy Byers Reid**; *42*: **Jon Lloyd**; *43*: **Mark Bradshaw**; *44–45*: **Stephanie Berger, © 2007**; *46, both images*: **Steve Wilkie**; *47*: **Manuel Harlan**; *48–49*: **Erick Labbé**; *50*: **Gene Schiavone**; *51*: **Luminato**; *52–117*: **Nigel Dickson**; *118–119*: **Luminato**; *120*: **Kevin Centeno**; *122*: **Luminato**; *123*: **Stephanie Berger, © 2008**; *124*: **Luminato**; *125*: **Cylla von Tiedemann**; *126*: **Stephanie Berger, © 2007**; *127*: **Stephanie Berger, © 2007**; *128, all images*: **Thomas Payne/KPMB Architects**; *129, top*: **Kar Wai Ng**; *129, middle*: **Stephanie Berger, © 2008**; *129, bottom*: **Stephanie Berger, © 2008**; *130*: **Blaise Misiek**; *132*: **Stephanie Berger, © 2007**; *134*: **Kar Wai Ng**; *135*: **Kar Wai Ng**; *136*: **George Pimentel Photography**; *137*: **Sandro Altamirano**; *139*: **Bruce Zinger**; *141*: **David Lee Photography**; *142*: **Kar Wai Ng**; *143, both images*: **Luminato**; *144, both images*: **Erin Seaman**; *145*: **Luminato**; *147*: **John Lauener**; *149, all images*: **Luminato**; *150*: **Luminato**; *151*: **George Pimentel Photography**; *152*: **Luminato**; *153*: **Jon Lloyd**; *154*: **GetStock.com**; *157*: **Graham Waite**; *158–159*: **Luminato**; *160*: **Luminato**; *162*: **Luminato**; *168*: **Kar Wai Ng**; *170*: **Luminato**; *172*: **Luminato**

Printed Laminated Case: **Erin Seaman.**
Back Cover: **Robert Faber/KPMB Architects.**

Mille Femmes: **Pierre Maraval turned his lens on the women of Toronto who enrich the city's cultural scene; 2008; Brookfield Place.**

CURRENT LUMINATO STAFF AS OF JANUARY 2011:

EXECUTIVE & ADMINISTRATION

JANICE PRICE, CEO

MARCIA MCNABB CA, Vice President, Finance & Administration

BRIAN CAULEY, Executive Assistant to the CEO

FIONA CRICHTON, Accounting & Reporting Manager

PROGRAMMING

CHRIS LORWAY, Artistic Director

JESSICA DARGO CAPLAN, Director, Education & Community Outreach

SCOTT MCVITTIE, Director, Programming & Partner Promotions

DEVYANI SALTZMAN, Curator, Literary Programming & Illuminations

PRODUCTION

CLYDE WAGNER, General Manager

CAREN CAMPBELL, Associate Producer

MITCHELL MARCUS, Associate Producer, Special Projects

BOB MITCHELL, Production Manager

RAY SALVERDA, Production Manager

TYLER SHAW, Production Coordinator

ROBERT VANDERBERG, Associate Producer, Visual Arts & Public Installations

MARKETING & COMMUNICATIONS

MIKE FORRESTER, Vice-President, Consumer & Corporate Relations

AKOBI ADAMS, Assistant Manager, Ticketing

LAURA BARRON MCDOWELL, Manager, Media Relations & Communications

SARAH BAUMANN, Marketing Communications Manager

MARY ANN FARRELL, Marketing Specialist

ISABELLE LY, Marketing Production Coordinator

ALLISON SARETSKY, Interactive Marketing Manager

KATIE SAUNORIS, Publicity Coordinator

NANCI STERN, Media Relations Officer

DEVELOPMENT CORPORATE PARTNERSHIPS

NATASHA UDOVIC, Director, Corporate Partnerships

MEAGHAN DAVIS, Development Coordinator

DONNA DWYER, Partnerships Manager

LOROL NIELSON, Events Coordinator

FOUNDATION, GOVERNMENT RELATIONS & INDIVIDUAL GIVING

ALLAN PENNING, Senior Director, Individual Giving & Foundations

JENNIE BIRNBAUM, Research and Stewardship Coordinator

MARTHA HALDENBY, Development Officer - Individual Giving

BRAD LEPP, Manager, Public Sector & Foundations

PAST LUMINATO STAFF

Tanim Ahmed, Coral Aiken, E.J. Alon, Michelle Arbus, Dale Barrett, Bill Bobek, Leesa Butler, Brittney Cathcart, Victor Correia, Daniel Davidzon, Scott Gainsburg, Maggie Greyson, John Hoffmann, Adrian Horwood, Laura Hughes, Loredana LaCaprara, Tahnee Lloyd-Smith, Heather McDonald, Trish McGrath, Paul Moran, Alison Neale, Angela Nelson-Heesch, Amanda Nowth, Damiano Pietropaolo, Nick Poirier, Mary Pompili, Morad Reid Affifi, Alicia Rose, Rekha Sadasivan, Carla Selzer, Angela Shackel, Julian Sleath, Kathleen Sloan, Meighan Szigeti, Becky Thomas, Kira Webb, Carol Wladyka

Each year, Luminato is made possible through the hard work of hundreds of staff, short-term employees, interns, and volunteers. Thank you to all those who have been part of the team since 2005.

171

At the Luminato staff party, following the inaugural Festival, 2007.

ACKNOWLEDGEMENTS

The inspiration for this book began with a four-hour recorded conversation with David Pecaut in August 2009. David knew that, for him, time was running short and he wanted to document the story of the founding of Luminato. I wanted to record David's reflections on why he devoted so much of what turned out to be the last years of his life to establishing an arts festival, and what Luminato meant to him.

With David's passing in December 2009, we all knew that no matter how successful the festival continued to be in the future, the first chapter of the Luminato story was over. We wanted to find a way to capture it while it was still fresh in our minds and our hearts. During the fall, David and I discussed the idea of publishing a book, and as always, he was encouraging and enthusiastic.

The first five years of the life of a festival is not a long time—certainly not for a commemoration. Perhaps we could have been more modest about what is, after all, only a beginning. But these pages are not only about Luminato. They are about the creative spirit. They are about the artists, advisors, patrons, corporate partners, volunteers, and staff who have made Luminato possible. To them—and to our audiences—I extend my sincere thanks.

In the spirit of Luminato, the production of this book has been a collaborative effort. Writer David Macfarlane, portrait photographer Nigel Dickson, and I joined forces with editor Jenny Bradshaw and designers Scott Richardson and Andrew Roberts of McClelland & Stewart to create this celebration of the festival's founding and first five years. Tony Gagliano, Janice Price, and Chris Lorway provided invaluable guidance and support. Clyde Wagner, Robert VanderBerg and the rest of the dedicated team at Luminato were outstanding partners throughout the project. For me, working with them all has been yet another rich "Luminato moment" of celebrating the creative spirit.

LUCILLE JOSEPH, Vice-Chair,
Board of Directors

Luminato: Painting the Canvas of a City
Text: **David Macfarlane**
Portrait photography: **Nigel Dickson**
Producer: **Lucille Joseph**
Luminato Staff: **Clyde Wagner**, **Robert VanderBerg**, **Martha Haldenby**; Publications Assistant for Luminato: **Niwah Visser**

Design & assembly: **CS Richardson, Andrew Roberts**
Production: **David Ward**
Editor: **Jenny Bradshaw**

Typeset in Helvetica Neue and Linotype Didot

Printed and bound in China